Wedding Photography

Building A Profitable Pricing Strategy

incite!
publications

1809 Central Ave.
Ceres, CA 95307

Steve Herzog

Comments From Photographers Using *This Book* To Gain Better Control Of Their Wedding Pricing

"The book arrived just as we were in the process of rewriting our price list. It was an enormous help and saved us from making a number of possibly costly mistakes."

• Gary and Anne LeBouton
LeBouton Photography
Wautoma, WI 54982

"After reading your book, I set up a new expanded price list. The first week of use, I booked three weddings with an average package of $800. My old average was about $550. Brides loved what I had to offer them. One thing all brides said was how easy my price list was to understand. Thanks to this book, my new pricing strategies are bringing our studio the weddings we want! I'm smiling all the way to the bank!!!"

• Brett Behrens
Photo Images
Lakeport, CA 95453

"As a beginning photographer, I am very interested in receiving educational information on wedding photography. I have never worked with another photographer nor ran a business. I have found your 'Pricing Strategy' book VERY HELPFUL and am about to read it for a second time."

• Robert Zanine
Special Images Photography
Phoenix, AZ 85019

"I can honestly say your book has, for the first time in six years, given me total confidence in pricing my weddings— which you know is no easy feat. Excellent book, well layed out, and eye opening information."

• Geri Biondich
Geri's Photography
Ft. Myers, FL 33907

"Fantastic!! Outstanding!! After years of trying to come up with a logical formula for pricing my work, this answers all my questions. Not only will your book have an effect on my future pricing, but the comments you shared on how to move from a 'home–based' operation to a studio were also invaluable. Please keep me informed on future updates"

• Patrick Eubanks
Free Flight Photography
Milwaukee, WI 53216

"Very good approach, very rarely use time as a booking factor on the East Coast. Many photographers are unrealistic here and don't mind working all day and evening for average rates of $700–$1000. Your advice is very useful. Thank you."

• John Uzarski
Jersey Coast Studio
Toms River, NJ 08753

"I very much appreciated the actual price lists being included in the book. Following the evolution of 'real world' pricing was a lesson in itself. The earlier section without actual dollar amounts on the lists helped me understand the theory of pricing, but seeing one man's changes over the years made everything clear. Good book!"

• Steve Barilovits
Rosecran's Photofinishers
Gardena, CA 90249

"As an accountant and the business manager for my husband's photography business, I felt the book had many terrific ideas and plans. I also felt the price asked for the book was very fair. Excellent product, keep up the good work."

• Carol Guy
Photography by Bill Guy
Phoenix, AZ 85040

Wedding Photography
Building A Profitable Pricing Strategy
Steve Herzog

incite! publications
1809 Central Avenue
Ceres, CA 95307-1806

209/537–8153 (phone)
209/537–7116 (fax)

This publication is designed to provide accurate and authoritative information in regard to the subject matter covered. It is sold with the understanding that neither the author nor the publisher is engaged in rendering legal, accounting, or other professional service. If legal advice or other expert assistance is required, the services of a competent professional person should be sought.

From a Declaration of Principles jointly adopted by a Committee of the American Bar Association and a Committee of Publishers.

Printed and bound in the United States of America

ISBN 0–9633158–0–3

Table of Contents

Introduction

You're reading this book for a reason. Maybe you're just getting started in wedding photography and don't want to waste time making mistakes in pricing your work. Maybe you've been photographing weddings for awhile, yet you're unhappy with the fact that your photography is improving—but your bottom line isn't. Or, you might have had a few outstanding weddings and seen how lucrative this business can *really* be...and want to see more of them.

What I intend to do is lay out the basics of a structured pricing *strategy*.

Sound ambitious? Good—because I intend for you to get your time and money's worth from this book, and then some. There is nothing I'd welcome more than to see you, and all wedding photographers, start getting paid what your work is worth.

It's for you, if you want a pricing system which finds a balance between the extremes of setting prices too high and scaring away good customers—or, just as suicidal, resorting to low prices just to get the job.

It would be very easy for me to spend the rest of this book simply outlining that in a *successful* wedding price list, the price of an 8x10 is $20. Or, that the price of a good package is $250, or $900, or whatever. I'm not going to make it that easy for you. This book will provide the tools, but you're going to do the work of putting together a strategy for your own wedding business. The end product will be a price list which will reflect your skills, your community, your expected profit level, and your goals.

When you consider how a slight shift in your approach to pricing can help you book a wedding you'd otherwise miss, or that a small adjustment in your pricing strategy can add hundreds of dollars to your average sale—I think you'll agree that investing the effort in "pricing theory" can not only be profitable, but fun as well.

Pricing is really what professional photography is all about, not photography. Pricing, and all the other money–related areas of your business, is what will keep your business afloat. What about the pictures? Pictures are your product; making a profit selling that product is your objective.

What Your Prices Should Do For You

Before you do anything further, there is one person whose needs must be taken into account: You. Without you, your business will not exist and the customer will not have access to your skills as a photographer.

Your pricing structure should not only generate an immediate profit, but it should also provide the incentive to *stay* in business. Artistic satisfaction isn't enough; if you're not making money, you won't stay in the wedding photography *business* very long.

Here are some of the things a good price list should do for you:

• **Your prices should allow room for you to produce a quality, professional product.** Low prices will force you into delivering a lower quality product—or at least a product that's not as good as it could have been. Your work should reflect the fact that you are a professional. You don't want to have your work compared with the prints Uncle Harry gave the bride and groom.

In the area of "quality control," you have a lot of options: How much time you spend with people, how much time at the wedding. How many pictures you take. The quality of your processing, proofing and finished prints. The quality of the albums in which the prints are delivered.

• **Your prices should make it worth your time as a skilled craftsman.** Forget about the fact that you enjoy taking good pictures. This is a business. You are being hired to create a product from an event which is very important in the lives of the people on the other side of the camera. You are not a middleman selling something made in a factory someplace. You're a skilled photographer. You deserve respect—and you deserve to be well paid for creating a custom product.

Start adding up how much time you spend on a wedding—from the first meeting with the bride and groom, through the wedding, delivering previews and albums, taking orders, etc. Then add in the time you spend running your business—plus, the time you've already invested becoming good enough to be a professional. There's no way you should be making the

same return on your time as a high school student makes pumping gas. If you're counting only the time you're spending at the wedding itself, and thinking "Hey, I'm making $100 for only 5 hours work," you're ripping yourself off.

• **Your prices should generate enough profit that you have funds to reinvest in your artistic and professional growth.** If your prices are close to the break-even point *when you count all your costs,* including your salary, then your business is not going to have the necessary extra fuel to propel it to future growth.

After you've paid your bills, the decision should *not* be whether you keep some of the "extra" money for yourself, *or* plow some back into the business! Your prices should have room for both—and then still have some un-committed profits left over! Once you have paid yourself, there should be money remaining for new equipment, attending seminars and trade shows, traveling to visit other photographers and/or to start hiring other people to help you. Profit is not an "extra"—it's a *requirement* if you want your business to grow and keep getting better.

These should be the "minimum requirements" for your pricing strategy.

Once you make this decision, you've achieved one very important goal: You've established a profit floor that you won't go below "just to get the job."

Basically, what I'm advocating is that you ignore those couples who call you looking for any photographer they can find...and will hire you, as long as you are c-h-e-a-p. These couples have a right to wedding pictures, just like any-one else. But the smartest thing *you* can do for your business, is to let other pho-tographers fight the low price war for the "privilege" of working with them.

What The "Quality" Customer Wants

Once you have made sure your pricing structure will provide for your needs, then you can turn your full attention to serving your customers.

Now you can concentrate on the photography. Now you can "specialize" in working with couples who know that quality photography is not inexpen-sive. They have consciously bypassed other photographers whose low prices ac-curately reflect the quality of their work, and are looking for a photographer who is willing to provide excellent photography in exchange for *fair* prices.

These are the customers you want! These are the customers who will hap-pily pay your prices—*if you can satisfy their needs.*

From *their* standpoint, as the people doing the hiring and writing the checks, a good price list will achieve several objectives:

• **Inspires confidence.** This is the most important function of your price list. Every customer contacting you is going to be asking this question: "Is this photographer a real professional, or another amateur masquerading as a pro just to make a few quick bucks?" There's only one answer, if you intend to build a business which will make people want to pay premium prices for your work.

If the price list you present to customers helps establish the idea that you can be trusted to do a good job for them, that you are a professional in every sense of the word, then your price list is an asset which is reinforcing the impressions made with your pictures. If your current price list is doing anything else, it's working against you and undermining whatever quality you are building into your photography.

• **Easily understood.** The best price lists are those which answer the customer's questions before they are asked. Can the couple quickly see what is being offered, how it's organized and what the cost will be? If the money side of your business can be handled quickly and easily, you'll be able to get back to what the couple is really interested in: Your photography, and the great pictures you are going to take for them on their wedding day.

You don't want the price list to become an issue. You don't want to dwell on the price list deciphering cryptic packages and pricing formulas. If you're spending most of your wedding consultations having to explain packages, explain prices, etc. then your price list is working against you. A well constructed price list should be an asset, not a liability.

• **Gives the customers what they are looking for.** This means listening to what your customers are telling you they want. A big mistake is assuming you know more than the customers do about what they want their wedding album to look like. Even if you know that later they will probably come around to your way of thinking, it's one thing to accomplish this through gentle persuasion. It's quite another to say "this is the way I do it. Take it or leave it." Call it flexibility, call it "the customer is always right," call it service, call it professionalism—call it whatever you like. It all boils down to the fact that, to them, the pictures you gave them are worth more than the money they gave you.

Far too many photographers seem to approach pricing from the standpoint of seeing how much they can get away with. If you've been around professional photography for any length of time, I'm sure you've talked with customers who are calling you because of bad experiences with other "professionals." I know that I've heard some pretty amazing stories over the years about photographers who put all their energy into getting hired, then totally screw up when it comes time to deliver on the promises made *before* the wedding.

A good reputation is worth a lot, and that worth can be added directly to your prices. Building that reputation is easy: Just treat the customers right, and do what you say you're going to do.

1

Building A Marketable Pricing Strategy

No doubt about it: Wouldn't life be great if this book could unveil a foolproof, guaranteed, all-purpose wedding price list? Life would certainly be a lot easier, with the "perfect" price list.

Yet, it's not that easy.

It's one thing to talk theory, make lists of all the options you have for setting up your wedding price list, and project all the profits which are going to pour in. That's fun. That's dreaming.

It's another matter entirely to finally sit down with those lists, and then on a blank sheet of paper make *real* decisions about exactly which of these ideas you are going to use, and which you are going to bypass. That's stress. That's reality!

What makes it doubly difficult is the knowledge that even the simplest miscalculation can torpedo assignments and/or profits. Over time, these missed opportunities can total tens of thousands of dollars—money which could have easily been yours *if* you'd been on target with your pricing strategies from the beginning.

Three Ways To Establish Prices

As you get closer to the point of actually making your "best guess" about prices, there will be several "formulas" you can use. Let me summarize what I have seen as the three main approaches photographers use to set their prices—and offer my admittedly biased opinion of each:

• **Prices based upon "cost plus."** This would mean simply adding up all of the costs of running your business, then adding on a bit of profit as a percentage of sales. At least this guarantees some degree of profit, yet it ignores the issue of creativity. It costs just as much to print an 8x10 of a great image as it does to print one of a lousy image.

This is "commodity" pricing—something like I'd imagine farmers use when pricing pork bellies or corn. They concentrate on producing the product, then sell at whatever the going market rate is at the time. The assumption is that everyone is producing essentially the same product, with the profits going to the volume producer who can control costs most efficiently. I can understand where this approach might be used by a photographer doing school pictures, sports teams or passport photos—any kind of pictures sold in bulk, and devoid of any emotional content. Wedding photography definitely does not fall into this category!

• **Prices based upon what the competition is doing,** then "we'll meet or beat any price in town." This pricing style is the easiest trap to fall into, but also one of the most dangerous. It's really reverse pricing, since you are basing *your* pricing (reputation, service and income) on what the "other guys" are doing. You raise your prices only when they raise theirs. If they are watching you, then both of you will go nowhere and essentially end up in a "price war" situation over who can offer the lowest prices.

Let me put it another way: What if the guys across town are idiots and are pricing their business into bankruptcy? Are you going to follow their lead?

When you come right down to it, what does their business have to do with your business? Their costs might be different, their objectives might be different, their photography *will* be different. So, if they are charging $8.75 for an 8x10, what does that have to do with you? Let them go bankrupt... alone.

(Of course, you have to be aware of what's going on in your market. You can't totally ignore your competitors. But, you can't let them define your pricing. If they are cheap, then chances are good that they aren't delivering good quality—and that people know it. If you can do a better job, you can just ignore them because you are *not* providing the same low level of service! This is a theme you'll see repeated at least 439 times in this book.)

• **Prices based upon value of your work,** which you continually work to increase—along with the prices. This is where pricing starts to get creative! Now, instead of almost looking for reasons to keep prices *low*, you look for

ways to *justify* higher prices. This is the option which allows you the freedom to do the best you can in every aspect of your business. It gives you a reason to want to do the best job you possibly can. Take my word for it, enough people take their wedding photography seriously and will pay higher prices for better photography and service!

While each of these formulas may be useful at some point in your business' life cycle, I have a definite bias towards using *value* as the basis for prices. The best approach is to closely monitor your costs, be keenly aware of your competitive landscape—but then listen to what your customers are telling you about the value of your work. Instead of letting your costs or competition be the principal ingredient of your price list, let the customers vote with their wallets for what they think your work is worth.

Sub–Dividing Your Market

Precisely what form your price list takes is going to depend heavily upon where you stand now in your career as a wedding photographer—and what direction you want to go.

In this section of the book I am going to help you begin identifying some of the preconditions of establishing a *successful* wedding price list. However, I am not going to even attempt to organize a Universal Wedding Price List. Instead, I have broken the market down into three categories, which I will be using throughout the rest of the book:

> • **The "Basic Level" wedding photographer**, specializing in "budget" weddings where the selling price is the main consideration.

> • **The "Mid–Level" wedding photographer**, whose work is good enough that it's obviously "professional," but with pricing still constrained by competitive pressures.

> • **The "High End" wedding photographer**, whose work and reputation are "the best"—enough so that people will pay whatever is necessary to book his or her services.

These classifications are arbitrary. In using them, the point I want to drive home is that you shouldn't assume wedding photography is a single, huge market in which every photographer is competing with every other wedding photographer. That's just not the case.

Finding Your Niche

Within any community there are scores of different markets. No matter where *you* are right now, and which group you are best positioned to serve, you must

first understand what each group is looking for—and what they will be willing to pay to get it.

Even though photographers from each group may be working in the same community, and be listed together in the Yellow Pages, in every other way they are totally different. There is some overlap, but the objectives of pricing are going to vary considerably. (The best parallel I can think of to sum up the situation is that in camera sales, I doubt Hasselblad sales are impacted greatly when Kodak runs a sale on their Instamatics. And, most people interested in Instamatics have never heard of Hasselblads. These market segments are worlds apart in pricing, and to whom they appeal. It's the same situation in wedding photography.)

What you can try is to work at becoming the best photographer within your current "niche," set the stage for moving up into the next category, and then working to replay the process by becoming the best within *that* group. If your prices keep pace with your advancing skills, you can work your way into a highly profitable business.

Whether your photography right now is good, bad or indifferent—there exists a segment of the bridal population which will be interested in working with you, and another (probably larger) group which won't. Your business will never be able to serve all groups simultaneously, and you shouldn't even try.

Knowing which group you're targeting will also make it easier to identify your competition. Don't make the mistake of thinking that you are competing with every "wedding photographer" within a 100 mile radius. You're not. In fact, you probably only have a few direct, serious competitors.

By knowing your position within your market, and setting realistic goals for future growth, you can steadily work your way up the ladder. It's going to be much easier than you might think because as you become a better photographer and businessperson, moving from one customer group to the next is going to be a logical, natural progression.

Basic Level

For the purposes of this book, the "Basic Level" wedding photographer is going to be defined as someone who is serving the low end of the wedding market: Couples who cannot, or will not, spend a lot of money on photography and are willing to settle for less as long as it's cheap. In other words, *price* is the main consideration for which photographer is chosen.

If you are new to wedding photography, this end of the market is most likely where you will start.

Criteria: Price

The operative words in this part of the market are "How much does it cost?"

Or, "How much will you charge to come to my wedding for 30 minutes and give me an album of 32–8x10s?"

Or, "Is that the lowest price you have? What if I substitute the 8x10s for wallet prints? How much will it cost then?"

I don't mean to be sarcastic, yet the one question you will rarely hear is "How good are the pictures?" Quality never seems to become a very large part of the process if you're working the low end. As I said, the people shopping this end of the market are really making a decision between whether to have a friend or relative take the pictures, or hire someone.

If you're working this end of the market, it's a contest between you and Uncle Harry.

The bride and groom hiring a "Basic" photographer are gamblers: They have made a conscious decision to bypass the more experienced pros, pay a lower price, and take their chances on what the pictures will look like. From the couple's standpoint, hiring the Basic photographer is preferable to letting their Uncle Harry take the pictures.

In many ways, these couples are paying their photographer to learn about wedding photography by volunteering their wedding as an "experimental test site."

It's a fair trade. If you're new to weddings and don't yet have the experience, the samples, or a clear idea of what you're doing—then this end of the market is currently the only one you can seriously approach. And it's a huge market! Kodak says that only about half of the weddings annually make use of a "professional" photographer, which leaves a lot of couples trusting their wedding to their Uncle Harrys.

These couples would be glad to hear from you...if the price is right.

Objective: Learn, Then Exit

Simply put, your objective should be to exit this market as quickly as possible. Learn what you need to know about weddings and wedding photography, then translate that education into a better product which will allow you to raise prices.

But you have to make that move intelligently. You can take the "low road," or the "high road."

One of your options when working with this group of customers is to give them precisely what they are paying for, nothing more. That's the low road. Since they will most likely be wanting to get their pictures for as little money as possible, then your response would be to deliver the lowest quality album possible: The cheapest processing and printing, the cheapest album, the most minimal amount of service you can get by with.

While you might be entirely justified in using this approach, I think that in the long run you will be making a mistake—if your ultimate objective is to produce quality work at higher prices.

What I would suggest is that you do these weddings primarily for *yourself*, as a learning experience. For the time being, put profits on hold. Let me explain.

The low budget weddings are, in most ways, exactly the same as those where people are willing to spend more on the photography. You'll be working with brides and grooms, parents, relatives and friends. If you succumb to the temptation to deliver low quality photography, you will impress no one.

But think what the effect would be if you attacked these assignments with every ounce of skill and professionalism you can muster? What if you reinvested the money people were paying you to take more and better pictures, to have a higher grade of print made, to use nicer albums?

Do you know what people would say then? They'd say "Wow! You sure do a nice job. And you're *cheap* too!"

If that's the route you take, what you have just done is overtake all of the "low budget" photographers in your area, and set the stage for competing with the Mid–Level photographers. You have just earned your first price increase. You have started to build a reputation based on delivering a quality product which is worth every penny you are charging. As your quality improves, then you have every right to increase your prices. You're on the high road...the Yellow Brick Road.

Granted, this is not a process which will happen overnight. It's going to take time before you are good enough to get the "Wow!" reaction from people. Yet that has to be your objective! If it's not part of your plan, what might easily happen is that the "give them what they pay for" work you are delivering will brand you forever as a "low budget" photographer. Every sub-standard album you release into your community is going to be working against any effort on your part to do a better job in the future.

What this means is that you can't attempt to "cash in" too soon. You have to pay your dues in wedding photography, just like any other profession. At this point, your only real concerns should be to build your skill level, and your reputation. Then push yourself to do even better, impress people even more.

I might also add that this phase needn't last long. An amazing amount of "low end" wedding photography is of abysmally low quality, produced by photographers who obviously have little pride. Even if your own work is currently not ranked among the world's greatest, just the fact that you are interested in improving will quickly push you past these "competitors" and into the middle levels. It's principally a matter of attitude.

Mid–Level

Mid–Level wedding photography is simply photography which is good enough that people are willing to pay more for it.

If Basic Level photography is dollar-based, then with Mid–Level the issue of *quality* becomes important enough to the couple that they are willing to bypass the low end in favor of a photographer who might not be the cheapest, but the pictures are "good."

For the Mid–Level customer, that improved quality is worth a higher price.

Criteria: Value

Couples looking for a mid-range photographer are worlds removed from those shopping the Basic end of the market.

When you have attracted the attention of Mid–Level customers, what you have done is made the move up into another, completely separate market segment. You are working with a different group of people. The difference is so striking, it's almost as though there is barbed wire between the two camps.

If the people in the Basic group were booking you as an alternative to Uncle Harry, and complaining all the while that your prices were higher "than K-Mart," *then the Mid–Level customer is hiring you as an inexpensive alternative to the "expensive studios."*

It's a totally different mindset. You're not judged on the fact that you are *cheap*; you're being judged as being *cheaper*. ($100 can be called "cheap," while $600 can be called "cheaper"…when compared, for example, with the $950+ package offered by a "High End" photographer.) These people want good photography, know they will have to pay professional prices, but they are usually restricted by a budget which dictates that they balance quality with price. What they are looking for is *value*.

The Mid–Level market covers an extremely wide range. Why? Because every couple has their own idea of how much that quantity called *quality* is worth. While one couple may have budgeted $200 for "quality" photography, another may have set aside $500. Or $1,000.

I don't have to tell you that it's within the middle level that wedding photography starts to become exciting as a business.

Objective: Reputation And Prices Based On Quality

While the Basic Level photographer is selling commodity photography at commodity prices, with Mid–Level photography the determining factor starts becoming your talent as an artist.

Here's what might happen to you, as you make your move from one level to the next:

During the time you're serving the Basic market, your photography will improve. Word will spread about your services. More and more people will call. You'll start having to turn people away because you're already booked for many dates.

STOP! You've done it! You're ready to raise prices based upon the wedding photographer's best friend: The Law of Supply and Demand.

If you've got more people calling you than you can work with, then you have every right to sell your services to the "highest bidder." In a sense, this is what resort hotels do. During the "off season," when they have more rooms than guests, they will drop prices to fill those rooms. But, when the "busy season" hits, there is absolutely no way you can get a room in that hotel for less than the full price—and maybe you'll even pay more if demand is high enough.

When you were first starting in wedding photography and needed to fill a lot of Saturdays with assignments, you would no doubt not risk losing the one bride who called over such a minor irritant as price. You'd do whatever you needed to do to book that date, knowing that the likely alternative would be to do nothing.

When the calls start becoming more frequent, you can start being "selective." You don't have to book the first person who calls.

In terms of prices, what you will do is raise prices high enough to attract enough volume to keep as busy as you want to be. And it's a cycle which will keep repeating itself over and over as you work your way through the Mid–Level ranks. You'll keep getting better and better at the photography, more and more people will call. Now, however, people on the low end will decide you've become too expensive, so they won't book you. Dates will stay open—ready and available for the couples who do think you are worth the price.

Of course, that is an extremely oversimplified example. It doesn't happen overnight, but it's worth the wait. If there's a trick to making it work, it's that you have to keep pushing yourself to the limits of your abilities as a photographer. You *must* get better! *Then, use prices to control demand.*

The Mid–Level stage is where this transformation starts to take place. If you were laying the groundwork for eventual profits during the Basic Level stage of your business, now you will start to see the profitable fruits of your labors.

It's only going to get better.

Your objective for the time you spend in the Mid–Level should be to polish up every aspect of your business. Your photography is going to improve as you gain experience. Instead of the "Basic" pictures you may have taken when you were just starting, now you can add to these a growing assortment of "creative" photographs. The pieces will fall into place. The average level of quality in your work will improve. You'll notice a continuing rate of growth.

At the same time, you should be experimenting with increasingly aggressive pricing. Now that you're building a reputation as a source of quality wed-

ding photography, you can begin to test the upper limits of what people are willing to pay for your services. I'm willing to bet you'll be surprised how you'll continue to book weddings even as you raise prices.

(A very real danger for any wedding photographer is making unfounded assumptions about what people are, or are not, willing to pay for quality photography. Most photographers don't have a realistic idea of how much their talent is worth to the non-photographic market. As a result, they play it safe and keep prices at unrealistically low levels. After awhile, they quit raising prices based on the "gut feeling" that "people will never pay those prices!" It becomes a self-fulfilling prophecy.)

Another benefit of higher prices is that you'll be able to afford a higher level of service. You'll be able to pay for better pictures at the lab. Better albums. You'll be able to take more pictures at the wedding—and do a better job.

It all works together, and Mid–Level is where it's going to be proven to you that people *are* willing to pay more to get more.

As you can guess, these profits can finance a new round of improvements in every aspect of your business. Now, you can start pouring on the steam. There's a snowball effect at work here. Now, if you keep increasing prices at the same rate as you're increasing quality, you can afford to keep getting better and better.

In a sense, what people are hoping for is to hire you before you become "famous" and start charging what you're *really* worth. A close parallel might be a singer who signs a contract for $10,000 to perform in concert six months in the future. One week after signing the contract, a new album comes out, it's a hit, and suddenly the fee for concerts is $60,000. That singer, however, is going to have a lot of singing to do at the old rate before the new rates kick in. In wedding photography, that's what the Mid–Level bride and groom are hoping to find: A great artist who hasn't been discovered yet. Prices are still reasonable, even though the quality is darn good.

High End

If a Mid–Level photographer is one who has learned to use quality to drive prices, then a High End photographer is a Mid–Level photographer "suffering" from too much of a good thing. He or she has done such a good job of serving customers, has mastered the photography, and as a result has found that demand is outrunning supply.

In other words, a High End photographer is really a good Mid–Level photographer using pricing strategy not to *generate* volume, but to *control* it.

What more could a wedding photographer ask for than to be able to name his or her own price—and know that people will be eagerly willing to write the check? It's not a bad way to make a living.

If this sounds a bit unreal, take my word for it—it's possible in *any* community—including yours.

Criteria: Quality

High End customers are concerned with having only one type of picture from their weddings: The "best." Quality is everything. They may still be working within a budget, but the photography is at the top of the list, and they will cut back on other areas of the wedding to ensure that their pictures are the best they can find. They pay attention to the price, yet if they can see that the quality is there, they will happily pay the price.

These customers don't have to be "rich;" in fact, they usually aren't. No matter what their income level, they simply know that they have waited years for their wedding day, have been planning for months, and want their pictures to be "perfect." (The phrase I have heard over and over is "We won't get another chance to take these pictures again.")

Be Prepared For Gasping Brides

As you begin your ascent into higher prices, you're going to notice a lot of brides reacting to your price list as if they had just had their oxygen turned off.

That's to be expected.

The problem is that not everyone you come in contact with will agree that you (and your photography) are worth "those high prices." You'll make a lot of appointments with couples who will love everything about your work, and be ready to book with you...until they see your price list. They will then quickly terminate the meeting and politely say they "will let you know."

That's what you want.

It takes nerves of steel to keep losing weddings, all the while waiting for the couple who agrees that you are charging a reasonable price for the level of skill and service provided. Such is the lot of the High End wedding photographer.

I imagine it's much the same situation for the Mercedes salesman. A lot of people coming by, just looking, laughing nervously at the price—then they're gone. Yet, every once in awhile, someone will come in and pay that $75,000. The customer knows he or she has "the best."—and the salesman has, I am sure, a sizable commission. Everyone is happy.

Meanwhile, over at the Hyundai dealership, they are selling the cars as fast as they can get them in. At $6,000 each, they sell fast. And the Hyundai people are thrilled, because they are gaining "market share." They don't make much money on each sale, but they sure do sell a lot of cars.

What's interesting about this is that while everyone in the auto industry is watching the companies like Hyundai and the other volume producers, manufacturers like Mercedes are doing nothing but raise prices and haul their money

to the bank. They can charge anything they want, and not only sell every automobile they can produce—but probably have a waiting list as well.

The same strategy works in High End photography.

Too many photographers get sucked into the idea of volume. It's easy to do when people are paying $700 for a few hours of photography, picture taking which, by this point, has become relatively easy. It's difficult to imagine purposely losing even one of these weddings.

But let me ask you a question: What would happen to your bottom line profits if you added $200 right to the top of your sales average? This is not $200 in added *gross sales*, with all the costs involved with film, processing, time, etc. This is *net profit*, added straight into your pocket. No added costs or anything, just a higher dollar figure on your price list than is printed there now. What would *that* do for the amount of profit you had left at the end of the year?

Let me tell you what it would mean. For example, on a typical wedding you might make $200 *profit* after you have covered direct expenses, overhead, and paid yourself for your time. By adding $200 to your prices you could make the same amount of money, doing *half* the number of weddings you're doing now. Or, you could *double* your income by keeping volume at current levels. Same work, doubled income.

Now do I have your attention? Now do you see the reason for objectively setting out to become a High End wedding photographer in your area?

Lockers vs. Buyers

As you might guess, the *real* High End customer is part of a rare breed. Not many people are actually willing to write a check for "the best." When prices for the entry level Bridal Album pass $1,000, there is a dramatic break between those who want the pictures, and those who are willing to pay the price.

As I am sure is true at the Mercedes auto dealership, there are a lot of lookers and tire-kickers in wedding photography. Couples enjoy looking at nice wedding photography, but only a small percentage are actually going to book.

The reason I am mentioning this is to comment on one of the largest differences between the High End wedding, and the Mid– and Basic Levels. In the latter two groups, you will find that if your prices are in line with what most people are expecting, you'll book a hefty percentage of the couples who call you. You're offering a good deal, so why not?

At the High End, the issue of value becomes much more debatable and blurred. Most people may like your pictures and want you as their photographers. BUT, they are not going to be able to swallow the price. You'll find that in order to book a date, you may have to meet with quite a few people. Instead of booking most or half of the couples, you may book only 20%, or less.

That's OK! As long as you are booking the number of weddings you want, you should be booking only those willing to pay the higher cost that being "the best" demands.

The biggest error in judgment you can make about High End customers is that they are like most "normal" people: That they are looking for a moderate balance between cost and quality.

The High End customer is not looking for *balance*. They just want the best. They either have money to pay for it, or they are willing to put their bill on their Master Card and spend two years paying it off. The bottom line is that for these people, quality is all that counts. If it costs more, so be it.

These are the people who are suspicious of low prices. These are "name brand" shoppers. For a purchase as important as wedding pictures they are not going to take any chances. They don't want to worry about it; they will just write the check, and *know* that their pictures are in good hands.

Admittedly, this group is small. Not many people are going to line up outside your door and hand you a blank check for pictures. However, it's not as difficult as you might think to find these people—they will find you. It's amazing how many photographers do such a poor job of treating people fairly and delivering superior photography. Yet, word travels fast when one builds a reputation based on quality and working his or her butt off to provide "the best."

Who Can Say What "The Best" Is Worth?

There is only one person who can accurately determine what "the best" is worth: The customer. If "beauty is in the eye of the beholder," then that's where the price is, too. Only the customer can decide when "high" is "too much."

Since this is a competitive business, there is no way you can escape comparison with other photographers in your community. But, here's where the High End photographer has the edge.

If you're a Mid–Level photographer, you are, by definition in the middle. On the low side you have the Basic Level photographer, whom you have beat out by virtue of your superior quality. But there is still someone better than you: The High End photographer. You're pigeon-holed, and no matter what you do with raising prices, you will come up against the standards of the "better" photographer. To get assignments, you will have to price yourself lower and work a little harder.

What about the High End? Totally different situation. He or she is "the best," and so defies comparison. Who can say *how much* better—or how much that difference is worth? Again, only the customer. When you're the best, you're at the front of the line and you can literally charge what the traffic will bear.

Let Customers Lead You Into High End

If you're wondering how you'll know when it's time to make the push into High End, my advice is not to worry about it—the customers will lead you there by their reactions to you, your work, and to your business.

High End is not a situation you can push. It's almost "by invitation only."

You most definitely can push your prices past what other photographers are charging, but as you pull out in front of other photographers, you'll find resistance at some point.

The main reason I want to delve into High End is to make it absolutely clear that the world of wedding pricing does not end at $500. Or $1,000. Or $2,000. Even if right now you can't imagine anyone paying more than, say, $500 for wedding photography—believe me, there are a lot of people who will pay a lot more than that for "the best."

What you don't want to do is limit yourself by making random assumptions about who is going to buy what, and how much they will pay. For example, if you have spent the bulk of your wedding photography career catering to people who have fits when your prices approach $500, then you should not worry about how to convince *these* people how to spend more. Instead, you should look for ways to bypass this group entirely by improving your photography to the point where you are appealing to an entirely different group of customers who may think nothing of spending $1,000 or more—*as long as you give them what they want.*

Set Yourself Up As A Standard

As you work your way through the ranks of your area's Basic and Mid–Level photographers, and get closer to becoming High End, you're going to notice that you have become a "standard" by which other photographers are judged. Your work is what other's work is being compared against.

This is the moment you have been waiting for. You have now become a "name brand."

What's going to happen is that other photographers are going to be forced to react to what you do. You are now a leader, not a follower. You can set your prices where you want.

There are a lot of parallels within the business world:

• Leica/Linhof/Hasselblad vs. "everyone else." I'm sure you've noticed some price tags attached to these cameras. High, right? But the cameras are "the best," and every serious photographer in the world covets these top of the line, name brands. Enough of us want the cameras badly enough that we are willing to pay the price, and these manufacturers sell every camera they can produce. That's the name of the game: Build the best, forget the rest.

• Kodak/Fuji films vs. the "store brands." While Kodak and Fuji set the standards and charge "professional" prices for their films, the "store brands" are left with the "generic" end of the market. (Have *you* ever used K–Mart's "Focal" film?) To sell film, these no-name films have to sport dramatically lower prices. Meanwhile, Kodak and Fuji watch from the high ground. If they don't feel threatened, they charge uniformly "high" prices. That's the payoff for good products. (On the other hand, if one of these Major Players attacks the other with good films, good marketing *and* lower prices, there's going to be a reaction. That reaction will likely be a counter-attack of *better* films, *better* marketing and *still lower* prices to protect market share. Isn't competition great...when you're the *customer*?)

A side benefit of becoming a "name brand" is that while it may take years to reach your goal, in the meantime you will be setting the standards for the group in which you're currently competing. For example, you may just be starting out, but if you aim to become the "the best" Basic Level photographer in your area, you can do it—and you'll grow from there. Same for Mid–Level. If you work to be "the best" within that price range, it won't take long before you're moving up, out, and into the next highest range. And so on.

Excellence can become a habit. What makes this approach so productive is that once you have mastered a photographic technique or any other facet of your business, it's easy to repeat a second time. After that, it's just "what you do." And you build upon it. Keep doing that long enough, and in enough areas, and you will push yourself to the top. While "High End" may be a term I am using in pricing, there is absolutely no reason you shouldn't be using "High End" thinking now—no matter where you are in wedding photography.

Why Many Mid–Level Photographers Stall...
Just When They Should Be Taking Off

The most difficult aspect of making the transition from Mid–Level to High End is the shift in *thinking* required. It's not totally a matter of continually improving the photography.

Here's a common situation for many Mid–Level photographers who should be making it into the ranks of the High End, but haven't:

The photography is good and getting better, yet the idea of selling primarily by price has become a way of life. It's become a point of honor to tell customers, "We're just as good as the best, *but we're cheaper!*" These photographers don't stop to think that because their work is past the point of merely being "good," brides would have paid more for it—and would still be pleased with the value received. In other words, by voluntarily capping the upper limit on their pricing these photographers are literally gutting their bottom line and making far less money than they might have otherwise. It's happening not because their customers won't pay higher, more realistic prices, but because the photogra-

phers can't break the habit of being timid about matching increases in quality with increases in price.

Because these photographers are underpricing their work, they are getting busier and busier. Instead of reaping the benefits which should come when selling a quality product, if these photographers continue to resist increasing prices, they have little choice but to increase volume if they want to increase profits. What they fail to realize, however, is that there's a limit to how long this can continue before the photography and/or service starts to decline. It's inevitable.

Once a photographer is as busy as he or she can be, if increased profits are an objective, there's always the option of following the time–honored business tradition: "We'll cut costs! The customer will never know the difference!"

This cost–cutting program may involve not taking as many pictures at the wedding, and thereby trimming film and proofing expenses. It may mean using a cheaper grade of print, or changing labs in an effort to "get more for less." It will likely mean not spending as much time with each couple before the wedding, to find out what they want, or after the wedding, to make sure they understand how to order, etc. At the wedding, it may mean leaving sooner than they might want—because the photographer has to go to another wedding.

There are a lot of ways to cut expenses, both direct and indirect, but the end result is that once this policy is adopted, growth and the passion for excellence comes to an abrupt halt. Any chance of making it into the High End, and staying there with the customer's blessing, has just been terminated. These photographers could have made it to the High End, but instead they're stalled at the Mid–Level because they cannot bring themselves to adjust their prices upward.

This means that while their photography may be good, it's never going to be superior. And *superior* photography is what the High End customer demands.

You don't have to let this happen to *your* business now, or in the future.

Pricing as "Volume Control"

A better, more sustainable route to building a successful, long haul business which keeps getting better and better is to concentrate on providing the quality brides want, and that many are happily willing to pay top dollar to obtain. In a sense, this has less to do with which level you're working within as it does with the attitude of always giving people your best. By pushing yourself to be better, you'll become more than just "good." Excellence is always accompanied by demand, since there are always brides anxious to pay more for something as important as their wedding photography...*as long as they can be shown that they are indeed getting more.*

Thankfully, in our business, when you're better-than-just-good you've got the pictures to prove it.

This brings us back to the issue of how prices can be used to intelligently moderate volume. When the crunch of demand starts to outstrip the supply of available dates, there's only one civilized, fair way to resolve the dilemma of too few dates and too many brides: Auction your limited supply of dates to the highest bidders. That's right. Establish prices that let you stay as busy as you want to be, working with those brides who agree your work is worth your "suggested retail price."

In many ways, that's what this book is about: Playing price against volume, and keeping them balanced. This is really Supply and Demand at work, and you can use it much the way you use the thermostat in your home to raise and low the temperature. The idea works just as well in business. When the volume gets too hot, you can use price to cool it back down into the comfort zone.

Notice I did not say "set *high* prices." Remember, with Supply and Demand at work, the marketplace is determining the true "market value" of your work. Not you. All you're doing is responding to demand, and using price to dial in the volume of work you want to do. Your brides will let you know if your prices are too high when weighed against your product and local conditions: Your competitors, the economy, your promotional activity, etc. That's the beauty of letting Supply and Demand balance out each other—everything is taken into account, nothing is ignored.

If demand for you and your photography should eventually force your prices into the "high" range, will everyone in your community agree you're worth it? Of course not. Then again, would everyone in your community pay as much as you have for camera equipment?

Pity the Brides You Turn Away

No doubt, the above strikes a raw nerve with some of you. I've talked with many photographers who take understandable pride in their record of booking practically every bride who sees their work. And that's good—or at least they thought it was, until their schedules reached the saturation point and saw they were turning away disappointed brides by the busload.

If you fall within this group, I'd like to ask you a question: What happens to those unhappy brides you turn away? If they called because they truly love your work and you were their first choice as photographer, isn't it a little unfair that the only reason they couldn't hire you is because they didn't phone first? Shouldn't they have access to your photography?

And, what about some of the brides who *do* hire you? If your "low, low prices" were the primary reason they chose you, and not your photography, then that strikes me as *very* unfair—both to the brides who lost out, and to you.

My theory is that you, along with any photographer who is booking *every* wedding, are too cheap. Compared with the quality and value brides are seeing in your work your prices are too low. Those prices represent a deal that's too good to pass up. If you raised your prices, these price-conscious brides would

have no trouble finding another photographer with prices just as low. There will always be photographers who compete on price, just as there will always be brides who value price over quality. If you're turning away brides who would pay more, then you shouldn't be participating in this lower end of the market.

It may seem like a contradiction, but if you want to be known for your *quality,* rather than low prices, by raising your prices you are doing your community a favor. Really.

I'll even go so far as to say that it's your *obligation* to raise your prices to the point where the money people are giving you is equal to the quality and service you're giving them. The reasoning is that by charging higher prices, you can afford to produce a better product. Rather than employing prices that limit your creativity, you'll be able to use some of that money to push yourself to the limit of your abilities. You'll be able to offer better albums and better printing. You'll be able to invest the time you need to do your best work for people who expect the best, and are gladly willing to pay for it.

Maybe we photographers are too close to our product to really understand how trivial price can become for those consumers looking, above all else, for Quality. Since you and I are consumers in the *camera* market, here's a parallel example with which I'm sure you'll be able to identify:

For my wedding photography, I use Hasselblads. When I purchased my camera and lenses, I about choked as I handed over the money. But it was what I wanted. It was important enough that I knew I would be happy with nothing less than the best.

I've never regretted it. I'm even *glad* the Hasselblad company has the guts to charge the prices they do. It allows them to produce a superior product, and stay in business. If they charged less, their product would suffer. And I'd have no option but to buy a camera which isn't as good.

Many brides view their weddings and wedding photography with the same degree of fanaticism.

Never forget that a wedding is an extremely important event in the lives of the people in your pictures. For many brides, it ranks higher than buying a refrigerator or water bed. If your work is perceived as the "best of the best," and your reputation is spotless, then you'll have little trouble finding brides who agree you are worth every penny you charge.

Or, I should say, they'll have no trouble finding you.

You owe it to them, and yourself, to be there when they call with the quality they want.

Skeptic's Corner

If you doubt these high caliber brides exist, because you've never met them, there could be a simple explanation.

Your prices may be too low. (Yes, you read that right: Too *low*.)

If the prices you're employing are so low that you have no choice but to deliver a less-than-top-quality (i.e., mediocre) product, then these quality-conscious brides are making a conscious decision to keep searching until they find a photographer who will give them what they want: The best photography money can buy.

Yes, these brides exist. And they exist in *your* community. They just aren't calling you.

(This may also answer your questions about how other photographers in your area can keep busy *and* charge prices so much higher than you deem reasonable. The brides not calling you are calling them.)

Thankfully, this state of affairs is not permanent or irreversible. You'll begin hearing from these brides once you've raised your prices to the point where you can afford to *not* cut corners and automatically deliver only your best possible photography. And advertise. And contain volume within manageable limits. With each jump in quality, you'll meet a new group of brides.

They'll be the ones who pull up to your office in the new Mercedes, open their Gucci handbag and pull out their diamond-studded checkbook as they put down the deposit to reserve their wedding date in your schedule.

These are your area's High End brides. I promise you'll enjoy working with these people.

2

Defining The Products:
The Bridal Album

There are only two things which you should consider when you are putting your price list together: What couples in your area want and are willing to buy, and what you feel most comfortable selling.

The great thing about adopting any pricing strategy is that, unlike the bride and groom, you're not signing on "until death us do part." You can have an idea, give it a fair chance—then, if it's not working, change it with the next phone call. You can always modify, always correct, always experiment, always improve.

Although they will not be the only people buying pictures, what you offer the bride and groom is critical for one very important reason: They have the most say over which photographer is hired. Naturally, what they are most concerned with is what *their* album will look like. If they like what you are showing them, you get the job.

It's this do-or-die feeling which makes packaging your Bridal Album so critical. It does you no good to be the bride's *second* choice as a wedding photographer. What this means is that you have to be as close as possible to giving the couple what they want—on your first try.

Role Of The Bridal Album In Strategy

In many ways, the needs of the bride and groom are the easiest to decipher. From having talked with hundreds of couples myself, and seeing what they responded to (and what they didn't), here are the two main ingredients most couples will be looking for in their album:

> • **They want "a lot of good pictures."** That sounds very generalized, but it's also accurate. By "a lot" most couples mean that they want you to take pictures of everything and everybody at their wedding. They have put a lot of time into planning their wedding. The fact that they are coming to you, a professional, means the photography is a priority item. They want your pictures to cover more than just the highlights.
>
> By "good" they would mean that they don't want to pay professional prices for snapshot-quality photography. They want the kinds of pictures only a professional can take. If they'd wanted amateur quality work, I'm sure that Uncle Harry and his seven Nikons could have been drafted to do the job.
>
> • **They want time to get the pictures without being rushed.** The completed album is not the only thing couples are looking for. They also want to enjoy the wedding itself. I've heard far too many couples complain about wedding photographers who've rushed a bride and groom around, never letting them enjoy their own wedding. After witnessing such an episode, most couples make the firm decision that they are not willing to sacrifice *their* wedding just for good pictures. If you can organize your Bridal Album packages to allow plenty of time for unhurried photography, you will win points with this couple.

What's important to realize is that these are *service* items—not price items. Rarely will you have any couple say to you "We'll pay you less if you give us less." What they *will* do is look at all you are offering, then decide if it's worth your price. If you're not offering much, they won't pay much. BUT (and this is an important *but*) if you make the effort to make sure you are offering more in the way of quality work and superior service, you'll find many couples are readily willing to pay more, for more. Not *every* couple—but since you can't photograph every wedding in your community, you might as well photograph those where the premium is on excellence, not just low prices.

Don't Worry About What You Offer

You can relieve a lot of stress if you adopt the attitude that it doesn't really matter what you offer, as long as it's what the couple wants.

Too many photographers work hard at coming up with an assortment of albums which they think are "perfect"—then spend the rest of their time with the couple trying to sell these ideas.

That's backwards. It's self-defeating...or at least not as easy as it could have been.

Although you will have to come up with some sort of "product line," it's best to base it upon what you find couples in your area are interested in. Let the market drive your product line. Don't fight the market!

If, for example, you find that couples in your community want 8x10" albums, then that is what you should offer—at least in the beginning. It doesn't have to be the only thing that you offer, but it should form the basis of your product line.

If, later, you have what you consider to be a better idea, add it to your product line—as an experiment. Let the two ideas compete with each other, with couples deciding which is the victor. Don't eliminate what sells until you've found something which sells *better*.

This approach will make your job easier because you'll be basing your business decisions of what the customers are telling you they want—not on what you *think* they want, and/or what you hope you can sell them.

(In truth, I am suggesting that you pay more attention to what couples tell you than what you are reading in this book. Ignore what I'm telling you if what you're hearing from paying customers is radically different. I'm just making suggestions. The brides in your area know more about what they are willing to buy than I could ever hope to suggest, and you are in the perfect position to find out. Just listen. They will tell you—and the fact that you are willing to listen will put you ahead of a sizable chunk of your competitors.)

Packages Mean "Value"

When most couples come to you, they will be looking for one thing: An album. They will also be comparing your offerings with what other local photographers are quoting. In most cases, their benchmark is going to be *value*.

Or, to put it another way, they will be wanting to get as much for their money as possible. There's nothing wrong with that...as long as you don't fight it.

If you've had people call about wedding photography, then I'm sure this scenario will sound familiar:

The phone rings, and on the other end is a young woman trying to ask intelligent questions about something she has never shopped for before...wedding pictures. Since she can't think of much else to say, her side of the conversation begins with the question "How much are your wedding packages?" You talk for awhile, give her what information you can over the phone—then make an appointment for her and her fiancee to meet with you to discuss their wedding, your photography...and your prices.

Right from the start of the meeting, it's quickly obvious they aren't *really* sure what they need. They want a professional photographer to take their pictures, but beyond that they have no real idea about what's the best way to purchase wedding photography.

They are at your mercy—and they know it. In a word, they are *wary*.

You can't blame them. Not only are they shopping for a product they've never bought before, but you're also talking about an event which is still months away—and pictures which haven't been taken yet. In reality, they have very little to go on in making their decision. They can look at your sample prints and get a feel for how well you handle a camera. From talking with you, they will form an opinion about you personally—and whether they want you at their wedding. As for the money, and what they will be getting in exchange for it, all they have to go on is your price list.

The best approach to presenting your wares is to, in a word, *simplify*. One of the best ways to *lose* customers is to make it difficult for them to understand exactly what they will be getting for their dollars. The best pricing structures are those which can be instantly understood, and that quickly defines the money side of your services.

For this reason alone I am a strong advocate of "packages:" Pre-defined sets of pictures that include a specific amount of photography and time in exchange for a specific number of dollars. Packages can be anything you want them to be; the operative word is that they are *defined*—versus *à la carte*.

Here are the reasons packages make such a strong booking tool:

• People understand the concept of "packages." They see them everyday. It's a marketing approach which automatically points to "value," whether they are buying "3 day/2 night" travel packages, "4 for the price of 3" specials on auto tires, or wedding photography packages where "everything is included." From their side, and yours, a "package" is a simple way to define exactly what is being purchased. People like that...especially when they aren't totally sure *what* they are buying.

• Packages quickly outline *exact* costs. Few people feel comfortable signing on the dotted line if not all of the blanks have been filled in. If they feel there is any chance of being hit later with "additional charges," most couples will avoid you and take a safer route—straight to another photographer who leaves fewer questions unanswered. (If your reputation is not yet fully established, this point is especially critical.)

• Finally, while "packages" imply value—*that doesn't mean the price has to be low*. Not at all! Your packages can generate a lot of profit—and still be a great deal for the customer. Providing value is simply a matter of giving the customer more than they are paying for. For example, if a $500 package is greeted with yawns by brides, you can increase the value by adding an 11x14. That print might cost you $8 from the lab, but if you include it in the package you have added maybe $50+ in *value* to the customer. That

might be all it takes to wake the bride up and motivate her to ask you to be her photographer. The same thinking can be applied to $1,000 packages: Offer $2,000 worth of pictures & service, at half price, and you've given value.

The great thing about packages is their flexibility. They can be structured any way you want—or rather, any way the bridal couples respond to. It's a great system that can be custom-tailored to your skill level, local market, competition, and the price range in which you need to operate. They can be structured to practically sell themselves.

Learn From Couples Who Don't Book With You

As important as it is to get selected to photograph a wedding, it's also wise to find out why people *don't* hire you.

Say you are a Basic Level photographer just starting to get calls from Mid-Level customers. Your name is coming up more and more in your community, and these "better" brides are beginning to call. If you do a good job on the phone, you'll soon be meeting with some of them. However, for the sake of this example, let's assume that you're not booking any of these weddings. You're getting close—but being the second choice doesn't count in this business. You won't get invited to the wedding as an "alternate." You have few clues about what you're doing wrong, or not right enough.

Here's how I would suggest getting this information:

Once you have had a meeting with a couple, if you don't hear from them within a day or two, call to ask if they have made a decision yet about their photographer. If they are "still looking," they'll tell you. If they'd like to hire you, your call may speed up the process of booking their wedding. However, some couples will simply state that "we have made other arrangements." Don't just hang up!

If you have done a good job of establishing rapport when they met with you, you should be able to follow their statement with a simple inquiry: "Oh, I'm sorry to hear that. I was really hoping we could work together. *Do you mind if I ask what it was about my pictures that you didn't like?*"

Now you're getting *strategic* information! Of course, not everyone will tell you very much. Yet enough people will that you'll be able to begin piecing together the puzzle of what the wedding photography market is in your area.

Maybe the bride will tell you that she simply "liked another photographer's pictures better." If you ask in a merely curious fashion, she may tell you *which* photographer. That information will let you know how the paying customers are positioning you and your work within your market. You'll start to learn where you stand.

Maybe the bride will tell you "your prices are too high." What you need to know is: "High in relation to what, or to whom?" If you see that brides are comparing your services with another photographer's, and you're coming up short, then you will need to make adjustments—either by giving more (the best option) or lowering prices (a last resort, and hopefully, only a temporary one).

Maybe "your packages weren't what we're looking for." If you hear this often enough, it may be time to seriously consider revamping how you pictures are packaged. It makes absolutely no sense to keep meeting with people who may like your pictures, but aren't thrilled with the way you present them in albums. If the bride tells you this, counter with the question "what would you like to see?" (Simply demonstrating a willingness to modify your album structure to meet their needs might well get you the wedding, if the couple hasn't yet firmly committed to another photographer.)

The objective of these extended conversations is to get information you'll never learn from the brides who *do* book your services.

If these brides had good, substantial reasons for not booking with you, what you gain from asking questions is a glimpse into other customer "Levels." You're not quite to the point of booking the weddings, but you're starting to learn how these customers think, what they are looking for, how they differ from the customers you're working with now. If you listen to what these customers are saying, and use their comments as a guide for your next round of product enhancements, it won't be long before you're not only talking with people in the next highest group—but getting asked to take the pictures, too. After all, you're giving them what, as a group, they have *told* you they want.

If you truly want these weddings, you have no choice but to listen to people—and the sooner you make any needed adjustments, the better. Doing so may simply be a matter of adding an hour of time to your package, adding a few prints, or whatever. Having this feedback from non-booking brides will give you a way to intelligently plan your business, as opposed to "flying blind" and guessing. Guessing is a process which could take years.

3

Outlining Your Pricing Strategy

Before you start assembling lists of print sizes and quantities, and adding prices, you should first understand the role of the different parts of a *strategically*-conceived wedding price list. No matter whether you are working within the Basic Level, Mid–Level or High End markets, your price list will need to be structured to accomplish several tasks:

• **You'll need a "phone" package.** When the phone rings and the person on the other end asks the inevitable questions about prices and packages, you need a package which sounds impressive. You need an attractive *verbal* package which will attract interest as you say, "my packages begin at $xxx." This package is your cheapest, so it's true role is to set the pricing floor for your work.

From a marketing standpoint, this is probably your most important package. Over the phone, where it's difficult to show pictures, this package is going to establish your "price/performance ratio" for the couple. It's what will catch their ear and help them make the decision to make an appointment to talk with you in person and see your photography. If your "phone package" isn't doing its job, the caller will hang up and you'll never have the chance to show them, in person, all of the other options you offer.

Although this package should represent good value, in reality the phone package should be your least impressive package—*when compared with the packages which follow it on the price list.* It's a good package, but it's left lacking several key features which most couples would want...features which just happen to be included in your next group of packages. (After all, it's your *minimum* package and it should reflect that fact. You don't want this package to be *too* appealing.)

• **You'll need "booking" packages.** These are the middle packages where you start pouring on the value. It's these packages you'll expect most couples to find most attractive—once they talk with you, see your work, and begin to understand how many pictures *need* to be taken at a wedding to produce a nice album.

The reason for offering several mid-range packages is to give people room to make choices without ending up at either extreme. It seems to be human nature to gravitate towards the middle. Couples feel good that they aren't going with the cheapest package—but aren't blowing their budget either by choosing the most expensive. The booking packages represent the "comfort zone."

The booking packages should be *obviously* superior to the phone package. To make it easy for the couple to quickly see the limitations of the "phone" package, the "booking" packages could include, for example, a combination of more prints, larger prints, more time, nicer albums, with the emphasis on a making sure each package offers a lot for the money.

Once you are past the minimum package, it's not difficult to quickly add value without adding much to your costs. Once you've been hired and you've spent time at the wedding, and spent money on film and processing, adding a few more prints isn't going to cost much from the lab. Yet, for the couple, those extra prints, and/or a little extra time, can make a huge difference in how their finished album looks. It's these extra pictures which start fleshing out the wedding coverage and take the pictures past covering only the "highlights." Even if over the phone it was your Basic package which caught their interest, once you've had a chance to talk with these couples about their options and your different packages, most will see the wisdom of spending a little more—and getting a lot more.

• **You'll need a "ceiling" package.** Here is where you'll do everything you can to create an album that will meet the couple's every want and need.

This may sound strange, but your *highest* package should not be one you expect most people to seriously consider. That's not its job. Rather, its role is to establish an upper boundary on prices which gives the couple something to reject—and steers them back to the middle, which is exactly what you expected.

That's not to say that this ceiling package shouldn't be attractive. It should be, and this fact means that some couples will book this package—just because they want "the best." Yet, for most people, the reality of planning a

wedding is that they are on a budget. They may *want* the best, but since they can't justify spending the maximum they will back off a bit and choose a package one step down. They may still end up spending more money than they ever dreamed their budget would allow, but because they didn't spend "the maximum" possible they still feel they've been *sensible*.

(Here's a non-photographic example of this thinking. Most people would consider a Cadillac an "attractive" automobile. But, after seeing the $25,000+ price they will retreat a step or two and buy a $15,000 Buick—*and pat themselves on the back for saving money!* It's amazing how inexpensive $15,000 can seem...when compared to $25,000. *Yet where would Buick be if not for Cadillac?* It would be the "high-end," and most people would automatically head for Chevrolet. It's called "positioning"—but it's really "applied psychology.")

What this means for your wedding photography is that your ceiling package should not be offered as a *value*-based package. It should simply represent the best package you can put together, letting the cost fall where it might. If the "phone" and "booking" packages represent ways for couples to exercise fiscal restraint, then your top package should offer a way for couples to go for the ultimate and ignore the costs. Some couples will definitely book this package, but most won't; again, that's precisely what you knew would happen.

As I said, these package groups are necessary no matter which segment of the market you are targeting. How you structure your packages, and the prices you attach, may vary widely—yet the theory still applies. If you are serving the High End customer and your minimum package is $2,500—you still need booking packages, and you'll want to have a $10,000 package just to make everything else look "reasonable."

Sample Packages And Strategies

In the following section I am going to offer an overview of how packages can be structured to meet your needs at different points in your business' life cycle.

I'm going to start with a representative example of how a photographer serving the Basic Level market might structure his packages—then move into the Mid–Level, showing how packages might be changed to accomplish new and different goals.

In each group, we are going to be working with a range of variables. These can be mixed and matched to achieve just about any effect you might want. They are:

• **Time:** How much time are you going to allow people? Are you going to stay two hours, or spend the night with them? The issue of *time* is an ex-

tremely strategic factor—and one which is often overlooked by many photographers.

• **Print Quantities:** How many prints are included with each package, and the sizes?

• **Price:** The dollar amount, and how quickly (or slowly) it changes between packages as more prints and/or time are added?

The theme of this section is *strategy*. Watch how the individual packages are constructed, plus how they relate to each other within each group. The thinking varies considerably between Basic Level, Mid–Level and High End. Once you understand the process, you'll able to analyze your own situation and come up with packages which may (or may not) mirror what I'll outline—but which will be right on target for *your* market, *your* brides, and *your* community.

Basic Level Strategies

Model Bridal Album Price List

Package A:	8–8x10s and 12–5x5s (up to 3 hours)—$(Base Price)
Package B:	12–8x10s and 24–5x5s (up to 4 hours)—$(Base Price + 25%)
Package C:	16–8x10s, 48–5x5s and 1–11x14 (up to 5 hours)—$(Base Price + 50%)
Package D:	24–8x10s, 64–5x5s and 1–16x20 (up to 6 hours)—$(Base Price + 70%)

These packages represent an effort to implement a good ratio between price and print quantities for the couple determined to spend as little money as possible on their wedding photography, and yet still have "professional" photography.

Basic Level/Pricing

Yes, you're right: There are no actual "suggested" prices listed next to these packages. I wish I could simply provide a guaranteed "best" price for each pack-

age, a dollar amount which would generate bookings and profits. I can't and I won't even try, for good reason.

The fact is that pricing is a process which is going to take place between you and your customers, not between you and I. I might be able to help you solidify your strategic thinking, but you are going to have to invest the time putting it all together and making it work.

The approach I will be using is that of a pivotal *"base price,"* which is the phone package described earlier. The base price is the highest price you can charge for your smallest package, *and still get hired.* This is the package you should work on first. The way to begin establishing this package, and its pricing, is to first of all finish reading this book, and second, start investigating what other Basic Level photographers in your community are offering. Know your competition. Know the price ranges they are working within, and what they are offering for those prices.

Once you have a good idea of what the community standards are for Basic Level wedding photography in your area, then you can start to construct your own pricing structure—and know what you are working towards. All of your packages after the "phone" package should relate back to that package, be built upon it. When the couple looks at your second package, it should relate logically to the first. It should be obvious to them not only how much more the larger packages cost, but what a great deal they represent in terms of ever increasing value.

If you are just starting out, I mean *just* starting, your "base price" should be aggressively low—"low" meaning in relation to what other Basic Level pros are charging. Over the phone, let your prices do the talking. If a "low" price in your area is $700, then you can charge $500. If low is $200, then you might have to charge $175 as the only way to entice your first couples to hire you.

Looking at the Model Price List, you'll notice that the prices for Packages B through D rise rather slowly compared with the quickly accelerating number of prints included with each package. That, plus the fact that you are adding more time, means each subsequent package represents more bang for the buck. The net result is that when the couple compares these larger packages with Package A, the thinking will be "Yes, Package A is a good deal at a great price—*but look how much more we will get in these other packages for only a little more money!"*

Get Hired First, Then Think Profit

Your pricing objective during this Basic phase in your business should be to book weddings first, make a profit second. You need the experience and you need samples. You need to understand weddings, and wedding photography. You need *volume.*

What this means is that the dollar amount you place at the end of each package description is going to be a lever for controlling the reaction of the po-

tential customer. If you set the price "low," they will be ecstatic. If you set the price "high," they will go elsewhere. It's that simple.

The best advice I can give you on pricing your work is to *always* work to give people more than they are paying for. This is especially critical at the Basic Level, where people will not be expecting much. Never let your (temporarily) low prices dictate low quality and service. Rather than lower your quality to meet the price, you should raise the price to meet the quality level of your work. Keep your standards high.

Don't Sit On Your Prices!

One idea I want to stress on Basic Level pricing is that you should constantly, and continually, be pushing those prices higher. You should always be testing the upper limits. This means that you do not type up a price list, and then feel obligated to use it for the next 12 months. Use it for a month, and if it's successful, then raise the prices and see what happens. Even if your raise your prices every week, it's doubtful your prices will keep up with your rapidly improving quality, experience, and know-how. That's only fair, for as you get better at what you do, your prices *should* increase.

With your first weddings, however, you may be doing them almost at cost. That, too, is only fair since the couples hiring you are taking a real chance on your abilities. If you do a good job for people, treat them fairly, and give them *more* than they are paying for, you will start getting more and more calls. You'll get the volume you need to learn quickly. When demand starts catching up with supply, that's your cue to raise prices.

You can practically change prices with each phone call. You can experiment with different combinations of time/prints/price.

Here's the secret to making this system work: Don't pocket the profits. Reinvest most of it in better quality prints from the lab, better albums, etc. Buy new equipment which will help you do an even better job. Keep this up long enough, and you will soon be exiting the Basic Level ranks and moving up into the Mid–Level, which is precisely what you want to do.

Basic Level/Print Quantities

How many prints do you include with your packages? As many as it takes to book the wedding *and* help convince couples that your larger packages represent superior value.

By definition, Basic Level customers are looking for print "tonnage" at the lowest possible cost. Giving them exactly that is not really difficult.

Here's the thinking behind the packages shown on the Model Price List:

• **Package A** contains only what could be called a minimum number of prints. Depending upon the response, you may need to raise or lower the

print quantities. (If too many people are booking this package, and you therefore need to lower the number of prints included, it's best to lower your costs at the same time by cutting 8x10s. If, for competitive reasons, you find you need to include more to generate interest and appointments, then add to the number of Preview-sized prints. You have this size printed anyway, so it costs you nothing to include more in the entry level package.)

• **Package B** shows a dramatic jump in value: Almost twice as many prints. Look closely, however. All that has really been added is 4–8x10s, plus more Preview prints. The added cost to you is small compared with the increase in value to the bride and groom. You are now starting to make money with little added direct cost.

• **Package C.** Again, more 8x10s and Previews, but now with the added allure of an 11x14. (By all means have sample prints on display in these larger sizes!). Including an 11x14 instantly makes this a High End package for most couples. More time, more prints in the album—plus an almost-free 11x14, all for only 25% more than the cost of Package B.

• **Package D.** Your finest package. Ample time for unhurried coverage, enough prints in the album for the bride and groom to have practically every picture taken, plus an impressive 16x20. Not an easy package for some couples to resist, once they begin comparing the fact that they are getting three times as many 8x10s, over five times as many 5x5s, and a 16x20—all for less than twice as much money as the most entry level package.

Here's how a typical couple might approach this price list:

Over the phone, when they first contact you, the price of Package A will let them know that you are within their price range. If you sound like you'd be nice to work with, and/or they have heard good things about your pictures, they will make an appointment to talk with you.

Once they see your photography, and begin talking with you about all the pictures which they will want taken from their wedding, most couples will quickly realize that Package A is not what they really want. For only a little more money, Packages B and C will give them more pictures and more time. Package D will appeal to some couples, but it's real role is to establish Packages B and C as the "safe and reasonable middle ground." (If you found couples were interested in what you offered in Package D, yet didn't want to be extravagant by going with the most expensive package, then simply add a "Package E"; this would make the current Package D one of the middle packages and lower resistance.)

You'll find, I'm sure, that as you become better at touting the advantages of the larger packages, and your photography improves, that more and more couples will gravitate towards Package C. This will become your most popular package since it combines a good combination of time, print quantities, a Wall Print, and a reasonable price.

Basic Level/Print Sizes

Since you'll be taking plenty of pictures in your efforts to learn and grow, you'll be getting a lot of Previews back from the lab. If your prices are indeed low, you should use these Previews in the finished Bridal Album—adding only enough 8x10s to document the highlights of the day, but letting the Preview-sized prints do most of the storytelling.

Here is my reasoning:

• There is no sense in keeping expensive Preview prints in your files, then spending more money at the lab to have 8x10s made. Basic Level photography is low budget for both you and the customer; you should make the most effective use of those prints you have while controlling new spending.

• Couples shopping for a Basic Level photographer are going to be more impressed with a package which includes more prints than they will with larger prints. As long as they can have 8x10s of the main pictures, they will be usually satisfied with smaller prints of the secondary pictures.

In the Model Price List, you'll notice that in Packages A through C, each succeeding package adds only four additional 8x10s, while the number of 5x5s doubles. In Package D, the number of 8x10s has increased by eight. What you are trying to do is convert the couple seriously considering Package C into a couple who can't resist going a bit further to Package D. You want the packages to literally *pull* the couples up the scale!

Of course, there are any number of ways you can approach building packages. As always, you will want to check out what other photographers in your area are doing, then work to improve upon it.

It's going to take some experience on your part to determine which mix of time, prints and price are most effective for you in your community. The specifics will change, but the pattern will remain the same: *Increase the value of what you are offering faster than you are increasing the price.*

What you should do at this point is use this price list as a guide for constructing your own strategy. Get out your lab price list and figure out your direct costs to produce each of the packages listed in the model. I think you'll see that by making liberal use of Previews, you can build the value of these packages quickly.

Time Is On Your Side

One of the things you should easily be able to offer couples is an ample allotment of *time*. If you're just getting started in wedding photography, you will probably need the time anyway to produce a good, solid, *salable*, reputation-enhancing set of pictures.

While I am generally very much an advocate of using time as a control and/or booking tool, for the Basic Level photographer the situation is *different*. If you're a new wedding photographer, you need this time as much as the bride and groom. If you are to have access to a real live bridal couple, at a real wedding, under real (hectic) wedding conditions—*you need to be there to take the pictures*. There is no way you can duplicate the experience you will get from simply being at the wedding longer, and using this time to try new ideas and/or do a better, more complete job. Any extra time you spend will easily be some of the most educational, on-the-job training you will receive. People will be paying you to learn.

My advice on Basic Level time limits is simply this: If, to do a better job, you need to stay an extra half hour, then stay. Ignore, somewhat, the time limits printed on your price list.

If the couple asks whether it's going to cost them more, I would recommend that you look them straight in the eye, smile, and say that "No, I want to stay to get the pictures I told you I wanted to take. I want to do the best job possible for you. It's my wedding gift to you." If you adopt this attitude, I *guarantee* you will impress people.

This may not be an approach you will want to maintain throughout your career, but in the beginning, it's a good policy to have. (In a later section I will cover how to handle "additional time," when a couple officially asks you to stay beyond what is included in your package.)

Computerize Your Price List

If you own a small computer, I highly recommend that you use it to generate your price lists. Why? Because it allows you to modify price lists instantly. You can test new ideas quickly—change packages, raise prices, whatever.

When I got my first computer, this is an approach I used extensively. At times, I had as many as five different price lists in effect simultaneously. (The price list I showed a couple literally depended on how I "read" them, and how badly I wanted the wedding.) I was testing every idea I could think of and fine tuning my thinking—and *experience*—with prices, packages, time, *everything*. I quickly learned what worked for me, what didn't; I dropped the losers, then started the cycle again by trying to improve upon what was already working quite well. If I'd had to stay with my old system of typewriter, X-acto knife and rubber cement, I wouldn't have attempted many of the changes which eventually became mainstays of my wedding business.

Putting together a good price list is a chore if you have to do the work by hand. The problem is inertia. If changing a price list was a time–consuming hassle, you'd likely postpone adding the new ideas until you got around to it. This means you'll use poor ideas much longer than you might want to. If you used the same price list for a year before changing it, it could take you years to get the same "feel" for wedding pricing and strategy that you'd get if all you had to do was sit down at the keyboard, delete a few lines, type in new ones, then

tell the computer to "Print." You'll be amazed at all the ideas you'll want to try once getting them down on paper is easy.

Summary Of Basic Level Pricing Strategies

The most important job of this Basic Level Strategy is to lay the groundwork for your entry into Mid–Level photography. Consider the time you spend as a Basic Level Photographer as a "training camp"—for your photography, for functioning on a professional level week after week, for working with people, and for selling your work based on the idea of quality.

As you prepare to jump into the ranks of Mid–Level photography in your community, you are going to notice one change immediately: Now that customers are paying "real" money for "real" photography, instead of competing with Uncle Harry, you are competing with other "real" photographers. You're now going to be competing with photographers who take their businesses seriously, and who are going to compete strongly, and well, for the same customers you are targeting.

It's not always easy.

I've seen it happen time and again in my own area, where new professionals will start getting busy based upon their low prices—then fall flat when they begin pricing themselves out of the Basic Level and into the Mid–Level. Their rising prices put them in direct competition with more experienced pros. When they were competing with Uncle Harry, it was easy to look good. Now, with their new "professional" price list, they are suddenly finding that 1) their old customers think the prices are too high, and so this group quits calling, and 2) the new customer group, those people willing to spend Mid–Level prices for good photography, are going to other comparably priced pros who have been around longer. Now that *serious quality* has been added to the equation, the situation becomes much more complicated than when price alone was what mattered.

Welcome to Mid–Level.

Mid–Level Strategies

Model Bridal Album Price List:

Package A: 3 hours, *Fridays only* (12–8x10s and 16–5x5s)
$(old Base Price)

Package B: 4 hours (24–8x10s and 16–5x5s)
$(*new* Base Price)

Package C: 5 hours (32–8x10s and 24–5x5s)
$(new Base Price +30%)

Package D: 6 hours (48–8x10s, 32–5x5s and 1–11x14)
$(new Base Price + 60%)

Package E: 7 hours (56–8x10s, 64–5x5s and 1–16x20)
$(new Base Price + 90%)

Open Plan: "The Open Plan is our most extensive and beautiful package, allowing you to design your own custom album by selecting only those print sizes and combinations you prefer. A minimum order of $(three times new "base price") is required, using listings for individual print prices. Up to seven hours coverage is included. For each additional hour, the minimum order will be increased by $(equivalent price of 8–8x10s). Albums for the Open Plan are priced separately; ask for details."

Once your business has built a momentum based upon your increasing expertise and low prices, you are going to soon find that your volume of calls will increase quickly. People will learn about you, and because they have heard good things from their friends, they will be basing their inquiries upon your now–proven track record.

You will notice a dramatic change in the way you do business. Now, instead of most dates being open, you'll find that you have to check your calendar to see if you are available. Plus, you will experience a new phenomenon: Having to turn people away because other couples have already reserved your services.

When this shift starts, you have begun your exit from the Basic Level market and moved into the "Mid–Level" of wedding photographers in your community. Demand is catching up with supply. You can now think seriously about raising prices and revamping your price list to reflect the fact that you can afford to be selective about whom you work with.

The transition from Basic Level to Mid–Level is one of the most exciting you'll ever experience as a professional. In a sense, this is where you are really making the move from amateur to pro. Nothing again will ever compare with the realization that people are actually starting to hire you because of the quality of your photography, not just your prices. It's the moment you've been working for since you first decided to "go professional."

The underlying assumption with Mid–Level strategy is that enough people are going to call you about available dates that you no longer have to do *anything* to book *every* wedding. If, with Basic Level strategy, you were making all the concessions, now you can start dictating a few of your own by the manner in which you price and present your work. No more do you have to beg and plead to get hired by using low prices. You know you are finished with that stage of your business because now you are getting more inquiries about weddings than you can handle.

What better way to control demand for your limited supply of available wedding dates than with higher prices?

What you are going to be doing is purposely setting your prices so that they are too high for some people—but not everyone. You *want* to discourage those people who are shopping by price alone. When you were in the Basic stage of your business, you needed the experience as much as they needed the low prices, so you had the basis of a good working relationship. That equation has now changed. You are getting calls from people who want to hire you even if you are no longer ridiculously inexpensive. The first couples you worked with got a real deal; you don't have to give away your work anymore. You have truly arrived as a professional wedding photographer.

What's happening is that you are now entering the mainstream. As a Mid–Level photographer you will now be pricing your work on roughly the same level as other "good" wedding photographers. You're not cheap, and you're not expensive. You're offering a good balance between price and product. You're offering *value*.

Mid–Level/Time

Whenever wedding photographers get together, the talk usually revolves around equipment, sales averages, album formats, labs, prices, etc. Naturally, everyone is looking for ways to take better pictures and increase income, yet rarely is much attention paid to what is actually one of the most powerful sales tools we have: *Time*, and its pivotal role as the major controlling factor in what any photographer will be able to accomplish on the wedding day.

What I've noticed about most wedding photography price lists is that time is treated as a non-issue. In the Basic Level packages I showed you how you can downplay time during that period when you need the hours at wedding more than the bride and groom. Now, let's get serious about controlling time.

Emphasize Time Right From The Start

On the Model Price List, there has been a major restructuring: Now the number of *hours* is listed first, the number of *prints* has been moved into the parentheses.

In my own wedding business, it took me years to realize the value of my time. For years I assumed I was in this business strictly to sell prints. My packages were designed around print sizes and quantities. When a bride came to talk with me, I emphasized album "tonnage." It was almost as if I was offering "wedding pictures by the pound." The amount of time included in my packages was always an afterthought.

At some point (probably while sitting in a corner of a Reception Hall waiting for the cake to be cut) it finally occurred to me that *before* the wedding, and at the wedding itself, there was only one real issue—and it wasn't the number of prints that would be included in the Bridal Album four months down the road. The issue was: In order to get the pictures the couple wanted, when would I need to start, and how long would I need to stay? The issue of print sizes, etc. was actually something which didn't come into play until *after* the wedding, once the couple was back from the honeymoon and looking at their proofs trying to decide which pictures to include in their album.

This was an absolutely critical shift in thinking.

This was one of those "bolt of lightning" situations. I realized I'd been booking weddings *backwards*. Instead of concentrating on how many prints the couple would receive in their album, what I needed to find out was the *amount of time* required to adequately cover their wedding day—*and then help them select the correct package to fit that schedule.*

This shift in emphasis produced dramatic, and instant, changes in how couples selected which package to book. Now, time was everything. By redirecting the conversation away from print quantities during the booking process, and stressing the issue of time and the importance of "being there," I was now able to quickly get the couple thinking clearly about what they needed. Instead of haggling over print sizes from pictures which hadn't even been taken yet, the conversation centered around ideas the couple had been working on themselves: What time would the ceremony be starting? Where would the bride be getting dressed, and what would be the best time to start pictures? What were the plans for the reception? Would there be a dinner? A dance? *How long would they want me to stay?*

Setting Time Limits

Most couples, naturally, would love to have their photographer stay from the opening bell to the final minutes of the reception. That's their ideal, yet it's also unrealistic—or at least is a level of service which shouldn't come cheaply.

This introduces the concept of limits and compromises.

If a photographer books a wedding based on a 36–print album, he could conceivably fulfill that agreement in a few seconds with a roll of 35mm film and a motor driven camera. That many pictures could be taken, 36–8x10 prints made, and then delivered. That's *not* what most couples want, or expect, when they purchase a "36–print album."

They are not looking for "36 prints." The Mid–Level couple is looking for *complete* coverage of their wedding. They are hoping to have a set of pictures which shows the events of the day evolving. At the wedding this has little to do with the number of prints which will eventually find their way into the album. At the wedding this has *everything* to do with the photographer being there. It has to do with *time.*

As you get into serving the Mid–Level customer, you will find that they easily understand this concept. In fact, if your packages offer a range of hour–based options and you discuss the wedding from the standpoint of how more time will allow you to take the pictures the couple wants, then you will find people thanking you for helping them tailor your photography to their wedding. Most photographers seem to dictate to people what they are going to do, and not do, for the couple. People get tired of this attitude, especially in relation to something as personal and important as a wedding. Couples will be very much relieved to find that they are in control of the timing, just by the package they select.

When I am talking with couples in my studio, once we get onto the subject of time and what they are planning, we very rarely go back to prices and print quantities. Those are self explanatory. Instead, the conversation revolves around what the plans are for the wedding day and how far into the reception they would like me to stay. They select their own package, based upon their needs.

The difference this shift in emphasis makes is amazing. Instead of trying to decide how many prints they will want of pictures which haven't been taken yet, the talk can center around the wedding plans and a rational decision made about which package will best fit their needs.

It really is that simple.

Best of all, it's absolutely logical. *That* makes all the difference.

From Adversaries to Allies

A side benefit of stressing time over prints was that I suddenly ceased being a salesman. Or at least such an *obvious* salesman.

I became an advisor, an ally. I'd been to a lot of weddings and could use that expertise to help them plan their wedding successfully. My answers to their questions made sense.

Let me give you an example of how the amount of photography time might be determined for a typical wedding. If the ceremony is scheduled for 3 p.m., we may decide I'd be starting at the bride's house at 1 p.m. for pictures

with her family and bridesmaids. That establishes one end of the time limit. Then, discussing the reception, the couple may tell me that the dinner will start at 5:30. With 300 guests, it may take an hour or so for everyone to be served. The cake will be cut and the band will start at 7 p.m. If they want me to stay for an hour into the dancing, the photography would be ended by approximately 8 p.m. Total time *required* for this wedding: seven hours.

As you can see, I haven't had to *sell* anything. The couple lays out their plans, and the amount of time needed to take the pictures just falls into place based on those plans—not on my trying to talk them into buying more. When an album is based on prints, as in the Basic Level packages, there is no logical connection between the package selected and the wedding. Producing an album of 48 prints may represent four hours at a small wedding—or 12 hours at an all day affair. Who knows?

Time Equals Control

Controlling time allows you to control the entire booking process. How? *Because it's you who sets the amount of time included in your packages.* If, for example, you think that $750 would be a fair price for a package containing 24–8x10s and 32–5x5s, that's fine. But, what will book this package for you is the fact that it's your "six hour package." A bride booking your services for six hours will automatically get this package.

Although the idea of time can be put to good use at any stage of your business, it's in the Mid–Level phase that the quality of your work begins to provide leverage in how you structure your coverages. Some examples of how stressing time over print sizes and quantities can be used to your strategic advantage:

• Say you are new to wedding photography and want every opportunity to book *any* wedding, no matter how small. Solution: Have a low minimum time limit, say two hours. This would be your "phone" package, as described in the previous section.

Your other packages would then quickly follow by adding generous amounts of time, with the price differential kept "reasonable." This would make it easier for the couple to move to a larger package and more time, while staying within their budget. Not only will the couples like this idea, but it will also guarantee that you have the time you need to do a good job. It takes awhile to get used to weddings and up to speed. If you are not yet to the point of being able to react quickly, then higher time limits will work to your benefit—as well as the couple's.

• Maybe you don't want to do "small" weddings. Or, maybe your schedule is getting filled with small weddings, and you're having to turn away larger weddings you'd rather book. Solution: Raise the minimum number of hours in your smallest package. If it was two hours, make it three or four. Of course, your prices will go up, too. The net effect will be that you won't book as many small weddings, which will leave your schedule open for the weddings you want to do: Those where people are willing to commit to the

higher number of hours, and are willing to pay more for it. (Do you really want to work with a couple *that* determined not to spend money? Maybe last year you had no choice, but now you do. Again, it's supply and demand.)

• Or, what about the question of doing one wedding per day, versus two or even three? Your policies on time will help you make that decision. If you only want to photograph one wedding, then you can offer couples a wide range of time-based packages, which will allow them the option of having you at the wedding "until it's over." Conversely, if you want to be available to do more than one wedding you can use shorter time limits to establish that you will be available to cover only the wedding's highlights. You can "specialize" in this type of coverage.

Weddings are not generally well–managed events, with split second timing. If you're doing only one per day, this isn't a problem and your schedule can be adjusted rather easily. That's not the case if you've booked a second wedding, and that bride is expecting you at a specific time.

Not having well–defined time limits can lead to disaster. Let me offer an example of what might happen if you booked two weddings without a firm understanding of time limits:

Wedding #1 starts great, but quickly falls behind schedule. Maybe the flowers were late, or the formal pictures took longer than expected, or the food and/or band were late. The reason doesn't matter; what *does* matter is that you have a lot of pictures to take yet—and you need to be leaving in 20 minutes to photograph Wedding #2. You've got a problem. You are now in the unenviable position of having to explain to Bride #1 that you have to be leave her wedding to go take pictures for Bride #2. Such an announcement would not please most brides, especially if the idea of time was never really discussed, and the assumption was you'd stay for "as long as needed." Bride #2 won't be thrilled either if you're late to her wedding. Just hope that neither is an attorney.

A simple, and firm, policy on time limits could avoid this situation—or, at least transfer the burden of scheduling to the bride's shoulders, and off yours. If you had booked Wedding #1 using a "Five Hour Package," and the clock starts ticking at noon, then you *know* you will be able to leave this event at 5 p.m. Better yet, you established this timetable when you *booked* the wedding, so when Bride #2 called about her 6 p.m. event, you knew you were available. This is the kind of information you *must* have if you are going to book yourself into a tight scheduling situations and/or multiple weddings.

"Friday Only"...And Other "Special Situations"

On the sample price list I have included an optional "Friday only" package which can be helpful if you are wanting to eliminate three hour coverages from Saturday weddings, but aren't quite ready to eliminate them completely.

When a couple calls for a Saturday wedding, quote the four hour package as your minimum. That's true, for *Saturdays*. When a couple calls for a Friday wedding, or a Sunday, or whatever you decide, then you can instantly quote a "special" package which is geared just to their needs.

This will be your Fridays–only *phone* package. It will help you maintain interest on the part of the bride and groom—interest you may have lost if you simply quoted your standard four–hour package. If you want to do Friday weddings, this will give you a way to handle them without sabotaging your primary Saturday bookings.

The point I want to make here is that you can fine tune your packages to accomplish anything you want. You can have a variety of packages which help you achieve specific goals. The Friday-only package is but one example. You may also decide to have a special price list for your "off season." If you are booked solid in the summer, you can use your main price list. But, when someone calls for a wedding on a Friday in February, and you know that your chances for getting another call for this specific date are remote at best, then you can have another price list ready and waiting.

You might also decide to have a "stand-by" price for fast approaching, unbooked dates—just like the airlines have "stand-by" pricing to fill seats that weren't booked at full fare. If the first question you ask the bride when she calls is "What is the date of your wedding?," you'll know soon enough how aggressive to get in your pricing strategy.

You do not have to have one "all purpose" price list! It's best to have several ideas going at the same time.

Mid–Level/Print Quantities And Sizes

On the model price list, you'll notice that the ratio between 8x10s and 5x5s has shifted in favor of more larger prints. There are several reasons for this shift in tactics:

 • First, while the Basic Level customer may have appreciated your efforts to use 5x5s as a way to trim costs and pass along savings, that is going to be less important to the Mid–Level customer. 8x10s are a "prestige" size; the Mid–Level customer is expecting this size to predominate in their album, not Previews. As a good businessperson, you recognize that the customer is always right...

 • Second, the fact that 8x10s are worth more to the customer means that you can charge more. I know that sounds simplistic, but the value of a "36–

print album" can increase dramatically as Previews are removed and 8x10s substituted. While an album of 36–5x5s may be worth $100 to a customer, taking those same images and having the lab print them as 8x10s can triple the value. From your standpoint as the photographer, it can't get much easier than that.

• Third, downplaying the smaller prints is a way to make it clear that you are now in direct competition with other Mid–Level photographers for this customer group's attention. You are letting your community know that you are pulling away from the budget, Preview–oriented tactics and strategy, and are now determined to offer a truly professional–level product line.

This shift in print sizes really has nothing to do with the photography itself. You're taking roughly the same pictures, yet now having more of them printed larger. Your costs will increase a little, while your profit potential will increase a lot. It's time to take advantage of the fact that for most people, bigger is better.

"Finished Prints," Not Previews

One of the sometimes forgotten aspects of increasing prices is the point that you should always be looking for ways to increase the quality of your product. Sometimes you can do this cheaply, other times it's going to cost you more to deliver more.

One approach you may well want to abandon, which was advocated in the Basic Level section, is that of using the original Previews in the finished album. The problem often encountered is that the quality and color balance of the previews will not match that of the 8x10s—which may be printed months later. This isn't really a problem, until you mix the two groups of prints in the same album.

For the Basic Level customer, using Previews was a valid trade-off between getting "a lot of pictures" and paying a rock–bottom price. Color match was not critical—or at least the customer wouldn't have agreed it was worth the added cost.

That's not the case with the Mid–Level customer. Quality is now becoming an important issue, and these customers expect their prints to look better than simply *acceptable*. They still like the idea of using smaller prints as a way to have more pictures in their album and reduce costs, but the bride is not going to be happy with a *white* dress in the finished 8x10s, and a *bluish* dress in the previews on the page next to it.

The way around this problem is to simply not use original Previews in the finished album. Instead, when the order for 8x10s and other additional prints is sent to the lab, have *new* "Previews" printed at the same time of those prints which will be going in the Bridal Album. Will this add to your costs? Sure, but the album will look better and more consistent, you will have fewer complaints,

and you will have performed a service which is worth the increased prices you are now charging.

Another point: If any of your competitors are building albums using mixed 8x10s and original Previews, it's not going to hurt at all to mention to customers that you "don't work that way." Don't be shy. Tell them—several times if you have to—that you have taken the more expensive route of ensuring quality by having *all* the prints in your albums printed as "finished prints." Let them know that you are going the "extra mile," and that their album would look better for it. (For graphic proof of the difference this can make, go through your files and find a Preview which is obviously off–color. Have your lab make a good 8x10 from that negative. Show both the Preview *and* 8x10 to your potential customer. Explain that Previews are printed quickly and have no place in a "quality" album. The Mid–Level couples who are looking for a nice album and don't want to play cost-cutting games with their wedding pictures will appreciate this candid explanation of the differences between various photographers' work—and add one more reason to the list of why they should hire you.)

Believe me, the serious Mid–Level customer will thank you for helping them understand wedding photography. If your prices are higher than your competitors, you have just given them a very good reason why this is so. Quality sells!

Mid–Level/Pricing

Now that you are past the point of needing to compete within the Basic Level market, you can finally do what you've been wanting with pricing: You can charge a *fair* price for your work.

When you were working the entry level market, you may have been literally giving your work away in order to get experience, samples, etc. As a Mid–Level photographer, you don't have to sell yourself short anymore. If you've been charging $300 for your photography and now you have people telling you that it's "every bit as good as the photographer's across town who is charging $450"—then you're in line for a well-deserved price increase. An *overdue* price increase.

Mid–Level Pricing Climbs Faster

On the Mid–Level Model Price List, you'll notice that the prices are climbing faster than those listed on the "Basic" Model Price List. Instead of jumping 25%, 50% and 70%, the percentage increases for the three packages following the base package are 30%, 60%, and 90%.

Combine those increases with the fact that Mid–Level prices are higher than Basic Level to start with, and you can see that the pay back for spending several hours photographing a wedding has increased substantially.

You aren't quite to the point of charging twice as much money for twice as many pictures, but you're getting closer to that ideal. In effect, the 60% percent increase between Packages B and D means you are giving a 40% discount—and that's not counting the 11x14. Or, to look at it another way, there is a 40% "value factor" which kicks in when the couple compares what they will receive with package D over what's included with package A. That's a strong incentive.

Mid–Level Balancing Act

When making the shift from Basic to Mid–Level, it's important to realize that long term success is going to be the product of more than simply raising prices. If you're delivering a decent Basic Level product, I have no doubt that you could indeed raise prices somewhat and not lose bookings. That would increase profits...maybe even double them, if your prices are as low as some I have seen. Yet you can only go so far with purely price raises. You can go much further by increasing both value and prices *at the same time.*

For example, let's assume you are currently charging $200 for your most popular package. You're booking this package with practically every couple that calls. It's a case of too much success. You decide to raise the price to $300. However, you begin to hit some resistance from couples who now think the price is a bit too high for what they are getting in return.

Your first reaction might be to simply back off on the price a bit. That would rekindle interest, but what have you really done: You've stopped the progress of your business dead in its tracks. Why not re balance the equation by adding more product or service in exchange for more money?

The rationale here is that it doesn't cost much to add a few prints to a package—prints which are worth quite a bit to the bride and groom in dollars. Adding six 8x10s to the package might cost you $20 from the lab, yet those prints will increase the *value* of your package by maybe $100 or $150. Why cut your price and give the couple less, when they would probably *prefer* that you charged more—and in return gave them more pictures? Instead of trying to sell what the customer may view as "$200 worth of pictures" for $300, by adding a few inexpensive prints you're now offering $300 worth of pictures for $300. You're back in balance, without having to lower your street price.

Add still more pictures, and your selling price could probably reach $350 or $400. There's no secret involved here; if you give the people more of what they want (pictures) they will give you more of what you need (money).

Lowering your prices should always be a last resort. When you lower prices, you are subtracting income directly from the bottom line. You are giving away your profit margin.

Another example: If you're charging $250 for your wedding coverage, after expenses you might be making $100—assuming you're working from your home and don't have much overhead. If, for whatever reasons, you were to cut your price by $25, you have just taken 25% of your profits out of your pocket.

To recoup that lost income you will have to do 33% more weddings just to be where you were before you cut the price!

I'm willing to bet you will find it much easier to keep the $250 price *and* probably book more weddings if you simply added $50 worth of *value* to your package. People are coming to you not to save money, but to have a great set of pictures from their wedding. Give that to them! You could add more Preview-sized prints, which essentially cost you nothing since you have them anyway.

If you're tempted to lower prices, think again. There will almost always be another route you can take to achieve your goals.

Lose The Battle, Win The War

What makes successful pricing so difficult is the fact that there is no formula for determining the *true* worth of your photography. Your customers are going to want the best possible photography at the lowest price; they surely aren't going to tell you that you should be charging more.

And how many photographers can accurately gauge the value of their work from the customer's standpoint? Not many.

The secret to pricing is to get the photographer away from the pricing process. *Let the customers do it!* Let them vote with their wallets.

When I was first getting into weddings, I attended a seminar at which the speaker passed along some advice which has proven to be a godsend to my business. It's simple:

PRICE YOUR WORK TO LOSE ONE–THIRD OF THE WEDDINGS FOR WHICH YOU GET INQUIRIES. IF YOU'RE BOOKING EVERY WEDDING, YOU'RE TOO CHEAP.

Think about those two sentences and their implications for your business. What they're doing is providing a systematic way for you to gauge "supply and demand" and put them to work for you. After all, if you can only do one wedding per day, you might as well sell your services to the highest bidder, right?

At the time I attended that seminar, I'd been thinking I must be a pretty amazing wedding photographer because I was booking practically every wedding I got calls for. I thought that was to my advantage. It hadn't yet occurred to me that once I had booked a date, I was also being forced to turn away other weddings—*weddings which might have been better bookings.*

Nothing Good Lasts Forever...it gets better

You can't invent new prices on a wedding-by-wedding basis. You can't have one price list for people who drive Mercedes, and another for couples driving Hyundais. You need some kind of systematic approach to pricing which, *on average*, will give you the best chance of booking as many weddings as you

want to do—each at the best possible price. You need a system which you can *monitor*.

For example, let's say you put together a new (higher) price list using this "lose-a-third" idea. You lose some weddings for a specific date, sweat a little—yet sure enough, the phone rings, and on the other end is another couple calling about the same date. This couple is looking at quality more, price less. If you'd booked the *first* couple, you would have had to turn this second couple away. Except you're *not* booked, and the second couple says "we do" and writes a check for the deposit. Bingo. You've made them happy...and yourself. (Even if you book the first couple who contacts you about a specific date, they are now paying higher prices than they would have been. And they aren't complaining. They booked.)

But, as time goes by, your photography improves *while your prices stay the same.* People know a good deal when they see it, and you gradually realize you're once more booking most of the people who see your work and prices. Again, you're back in your old position of having to turn away weddings which might have been better. You're no longer "losing a third." Darn! You've outgrown your current price list, *and it's time to raise prices.* Welcome back to the plus side of Supply and Demand.

You'll find this Lose-A-Third concept invaluable to your business. It provides the "scientific proof" you need to monitor customer reaction to your prices, photography and everything else about your business. As long as you keep adding value and improving the quality of your work and service, you'll be able to put this theory into profitable practice.

Test Drive This Idea!

If you need proof that your prices are too low, yet are hesitant to try this idea with your customers, in your community, here's a way to remove all doubt as to whether or not "Lose-A-Third" will work for you:

Keep a log of your wedding inquiries next to your phone for six months. Track the number of calls you get for *each* date you are available for wedding photography. Next to each date, write down the date of the call and the name of the person who called. Make your usual arrangements to meet with couples to discuss prices, packages, etc. Then, once you book a date, go back to your log and *circle the call which was from the couple who actually books the date.*

You're not done yet. If you're like most photographers, even after you've booked a date you'll continue getting calls from other couples asking if you're available. On your log, you're going to track these couples, too.

Let's assume, for the sake of this example, that today is October 4th, and one of the dates you are tracking is October 5th. Tomorrow.

Looking at your call log, you see that over the last six months you've received a total of five calls for October 5th. The couple you will be photograph-

ing was call number two. This means that you had to turn away the last three callers, sight unseen.

Aren't you curious to find out whether, out of those five callers, one couple might have been willing to pay 10%...20%...30% or more for the privilege of having you be their photographer?

If, after keeping this log for six months, (or a year, or three months—whatever it takes), you see that all your circles are *consistently* towards the top of the list and among the first calls you got, *you are booking too early.* You're selling too soon. If your photography is good enough that the first couples to call book and fill your schedule quickly, *then you are too cheap.* People are snatching up your services quickly because they represent such a good deal.

What you want to see is all those circles scattered all over the chart. Some dates will book early. Some will book late. Yet, *on average,* you've given yourself a chance to see how much couples think your work is worth. Overall, you'll come out ahead—as will the couples who most want you to be their photographer, and will now have a better chance of finding you available.

This approach will also tell you when you've *raised* prices too much. If you notice a sudden drop in bookings, or if you talk with a few couples and still don't book the dates, then you may decide that maybe you've gone too far and need to make "price adjustments." Few people will complain when you lower prices. My feeling is that it's better to be too high for the short haul, and then back off if needed than to spend years being too low—and never knowing it.

(And don't forget: If you see a rapidly approaching date is not booking, and you find yourself on the phone with a couple about that date, you can *always* sweeten your offer and make them an offer they can't refuse. An extra free hour, a 16x20 instead of an 11x14, whatever. If you want the wedding badly enough, you can get it.)

Pricing is very much a matter of experience and "feel." However, it's worth your time and effort to let your customers help you push your pricing to the upper limits of the scale, rather than going it alone, playing it safe and pricing your work low just to make it easy on yourself.

You can carry this system to any extreme you wish. At the outset, you may find that on average you talk with two couples to book one wedding. Later, you may be able to go for one of three. Then one for four. The percentage doesn't really matter...as long as when the year is over, you've been as busy as you wanted, photographing the best weddings.

Why else are you in business?

Incentives: Still A Prime Mid–Level Motivator

As you saw with the Basic Level "price shopper," the value–conscious Mid–Level customer, too, is looking for ways to save money—and needs good reasons to spend money beyond what has been budgeted.

Wall Prints are good reasons.

On the Model Price List, Packages B and C have been structured to meet the needs of the couple shopping for moderately priced coverage of their wedding. These are "few frills" albums.

With Packages D and E, Wall Prints have been added for precisely the same reasons they were included in the larger packages in the Basic Model Price List: They provide the needed push to help couples decide, for example, that because their wedding is going to last six hours anyway, they might as well have you stay the extra hour or two, pay more, get more pictures in the album—plus, get a beautiful Wall Portrait.

(One thing I'm willing to wager is that these larger packages will be even more difficult for the Mid–Level couple to resist than they were for the Basic Level customer. Many Basic Level customers will still have their eyes glued to the bottom line. That won't be quite as true of the Mid–Level customer, who is already more predisposed to the idea that good photography isn't cheap. They will have a harder time resisting the temptation that the larger packages offer, especially with the almost-free addition of the Wall Prints.)

The whole idea behind using incentives is to incite action. The danger with incentives of any kind is that they will become a habit. Whether you are adding Wall Prints to packages, extra time, nicer albums, or whatever, you should monitor how much they are contributing to achieving your objective: Booking weddings you might otherwise have lost, or helping couples make the decision to go with a larger package. Once you begin to sense that couples would do these things anyway, even without an incentive, just because they like your photography—then by all means drop the incentives. Don't give something away when you don't have to!

For example, if Wall Prints have been a fixture on your price lists for years, you may gradually notice that while people are gladly accepting them, the larger prints aren't directly helping you book larger packages. Maybe you've become good enough at selling on the basis of time that couples are booking the package they *need* anyway. Remedy: Delete the Wall Print from your main price list.

That's not to say, however, that you can't resurrect Wall Prints when you need a "little something" to help a couple make a decision. Notice in the above paragraph I suggested to "delete the Wall Print from your main price list." That doesn't mean kill the idea totally. Instead, have a *coupon* printed which offers the exact same Wall Print (or other incentive) you were freely giving away before. The difference between having this idea listed on your price list and on a separate coupon is that now *you* decide when to use it. It's no longer an automatic giveaway.

One thing I've noticed about using any type of incentive is that the reaction is much stronger when the customer feels it's "custom designed" just for them. If the couple sees a free 16x20 listed on your price list as a standard part of a package, they might hardly notice it. It's not going to have nearly the im-

pact it would if they were almost ready to book without it—then you pulled that same 16x20 out of your hat and knocked their socks off by offering them a "print valued at $150" if they booked with you, went with a larger package, or whatever.

This is a modification you might want to make to the way I've structured the Model Price List. If you like the idea of *selective* incentives, use coupons. They are a powerful tool. Best of all, they let you control the selling process. Once you prove to yourself that you can book weddings without giving anything away, you can take the preferable route of letting people *buy* that 16x20 "valued at $150"—and pay $150 for it.

Open Plan: Special Weddings Only!

The Open Plan is in a class by itself. It's a special–purpose package designed to meet a very specific need.

No matter how hard you try to come up with a group of packages which offer a high level of value and a good assortment of print sizes and quantities, not every couple is going to agree with your choices. That's not usually a problem. But it is a problem when you are talking with a couple who you *know* will be the best wedding you have ever done, and you don't have a package they like.

You need help. Fast.

Enter the "Open Plan": A free–form "package" which lets the couple select any combination of prints and sizes they like, the only requirement being that their total order reaches an agreed–upon minimum dollar amount.

Risk And Reward

The wording used in the model to describe the Open Plan is meant simply to control who books this package, and eliminate much of the risk to you of not using pre-defined packages.

There are any number of ways you can handle the Open Plan concept. However, since it can become complicated quickly, it's best to keep it simple and straightforward.

The "risk" with this package comes from the fact that you don't know how people are going to use it. While, with all the other packages, you know that in exchange for a specific number of dollars you will be having to deliver a specific number of prints, you don't have this control with the Open Plan. What if the couple selects an all–8x10 album? What if they get no album, and go with all 16x20s? Maybe they will group all the orders under the minimum, and not go beyond the smallest possible order while getting prints for friends, parents, and everyone else? You don't know.

The one way to decrease the risk is to increase the *guaranteed* reward. You simply place a high price tag on this package, and let the couple make up their mind whether it's to their liking or not. The price should be high enough to close all "loopholes" anyone could find to use this package to undermine your regular pricing structure.

In addition to helping you book weddings you *really* want, there is one very good reason for offering this package on your price list: It's invaluable as a tool for learning what "High End" customers are thinking. High End? Yes, in the sense that couples booking this package are willing to pay top dollar to get *exactly* what they want. You want to work with as many of these couples as you can find. The Open Plan concept offers you a way to watch, listen and learn what couples will do with their wedding pictures when price is not the main consideration and they can mold their album into any shape they want.

In other words, *what makes this package valuable is the quality of the customers who will find this arrangement to their liking.* Couples willing to come up with their own packages are often going to become your best customers. They take their wedding pictures seriously and aren't willing to go along with "the usual." You don't want to lose the booking over something as trivial as the number of 8x10s in their album. You want to be their photographer, and the Open Plan gives you a way to be "flexible" in a controlled manner.

In the long run, the experience you get from watching how different couples engineer their albums will come in very handy when you are putting together new price lists and packages. Some of your best ideas will come from couples who are simply doing it "their way." (I used the Open Plan approach on my price lists for many years, and some of the ideas listed in the various Model Price Lists in this book were first shown to me by couples making good use of the freedom the Open Plan allowed.)

Open Plan Option: Don't Put On Price List

One suggestion I will add about the Open Plan is that it doesn't have to be listed on the same price list as your other, standard packages. You can have this plan listed separately, on another sheet of paper, and bring it out only when you are talking with a couple who you feel would make good use of the Open Plan concept.

This will give you control. It will also save you much time explaining the Open Plan to customers who aren't going to be good candidates anyway for this type of arrangement.

By keeping the Open Plan totally separate from the other packages, you can let the "special" couples know that you are willing to go above and beyond your normal packages to make it easy for them to hire you. They will appreciate that you want to work with them badly enough that you're willing to let them plan their own package.

Summary Of Mid Level Strategies

You are going to learn an enormous amount about selling photography as a Mid–Level practitioner. The reason is simply that it's a very crowded and competitive segment of the market. It's also where most of the customers are.

What this means is that you are wildly free to experiment. You can try practically anything, and as long as a part of the picture buying public finds it "reasonable," you'll stay in business.

Part of what makes the Mid–Level so exciting is that you're learning quickly. By definition, the fact that you are Mid–Level means that you're getting busier. If you're talking with couples on a daily basis, meeting with them, and doing weddings every week-end, you have plenty of opportunity to learn lessons, make mistakes, try again, and keep getting better.

My advice: Make the most of it.

High End Strategies

Model Bridal Album Price List

Package A:	5 hours (32–8x10s)	$(32 x base *per print* price)
Package B:	6 hours (40–8x10s)	$(40 x base *per print* price)
Package C:	7 hours (48–8x10s)	$(48 x base *per print* price)
Package D:	8 hours (56–8x10s)	$(56 x base *per print* price)
Package E:	9 hours (64–8x10s)	$(64 x base *per print* price)

Primary High End Objective: Controlling Volume

Control is the name of the game in any kind of High End situation. If you were priced any lower, you would be overrun with volume. Pricing is used almost as a weapon to limit volume—and then make it possible for the photographer to afford this reduced volume.

If a photographer is doing a good job, and has been in business long enough that lots of people know he's producing superior work, then the phone *will* ring. Building that kind of reputation is the reason for always stressing quality and service, even in the Basic and Mid–Level phases when prices aren't yet high. However, while a Mid–Level photographer may raise prices, there is no

guarantee these price increases will have an effect on volume. Again, enough people will still want to book his services that he'll keep getting busier and busier.

At some point, increasing volume is going to run head on into the realities of maintaining quality, service and simply running a *professional* business. When this happens, the photographer will have two choices: Keep doing more and more while delivering less and less, OR put a cap of volume, cut back, then do the best job humanly possible for those customers willing to pay the price of supporting a "limited volume" photographer.

Let me give you an example. Photographer A is good. He's busy. Two years ago he was doing 35 weddings a year, now he's closing in on 80. He's often booked for several weddings per week-end, sometimes several per day. Two years ago he was doing an excellent job for people: Lots of personal attention, spent ample time at the wedding, got the pictures back to the people on time, as promised. That's changing.

Now, he's getting tired. Sometimes he calls the bride by the wrong name, maybe by the name of bride from last night's wedding. Quality is stagnant—he uses the same ideas for every wedding and is playing "beat the clock" to get the pictures taken, and get out of there. He's also more than busy the rest of the week: Talking on the phone, meeting with people. Instead of a two week turnaround for Previews, it's now taking over three weeks—and then only after the bride has phoned to find out why it's taking longer than he promised.

Something has got to give. He's beginning to lose "good" weddings because word has gotten around that he's "trying to do too much." It's "burnout" time.

Our photographer has reached the crossroads of his business's future. He can either continue cranking out volume, or he can cut back and coax higher profits from a lower volume of exceptional work.

The second option is "High End."

Succeeding with this maneuver is tricky. The danger here is in the fact that while 80 weddings may have been required to support the business at the old prices, if our photographer decides to cut back to 40, the prices are going to have to jump quite a bit to maintain profits while supporting overhead. The photography and service are going to have to be awfully good to justify what might be a 50% increase in prices. Profit–wise, 40 weddings are going to have to do the work of 80.

What makes the challenge of High End strategy so interesting is that in many ways it's the opposite situation from what the Basic and Mid–Level photographers are experiencing. While they are working to build reputations and volume, then capitalize on their skills, the High End photographer *has* succeeded—and is looking for ways to control "too much of a good thing." High End photography is very much a matter of drawing the line on volume, then unapologetically auctioning off those blocks of valuable time and skill to the highest bidder. This is "supply vs. demand" at its best.

For many of the photographers I've talked to, making the decision to try for "High End" has really been a matter of self-preservation. They either changed their way of working, or changed professions. They literally had no choice. Those who succeeded backed off on volume, invested their newly found time in further improving their work and service, and dedicated their businesses to serving only those customers who appreciate that superb, individualized quality cannot be mass produced.

The Right Stuff

There are several preconditions which you should have in place as you begin applying a "High End" strategy:

• The quality of the photography must be superior. It's the end result of everything you have been doing since you photographed your first wedding: You worked to become better and better, until finally your work could be counted among "the best." The quality of the work is *consistently* superb; nobody does it better. The fact that you've finally made it is no accident. It was your target all along.

• You are handling every other aspect of your business so well that nothing detracts from the quality of your photography. You keep your promises to people. You don't take two years to deliver the finished album. You don't show up at the wedding in a T-shirt emblazoned with "Think Sex" on the back. Everything you do is First Class. Everything.

• You need to be able to look people in the eye, as they scan your price list, and with unblinking confidence say "Yes, those prices are 'expensive'—but they are worth it. I'll deliver for you. No excuses." And then you will proceed to do just that, for all your customers, week after week.

All of the above is not as difficult to achieve as you might think. It's going to be the natural outcome of your unswerving determination to be the best wedding photographer in your community.

High End/Pricing

Upon looking at the Model Price List, you'll notice immediately that there's been a shift in thinking about pricing with the High End packages. With Basic and Mid–Level, the prices were *package* prices. Each package had a "base price," with each succeeding package being priced cheaper *per–print* than the one preceding it. This was *value*-based pricing, with the intent being to help people move to higher packages by giving more for each dollar spent.

That's not the strategy behind this sample High End price list. Instead, the price *per–print* in all packages is the same. The exact per print price is selected based upon where you want your price for Package A to fall, and the number of prints you want to include. Then, this price is used to compute the cost of all

the other packages. For example, if the price per print was set at $25, then the cost of Package A would be $800 (32 x $25) and Package D would be $1,400 (56 x $25).

Look at packages A and E. The number of prints has doubled, and the price has exactly doubled also. There are none of the incentives or "bonus prints" to move to higher packages that were discussed in the Basic and Mid–Level sections.

Probably the best way to approach the decision of what to charge as the per print price is to first determine the total price you want to charge for your entry level package, Package A. Let's say that is $800—as in the example above. But, what if you see that couples are balking at paying $800 for 32 prints, or $25 each? Easy solution: Just add more prints to the package, *keeping the $800 price.* Instead of 32 prints, include 36 or 40. That would adjust the per print price to $22.22 and $20.00 respectively. Your "phone" price will still be $800, yet now couples will be getting more for their money. The print quantities of Packages B through E would then also be adjusted upwards, with the prices being figured using the new per print price.

It will take some experimentation on your part to find a ratio between print quantities and prices which will do the job of booking good weddings, without scaring people away. It shouldn't take long. Once you have a feel for it, you'll be able to tune your pricing structure to fit your objectives—and play your market with any volume level you want.

This streamlined approach to High End pricing is the one I have settled on in my business, and my experiences with this *per–print* strategy have been wholly positive. It's an extremely simple system to understand. No wheeling and dealing. No sitting there with a calculator trying to figure out how to massage the numbers to get the best deal. Compared with the strategies outlined in the sections on Basic and Mid–Level pricing, there is very little discussion about packages, how they work, etc. If the couple asks about other options, I'll explain about adding extra prints, Wall Prints, etc. I'll also emphasize that "before the wedding the main thing is understanding what you want and making sure that at the wedding I get those pictures. After the wedding you can think in terms of laying out your album, what sizes you want, etc. There's plenty of time for that later." This is often precisely what they want to hear; I'm not trying to sell them anything, I'm not trying to entice them into going with a larger package. I'm letting them make all the decisions based upon the time they will need me at the wedding. I like to think of this approach as "elegant in its simplicity." Whether that's true or not I don't know. But it works.

Admittedly, this is a hard-nosed approach to *pricing*—and pricing is what this book is about. What the Model Price List can't show is the quality of the *photography*, and the level of service, which MUST be offered to justify the higher prices. There can be no question but that the customer is getting what they are paying for—even if they are paying "a lot." While with Basic and Mid–Level the prices, profits, quality and service were juggled somewhat to get the booking, that's no longer a central requirement with High End. Now, couples

are calling for the quality and individualized attention to their needs, and the cost be damned. High End customers are not interested in compromising quality for *any* reason. This fits the objectives of the High End photographer: Limiting the customers to *only* those couples who are interested in the photography, not in saving money. Work with the best, forget the rest. As a High End photographer, it's your *photography* and *service* which will clinch the sale—not progressively lower prices and/or incentives. Your customers wouldn't have it any other way.

Adopting a system like this requires nerves of steel. You won't book weddings as easily (which is the objective)—but those you do book will be automatically among the best in your community. If the quality and service are there, you will build a following among those people who want what no other photographer can afford to offer—"the best."

High End/Time

On the Model Price List, the minimum number of hours available has been set rather high at five hours—and it could well be set even higher.

As a phone package, the five hour minimum, combined with the correspondingly high price, has the effect of discouraging most couples from even considering making an appointment to meet. This is intentional. By immediately making it clear that the price range is high, the photographer's schedule is not filled with lookers: People who might enjoy looking at the sample albums, but who in no way can afford the prices. For the most part, only those couples willing to spend serious money on photography will make appointments.

The minimum package pre-qualifies people. Those who do make appointments are not expecting price breaks, discounts, or any kinds of "deals." The other packages follow in a straight line from that smallest package. The price per print is constant.

The great thing about High End *customers* is that very little of the initial conversation concerns prices or packages. There is almost a feeling that it would be an insult if you were to suggest cutting corners as a way lessen the costs. If they'd wanted to cut corners and save money, they would have gone to another photographer! The costs are noted, but the *real* talk is about the wedding, and about the great pictures they are expecting. Only rarely is there any talk of speeding up the wedding for the sake of controlling the amount of photography time required. These people are determined to have a great wedding, and they want great pictures of everything. If that requires eight hours, so be it. For the photographer, that's a nice feeling.

High End/Print Quantities

As with every other aspect of the sample High End price list, the approach is Spartan and very straightforward. There is no sliding scale, no incentive to go with a larger package over a smaller one.

The difference between each package is eight 8x10s.

You may be wondering why the 5x5s have been cut from the Model Price List? After extolling their virtues in the Basic and Mid–Level sections, they would seem to be a great size to offer couples.

They are. But not as part of the core package.

Since one of the purposes of the High End price list is to serve as a "test" for the seriousness of the couple, there is no reason to make it *easier* for them to book. What this means is that prints which may have had a strategic reason for being included in a Mid–Level price list are simply not needed any more. You're trying to *limit* volume and *increase* profits, remember? You don't need incentives.

Now, in High End, what used to be given away can be offered as "extras."

For example, if a couple using the High End Model Price List had you stay at their wedding for seven hours, they would automatically be entitled to an album containing 48–8x10s. What if they want more prints...like 5x5s? Easy. For $40 per page of four prints, they could add these prints to their core album. If they want to add extra 8x10s, they can do that too, using the prices people are paying for loose, individual prints. (These prices will be discussed in a later section.)

The same is true for the 11x14s and 16x20s which were freely included in the Mid–Level packages. They are now paid for, not given away.

The point here is that the core package has been stripped of all extras.

Ace Up Your Sleeve

Removing all the "extras" from a price list does not mean, however, that you can't do whatever it takes to book a wedding you *really* want. All it means is that you aren't giving anything away until you have a very good reason.

For example, say a couple comes to talk with you about their plans. After a few minutes, you know this wedding is going to be *good*. The couple is nice, they are talking about a large album, Parent Albums, Wall Prints, and gifts for everyone in the wedding party. And they are *sincere*. They may not know it yet, but you do: They are going to spend a lot of money on their wedding pictures. You want your name to be the one on the check.

As you discuss your packages and prices you notice that they are hesitant. They like the photography, like you, and would ask you to be their photographer in an instant...if only your listed prices weren't so high. That's a problem.

Since it's not good form to start slashing away at your prices, here's one approach you might use to get what you want by giving them what they want.

If your packages are based on time, then you can offer them something which costs you very little, but which can dramatically lower the cost of hiring you. You can give them more *hours*.

Let's say that based upon their plans, they need a photographer for six hours. On the Model Price List, that's Package B. Yet after you've talked with them you learn they can only justify committing themselves to spending the price of Package A. No problem: Give them an hour of your time at no charge. Note that I said a free *hour*; no mention was made of free *prints*. You are not offering to give them Package B for the price of Package A. No! You are simply offering to stay an extra hour and give them a 32–print album for the standard Package A price.

I've used this technique many times in my business, and it works great. It gives me some room to maneuver without undermining my pricing structure. The extra time gives the couple more time to enjoy their wedding without feeling that a few minutes spent talking to guests, instead of taking more pictures, is costing them money.

What makes this approach work so well is that by the time I make my offer to the bride and groom, we both know we want to work with each other. I can now say "It looks like you are planning a really great wedding. I'd love to be your photographer since I know I can give you the pictures you're looking for. Since time seems to be the big question mark, would it help you make up your mind if I offered to give you an extra hour at no charge?" I then go on to explain the offer and how they can get the time benefit of one package at the price of another. When they see that I have solved their problem for them, the answer is almost always "Yes! If you give us the hour, we'll book you as our photographer."

I like having an ace up my sleeve. If I'm talking with a couple I'm not wildly enthusiastic about working with, I simply don't make any offers above and beyond what is printed on the price list. If, on the other hand, I can sense the total order will be several thousand dollars, do you think there is any chance I won't do *almost* anything to be at that wedding with my camera? Sure I'll stay an extra 60 minutes!

Although I am detailing this idea in the section on High End strategies, I should emphasize that this approach is one you can put to good use with any pricing level. It's not just a "High End" strategy! No matter what level you are currently working, it's smart to have a plan thought out *ahead of time* which you can mobilize instantly when you find yourself sitting across from a couple whose wedding you'd *beg* to photograph. If you know what to offer, you can usually get what you want.

Why No "Open Plan"?

You may have wondered, too, why the Open Plan has been eliminated from the Model High End price list.

As you may recall, the Open Plan was described in the Mid–Level section as a way to give your couples control over their finished albums. From your standpoint as photographer, it was designed as a way to save a booking with a bride who might otherwise go to another photographer offering a package more to her liking. In many ways, it was meant to be a window for the Mid–Level photographer to get some experience working with the High End customer—*before* that was the customer they usually worked with. It was an experimental package, meant to serve as a learning tool.

By the time you are serving the High End customer, you will have had plenty of time to make decisions about how you want your business to function. You will have settled on a way of working and may not want to allow so much "freedom of choice" as the Open Plan permits. Solution: Drop the Open Plan.

That's the route I've taken in my own pricing. The pricing structure outlined in the Model Price List is roughly the same as I am currently using; it's a system which works well without an Open Plan, and I like it. I simply dropped the Open Plan because I was doing all the weddings I wanted without it. (See Price List #3 in the Appendix of this book for the price list containing the Open Plan.)

You may think differently. In fact, you may elect to go in exactly the opposite direction, adopting a "à la carte" structure as the basis for your entire pricing strategy—High End or otherwise. That's fine, and if it works and you're pleased with the results, then this is an absolutely valid approach.

Here's how you might build this system:

Instead of pre-fabricated packages, you might have add a "Photography Fee" for taking the pictures (say $300), and then let the people pick and choose print sizes and quantities from a menu-like price list. For each hour you are at the wedding, you might have a higher minimum order. For example, if you stay 5 hours, the minimum order might be $1,000—with $300 as the Photography Fee, and the remaining $700 being applied to the cost of the selected prints and albums. Since that $700 is the bride and groom's to spend in any way they wish, their order could be made up entirely of 16x20s, if that's what the bride and groom wanted. Or, all 5x7s. Or, one 30x40 Wall Print and two 8x10s. Whatever.

The reasoning behind this system is the expectation that couples will spend more if the upper end of the album is open-ended. Instead of the bride and groom locking in on a set price for a set number of prints, the amount of the minimum order is really a "deposit" towards whatever the final order becomes.

If you're comfortable in the role of salesperson and can routinely take a $1,000 basic commitment and turn it into a $2,500 final order, then this may be the best format for you...assuming your sales average from packages wasn't $3,000.

Selecting A Winning Album Format

A sizable percentage of wedding photographers use systems like this. A lot of others don't. This naturally has lead to an intense debate within the industry, with the pro-à la carters facing off against the pro-packagers. Each side calls the other side "crazy." It makes for interesting, if heated, discussions.

While the argument about the best format rages at all levels of the wedding profession, it seems most intense among the High End photographers simply because it's this group that has enough weddings under their collective belts to have formed some rather strong opinions about what works, and what doesn't. It's this diversity of approaches that keeps this industry entertaining and interesting—and, not coincidentally, gives the brides as many options as they could ever want. Everybody wins.

Personally, I think it's a non-issue. As mentioned, in my own business I've gradually migrated to a preference for structured packages. There's really no reason, other than that I feel more comfortable with them, have no trouble selling them, and have photographed hundreds of brides who have spent a lot of money obviously agreeing that packages make sense as a way to buy wedding photography.

As far as I'm concerned, those are the only reasons that count. That's not to say I'm "right," and that my à la carte-based competitors are "wrong." We each have our preferences in selling, just as we use different equipment to produce different looking photography. They have their businesses to run, I have mine.

If you're not yet sure which approach is best for you, my suggestion is that you jump in with both feet, test anything that seems valid, and see which produces the best results. You might try having two price lists and give brides a choice between your current format, and the one you're testing. Learn to present both well. Then, watch the brides' reactions. Like photographers, some brides will enjoy the freedom that comes with à la carte pricing, while others will prefer the security of having a structured format to work within. Watch *yourself* to see which approach is the most comfortable for you to present and sell. If *both* systems work well for you, then keep both and leave the final choice up to each bride. If one approach consistently outperforms the other, and you're as busy as you want to be working with brides who like your system, then go with the winner, and drop anything that's second best. (Of course, you'll keep your options open. As soon as you learn of a new idea which might help your sales and/or bookings, you'll test that one, too. It's a never ending process.)

To put this decision in the proper perspective, let me say that I have a sneaking suspicion that many brides—and *especially* "High End" brides—select photographers based more upon the photography, and less upon whether the prints are sold individually à la carte, or by the dozen as part of structured packages. Either way, they know they'll end with a series of photographs from their wedding, and how they get there is a secondary issue. For them, that's the bottom line.

Another thing to consider as you mull over your options is that by the time you're within sight of the High End market, and probably long before, your sales instincts will be fine-tuned enough that decisions about package formats and sales techniques will be relatively easy to make. You'll have your own strong opinions. You'll have the experience to make a highly educated choice. The best ones, *for you*, will just *feel* right.

Another hint: The right choice will also be the one with the highest sales averages. (Amazingly enough, the higher the sales, the better *any* system feels.)

Summary Of High End Strategies

No matter how you package, present, and sell your work, I think it's reasonable to say if you put in the time necessary to build a first–rate wedding business, and if you keep pushing yourself to become better and better, at some point you will become "the best"—or at least, one of the best.

When you see this happening, it's going to be for two principle reasons:

• You've paid your dues—in full. You've mastered your craft, you've paid close attention to what people want and are willing to pay well for, and you've made sure that every decision you make about quality and service has been to enhance them, not cut corners. You've made excellence a habit.

• Your competitors have quit growing, and you've passed them by. While maybe a year ago you were feeling the heat of a particular competitor, you're now not hearing much about him or her anymore. Instead of customers having to make a decision between two similar businesses, they are now calling you first—and booking your old competitor only because *you* are not available. You are their only "real" choice. It's happened not only because you have continued to grow, but because the competition has fallen behind.

In many ways, you really aren't the one who determines when you are "the best." Your customers do. They are the ones who vote with their wallets and let you know that all the years you've invested in mastering your craft are worth your High End prices. This isn't your signal to rest on your laurels either. No way. It's your signal to work even harder to continue growing.

Want a parallel from the non-photographic world? How about a brain surgeon "selling" brain surgery? The success of the operation is of prime importance to the patient. All questions revolve around the skill of the surgeon; the last thing the patient wants is the feeling that the surgeon doesn't *really* know all there is to know about brains. (Like wedding photography, you can't usually "redo" brain surgery.) Cost is no object; the patient wants *the best*...end of discussion about money. And the surgeon makes no concessions—no "free nose job if you schedule your surgery two weeks in advance." And, have you ever seen an ad for "discount brain surgery?"

High End wedding photography is the same situation. No excuses expected—or accepted.

High End photography is tightrope walking without a net. The High End customer bypassed every other photographer in your area, ignored every discount and incentive, and chose you because of your reputation for "no excuses" excellence. The customer expects the best, is willing to pay for the best—and you had better deliver.

It Ain't Over 'til It's Over

As you plot your pricing and album format strategies, keep in mind that whatever you write down on your price list is just the beginning of a process that can stretch over months or years. You've got a long way to go before the assignment is complete, and all the checks are in. You'll come out ahead if you control your urge to load up your price list with every option you can think of, and instead restrain yourself to outlining the basic information a bride needs to book your services.

Pace Yourself

Taking the Model High End price list as a guide, here's an illustration of how you might pace your sales effort to better match the "natural" progression of events as a wedding moves from booking, to the wedding itself, through the ordering process, to the final delivery of the finished orders:

• At the time when first talking with the bride about booking the wedding, base the discussion on *time*—and the album on all–8x10 prints. Spend your time talking about her wedding and the great photographs you'll take. If your price list is clear and simple, it won't take long to explain.

• After the wedding, when the bride sees how you lived up to your promises to create a ton of breathtaking images, she'll first weep with joy at how wonderful her pictures turned out. Then, she'll start asking about how to get more of those pictures into her album.

You're ready with an answer. She can either buy additional 8x10s, or she can supplement the 8x10s with *pages* of proof-sized prints. (I recommend

that you don't use your original proofs as finished prints in the Bridal Album. Aside from the differences in color you'll inevitably see between the proofs and the newly printed 8x10s, there are some good reasons why you'll want to keep the proofs intact as a set. More on that below.)

If this concept of mixed formats sounds vaguely familiar, you're right. It's the same idea outlined earlier in this book as an Entry and Mid–Level strategy. The only difference is that instead of combining the two sizes together at the *booking* stage, they have been separated into *two* "selling opportunities." Although in both instances the final album may have the same mix of print sizes, the sales potential is much greater when they are sold as two distinct and different options.

• Finally, if you use paper proofs of good quality, you can also *sell those prints as a complete set.*[*] Why give them away, or throw them away, when they can easily produce hundreds of dollars in added sales?! You'll find that once the bride and groom have made their decisions about what prints to include in the official Bridal Album, many times they'll still want to keep every print you've produced. Darn! (This is the reason mentioned above for not breaking down the proof set to use individual proofs as part of smaller format pages. A *complete* set is worth far more than a picked-over set.)

By subdividing your sales efforts into timed, logical stages, you've built the sale gradually, rather than trying to scoop up every penny when the wedding is originally booked. Patience pays. If a bride, for example, books a $1,000 package, then later adds four pages of proof-sized prints to Bridal Album at $50 per page, the total order climbs to a respectable $1,300. If she also buys the set of proofs for $400, the order advances to a pleasant $1,700. Add to this the orders from parents, relatives and friends, and you'll happily see that the original, not-expensive $1,000 package has blossomed into a $2,500 *total* sale.

If you've wondered how some photographers consistently achieve those fabled $2,500+ averages you've heard about, that's your answer. It's done one step at a time. They know that the entire sales process stretches out over many months. Instead of firing all their sales guns when they first start talking a bride, they hold some options in reserve—knowing full well that as the order progresses, they will have plenty of time to introduce new buying opportunities for the bride and groom. In the end, it will all work out.

There's no reason you can't pace your orders in much the same way. There's really no rush. With good planning, and a good product, the orders will come. All it takes is a little planning, a little restraint. And, you'll agree, it's better to pace yourself and add to the sale in stages, instead of dumping every option on the table initially, then having little left to sell later.

As they say, timing is everything.

[*] An in-depth outline of how to sell proofs as a set is dealt with in my book, *Wedding Photography—Getting Clients To Return Their Proofs.* An order form is available at the end of this book.

4

Controlling
Additional Time

Although we have discussed time within the framework of the different package groups and shown ways it can be used to help achieve strategic advantage and make packages more (or less) appealing, that's only part of what you need to know about handling time. All of the discussion so far has dealt with using the time *included within the original package.*

What about *additional* time? What if the couple books a package containing five hours, but then at the wedding wants you to stay an extra two hours? How will you handle that?

In a word: *Carefully.* Since this is going to be a situation you will face repeatedly, the best course of action is to establish firm policies, in writing, *before* the wedding. Then, when the request comes for you to stay longer, there will be no surprises for you or the bride.

If you are using specific time limits within your packages, there are two ways you can handle additional time:

• **Package + Hourly Rate.** A two-tiered system of the time included in the package, then an hourly rate to cover *additional* time.

• **All "Album Time."** You can totally eliminate the idea of "additional time" and make every hour you spend at the wedding "album" time.

Package + Hourly Rate

On your price list, here is how you might word your policy statement on additional time if you choose to use a combination of "album" time and "additional" time:

> **"Availability of additional time beyond that included with the basic package selected is not guaranteed. However, if available, additional time is charged at the rate of $40 per hour."**

This is the wording I used on my price lists when my packages were set up using roughly the system described in the Mid–Level section. (See the Appendix.) A couple would book, say, a five–hour package and then at the wedding, if they decided to have to me stay longer, the cost was $40 per hour.

This is probably the most common way for photographers to handle additional time. It works, but at the same time it doesn't work as well as it could.

There are three fundamental problems with the approach:

• First, even $40 per hour will not cover the added cost of the pictures taken during 60 minutes. Film and proofing costs for three or four rolls of 120 film can total around $40, which means if you are using this tactic you're doing it for free. You're breaking even, or close to it. So, why do it?

• Second, most people won't react well to being charged $40 per hour for nothing but your time. They don't understand, and aren't particularly interested, in the fact that you are spending a lot of your money during that hour on film and proofing. Since they are getting nothing in return for the extra payment, such as more prints for the album, they resist this fee.

• Third, is a loophole which I discovered the hard way: By losing money. I learned that people could book a small *package*, then pay the hourly rate and end up with a small album—but a lot of my time.

For example, one couple might need my services for six hours, then book a six–hour package. Another couple, however, might select a four–hour package, then pay for two extra hours on an hourly basis. Both weddings total six hours, yet I was the loser with the second wedding since the extra time didn't automatically translate into more print sales. I was doing six hours of work and being *guaranteed* only four hours worth of album sales.

I used the "package + hourly rate" system for many years. While it paid something for the extra time I spent at a wedding, from a business standpoint it was spectacularly unproductive. The only reason I stuck with it was because I hadn't yet thought of an alternative.

All "Album Time"

It was a long time coming, but I finally did come up with a strategy for time which should have been obvious from the start: Do away with the concept of "additional" time. What did it matter if the bride and groom were inaccurate in their estimation of how long they would need me? In place of "additional" time, I simply made it my policy that the package selected was determined by how long I actually spent at the wedding. If a date was booked on the assumption that I would stay six hours, but I eventually ended up staying eight, *then the couple got the eight hour package.* No more two-tiered system. It made no difference whether they added time or stayed with their original estimate: How much time I was at the wedding determined the package. Period.

Here's the wording I use on my price list today:

"Availability of additional time beyond that included with the selected coverage cannot be guaranteed. However, if required, any extra time will advance the coverage to the package including the total number of hours spent at the wedding, in quarter–hour increments. Each quarter hour adds 2–8x10s to the package. (If needed, packages may be extended beyond [the number of hours for the largest package listed] hours.)"

What seems to make this arrangement work so well is that as more time is added, *the number of pictures included in the package increases, too.* It is no longer just a matter of paying for pure time, and getting nothing in return.

This approach to time has also made those extra hours very profitable. People are now getting pictures in exchange for the money they pay to have me stay longer: Two 8x10s for each quarter–hour. They get what they want, I get what I need—$224 for each additional hour I stay. It's a fair trade.

I very much recommend this system of handling additional time, no matter what level you are working within now. Basic and Mid–Level packages can be structured using this system just as easily as High End. (See the price lists in the Appendix for a more complete picture of how I've implemented this approach to time.)

Extra Time "Not Guaranteed"

It is absolutely critical when discussing "extra time" with couples that they understand that the only amount of time you can *promise* them is what's included in the package they select.

This will become more important as you become busier. It will become *mandatory* if you will be booking more than one wedding, or other assignments, per day.

For example, let's say that in February you meet with a couple planning a wedding in August. After going over their plans they decide they will need you

for five hours, from 11 a.m. at the bride's house, through the 1 p.m. ceremony, and until 4 p.m. at the reception. You book the wedding, letting them know that if they decide at the wedding that they need you longer, you "can always stay an extra hour or two." They file this away in the back of their mind.

In April, you get a call from another couple about their wedding—on the same date in August as the couple needing you from 11 to 4. The second couple, however, is planning an evening wedding and wouldn't need you to begin until 5:30. What to do?

Here you are going to have to make some fundamentally ethical decisions. Since the first couple has actually only booked you for an *official* five hours, you could book the second wedding. You could—but if you do, and the first bride wants you to stay an extra hour or two, you're going to have a major problem. You'll either have to leave before the first couple wants, or be late to the second couple's wedding. Either way, your reputation is on the line.

All it takes to avoid this situation is a very clear and specific policy, clearly and specifically explained to the couple when they select their package. This will not only let the couple know the situation and help them book the "correct" package for their wedding, but it will also keep your schedule under your control.

The fact that you cannot be expected to commit yourself to hours the couple are not booking within their package is logical—and making this policy clear is a good booking tool. If a couple is considering booking a package smaller than they really need, assuming that they "can always decide to add more time at the wedding," this policy will make it clear that they are taking chances with that thinking. Let them know that the only way they can be sure you will be available for the, say, six hours they require is to book the six hour package. Let them know that if they instead book the four or five hour package, that you may have to leave at precisely when those time limits are up. Most couples, if they are serious about their pictures, will not take the chance—and book the package they want.

In the example above, if the first couple had decided at the time they talked with you that it would be safer to go ahead and book the larger package and have you stay until six o'clock, then the "no guarantees" policy would have helped you book a larger package than you might have otherwise. However, the fact that on your schedule you are clearly committed until 6 p.m. means you would have had to turn away the second wedding. That's the way it goes. (It also brings us back to issue of pricing, and supply and demand. The secret to making these "ethical decisions" easier to make is to have your prices high enough for the weddings you do book that you aren't quite so tempted to risk damaging the very reputation for fair play that permits those higher prices.)

As I've said, time is your most potent booking tool. Use it, or lose it.

5

The Booking Deposit

It's not always easy to know what people are *really* thinking when they come to talk with you. Talk is cheap—and it's generally harmless, unless you are booking weddings based on verbal contracts. That's trouble.

You may meet with a couple, and from their gung-ho and enthusiastic tone you *know* they are going to book with you. They even say they will...once they have "talked it over with the parents." Or, "can you hold that date for us until next Tuesday? Sure we want you! We'll get back to you with the deposit."

You play Mr. Nice Guy, pencil in the wedding on your wedding calendar, and wait. In the meantime, however, you get another call for that same date. Are you available? Your calendar says you're not, so you tell the new caller that you're already booked. "Sorry."

Tuesday comes, and goes. No word from the first couple. By Friday you're starting to wonder why the delay. You call. When the bride comes on the line, there is a noticeable change in tone. That once bubbly bride who swore she would almost change her wedding date to have you as her photographer is now telling you "No, we won't be needing you. We've made other arrangements for our pictures. Thanks for your time." Click.

Score so far: You've lost two weddings, and can now only hope a third couple will call. If they don't, you may find yourself sitting at home cleaning lenses and wondering how you might have spent the hundreds of dollars you won't be earning.

Another possible scenario brought on by verbal–only commitments:

A bride contacts you and makes a "tentative" booking. Tentative for her, that is. She's told you she wants you to take her pictures. To you it's a real booking since her date is on your schedule. What you don't know is that since no money has changed hands, she feels perfectly free to "keep looking." Several months later, when you call to ask some questions about her wedding and otherwise touch base with her, she casually mentions that "Oh, I never *really* booked with you. I mean, I know I talked with you—but I never put down a *deposit*. Gee, I'm sorry for the misunderstanding. No, we won't be needing you. I've booked with another photographer." Click.

These kinds of situations can drive a photographer up the wall! (And don't even ask *me* where I got these examples! It's embarrassing.) You want to accommodate people and be "reasonable," yet at the same time you've got a business to run. You need to know who really wants you to photograph their wedding, and who is just telling you they do so they can exit the meeting with a smile on their face. You need to know who is willing to put their money where their mouth is.

A two word solution: You need a *booking deposit*.

"A Check Will Be Fine"

If you're working to build a business, you don't have time to play games with people. Money talks. Nothing speaks more eloquently as to the true intentions of a couple than whether they are willing to put real money down to reserve their wedding date on your schedule.

Or, looking at this from the opposite direction, no couple is going to put a deposit down for your services unless they are absolutely positive about hiring *you* to take their pictures. If they have been talking with other photographers, a check for the deposit will let you know that they have made a final decision. If they are not sure, then they won't write the check. And you don't want them on your schedule until they are sure.

When a couple contacts you about pictures, do everything you can to impress them with your photography. Talk about all the great pictures you will take for them. Talk about quality and the level of service you provide. In other words, when you are discussing the *photography*, let them know that "the customer is always right." You are at their service and will bend over backwards to do anything and everything to make them happy. That's your job.

On the other hand, when the discussion turns to business, you must let them know that it is you who sets the rules. Rule #1 should be that "To hold

and confirm a specific wedding date, a deposit of $xxx is required. *No dates are promised or reserved without this deposit."* You gotta be firm on this one!

It's really a very easy policy to implement. It's simple and to the point. It leaves no room for misunderstandings about whether a date has been reserved or not. Best of all, it places the decision making process on the side of the couple, not you. If the couple puts down the deposit, the date is theirs. If they walk away without paying a deposit, as far as you're concerned the date is available.

Here is how I handle booking deposits:

During the conversation with the couple, when the talk turns to money and reserving the date, I explain the fact that the deposit is required to reserve the date. I simply tell them that nothing will be written down in my "official" schedule until the deposit is received. I make it clear that while the phone does not ring continuously with couples clamoring to book with me, if another couple should call and the date is still open, I will indeed book that date if the second couple writes their deposit check first.

Most reasonable people understand the reasons behind this policy. They understand "supply and demand"—and that if they want the date, they had better move quickly. Hesitate, and the date may get booked from under them.

The net result of having this policy, and using it, is that I know exactly what dates are booked and what dates are open. I don't have to worry about double-booking a date. I don't have to worry about a couple calling me four months after I talked with them, and two months after I booked another couple for the same date, then getting upset with me because they thought I was holding the date for them. No deposit, no promises. Period.

This policy has proven helpful in another way: It eliminates the compulsion some people have to tell me what they think I want to hear. If I make it clear that they can walk out of our meeting without booking, then they don't feel the need to make commitments they really don't want to make. I don't believe in pressuring people into booking. I'm perfectly willing to let them exit gracefully with the understanding that they'll go think about it and get back to me. (If I'm not particularly anxious to work with them, I let them disappear into the sunset. If they are a couple I definitely do want to work with, you can be sure I'm on the phone in a day or two, politely asking if they have any questions and how I'd love to be their photographer. Showing an interest works wonders.)

There is no reason *not* to have this policy!

Deposits: How Much? How Often?

On a theoretical level, there is no "right" amount for a booking deposit. Its purpose is simply to make cash the anchor for reserving dates, not verbal promises. On a practical level, however, there are several points to consider when establishing a specific dollar amount:

• **Not too low.** You want a "serious" amount. You don't want people booking with you just because your deposit is low. If it's *ridiculously* low, say $40, a couple may find another photographer and just write off the deposit they paid you. You don't want the deposit so low that couples will see it as an amount they can afford to lose.

• **Not too high.** You don't want to scare people away with a deposit which is more than it should be, considering that the wedding is still months away. Weddings are expensive and if a couple has to make a budgetary decision between you and another photographer, you don't want the deciding factor to be the amount of the deposit. Once you have booked the wedding, you will have plenty of time to collect the rest of your money.

• **You want the amount to fit in with the pricing structure of your packages.** This should be the starting point. If your packages begin at $250 or so, a deposit of $100–$150 will appear reasonable. If your minimum package is $900, then a deposit of $450 will not be out of line. (If you are looking for rules of thumb, I'd suggest you adopt the formula that the date is reserved with a deposit of one-half the cost of the package selected. With a $1,000 package, for example, the deposit would be a reasonable $500.)

Beyond the booking deposit itself, the flow of payments should continue in an orderly and pre-defined fashion. Here are a few other suggestions for ways to make this happen:

• A month prior to the wedding, have a second deposit due of the remaining balance for the package booked. On your $1,000 package, that would be the final $500. A good time to collect this payment is when the couple comes to talk with you at the final pre-wedding meeting. When you schedule this meeting, simply remind them to bring their checkbook. There should be no problem, as long as this policy was clearly stated when the wedding was first booked.

With this second deposit, the couple is paid up in full for your services. If they buy nothing else, they will owe you no more. (Of course, you're going to do your best to see this doesn't happen.)

(As your prices rise, you may want to modify the way you word your policy regarding this deposit. Rather than thinking in terms of a single, lump sum payment which is not paid until shortly before the wedding, let couples know that it's alright with you if they pay this balance in a series of installments. A $1,500 package could, for example, be booked with a $750 deposit; the bride and groom could then send you checks for $150 each month until the final $750 is paid off. You could also formally split payments into two parts, one due three months before the wedding and the second a month before the wedding. In any case, make it clear it's your *firm* policy that the balance for the booked package must be paid, in full, before any photographs will be taken.)

• At the wedding itself, I don't recommend that you collect any money—even if there's a good reason, such as the bride and groom asked you to stay two hours longer than originally planned. Collecting money at this point is not necessary, and it's tacky. Win points with the couple, and the parents, by demonstrating your total concentration on simply getting the best pictures possible. The wedding is picture time, not business time.

• When the Previews are delivered, have it your policy to collect any additional money due on the basic Bridal Album. This money would be for extra time requested at the wedding, extra newspaper prints, etc.

No matter whether you use my approach to additional time or not, I recommend that any and *all* money due be collected no later than when the previews are first delivered. Why? Because this will eliminate any temptation on the part of the bride and groom to keep the Previews any longer than they need to, because they still owe you money. They will want to get the Previews back to you on time so you can make their "real" album. This way, the only money you will have collect later is that for Parent Albums and any additional prints ordered by friends and relatives.

Think about the alternative. What situation are you setting yourself up for if you *don't* collect your Bridal Album money first?

Easy answer: If the couple has the Previews *and* your money, what have you got? *Nothing.* All you can do is beg and plead for them to return the previews, which often is a futile effort. If the couple still owes a balance when they are scheduled to return their Previews and place their final order, it's amazing all the reasons people can find to put off coming in. After all, what's the rush? The wedding is history, they've got pictures to show their friends. Why hurry ordering the finished album?

By collecting your money at logical and specific intervals, your checks will be written right along with those going to florists, caterers, bakeries, dress shops, etc. Since weddings have a way of running out of money just about the time the photographer is due to be paid, use deposits to make sure you are not setting yourself up to be the "the last one paid." If the customer controls the process, that could take forever. A fair and reasonable set of policies will eliminate many hassles and let you go about your business of providing excellent photography to happy customers.

Working With Friends and Relatives

This would be a good place to insert a few words about how you might handle the often touchy situation of maintaining amicable terms with family and friends now that you are their "personal professional photographer." Of course, these people will expect (demand?) that you will happily volunteer to take their wedding pictures for free—or at *greatly* reduced prices. After all, what are family and friends for?

You may very well know exactly what I am talking about. If so, you know, too, how quickly a friendly request can degenerate into hurt feelings and strained relationships. While family politics is emotional territory, the approach most likely to be successful is to not succumb to the temptation to put forth 150% effort for 50% off your normal prices.

The problem is precedent: If you do one friend or relative a favor by discounting prices, you're going to find it difficult to avoid offering the same kind of deal to everyone. Now and forever. If you're from a large family and/or the friendly type, you know what that can mean to your schedule and profits.

You have a business to run. With your wedding photography, you have only a limited number of available dates. If you book a date with a discounted wedding, then anyone else calling for that date will have to be turned away. Personally, I think it's unreasonable for friends and relatives to expect you to *lose* money to save them a few dollars.

The most equitable approach is to charge your full rates to everyone you work with—no matter who they are, or who they *think* they are. Then, if they still want you, give friends and relatives more for their money than you might otherwise. Let them see you sweat. Stay at the wedding longer. Start earlier. Take more pictures. You might even make their wedding gift an 11x14 or 16x20. Yet for the basic albums and additional prints, charge your standard prices.

The best time to make your Family & Friends Policy clear is right from the first moment you are asked to take the pictures. State clearly the fact that to reserve a date on your schedule, your policy is to require a booking deposit of $xxx. And, as with any of your other customers, don't accept verbal commitments from a friend or relative! If they change their date, change their mind, or otherwise play havoc with your schedule, there are going to be hard feelings. Like anyone else, have them write a check to prove they are serious about having you as their photographer.

I think you'll find that in many ways, this all–business approach is easier on everyone involved. At the wedding you'll be able to do a better job because you'll know people and have a better idea of what everyone wants. Because they are paying you full list price, you won't be as tempted to sit around and chat. Both you and the couple will be holding your work to fully professional standards, which is much easier to live with than trying to do more while they are paying you less. Thrill them with your expertise, not your low prices.

Once the word gets around that you aren't giving your work away, then only those people who like your photography will call because they think it's worth your prices—not because they know you. If they don't call you and instead hire another (cheaper) photographer, that's fine, too. They will have gotten what they want, and your schedule will be left open to possibly book another wedding. If you don't book another wedding, then you can go to the friend or relative's wedding as a guest, have a good time, and let the other guy work for peanuts. No hard feelings.

6

Defining The Products:
The "Other" Customers

Of course, it's the bride and groom who are the "stars" of the wedding celebration. They are what the fuss is all about.

The bride and groom can, however, only absorb so much of your photography. They will get their album, plus maybe a Wall Print and a few prints for gifts. That's it.

If your pricing for the Bridal Album has been structured along the lines of a "loss leader," with the price kept low to help ensure a booking, then it's going to be the prints sold above and beyond the basic package which are where you *must* make your money. In other words, if all you sold was the Bridal Album, you might actually lose money once you have factored in the direct and indirect costs of being a wedding photographer.

Luckily, at most weddings you will have a large, ready and willing market for your photography. It's very easy to make the mistake of concentrating so heavily on the pictures for the bride and groom that you all but ignore the needs of *everyone else* at the wedding.

"Everyone else" is a large group of potential picture buyers: Parents, grandparents, brothers and sisters, aunts and uncles, cousins, friends and anyone else

who might want to order additional prints. Failing to find out what they want is an oversight which can cost you a lot of income.

A Shift In Pricing Thinking

From the standpoint of pricing, the strategies used for "extra" prints are totally different than those we have been discussing for the Bridal Album.

The Bridal Album is really a *booking* tool. Pricing, packages, and everything else about how you structure your offerings are geared to appeal to some couples, and discourage others. As demand increases for your services, the packages are set up to maximize profits based upon limited supply. It's a "seller's market."

Once you have booked a wedding and the bride and groom have selected their package, those strategies are complete. Finished. Now, you need to mentally shift gears and address the needs of a *limited* group of picture buyers. Now, it's you who has the abundant supply of what they might want (pictures)—and only a limited number of potential customers for these pictures.

There are two ways you can view this situation.

The first is that once you have been selected as the "official" photographer, you have a captive audience for the sale of any additional prints. Being in the position to sell these prints is your "reward" for being in the right place, at the right time, offering the right pictures at prices which people are willing to pay. Profits ring up quickly because, when you sell an 8x10 to a friend, or an album to a parent, your only added cost is that of filling the order. Your time, film, processing and other costs have already been covered in the price quoted for the Bridal Album.

The flip side is that nobody *has* to buy anything from you. Unlike the bride and groom, they are under no obligation to order a minimum number of prints, spend a specific dollar amount, or whatever. Their buying decision will be made based on whether you have taken the pictures they want, and are charging a price they are willing to pay. If the parents, friends and other relatives don't agree that your pictures are worth the prices you're asking, or aren't *that* much better than the free snapshots they'll get from *other* friends and relatives, they don't have to buy anything from you. It's a "buyer's market." If they don't buy, your pictures are essentially worthless.

In other words, while you can you use all kinds of strategies and formulas to control who hires you via the Bridal Album, you have absolutely no control over what the parents or anyone else will buy. While the bride and groom may be perfectly willing to pay a hefty price for excellent wedding photography, the parents may balk at buying any prints at all.

The secret to making this two-market system work is take plenty of pictures of other people who are likely candidates for wanting to remember this particular wedding. You want to become *everyone's* photographer, not just someone the bride and groom hired to take pictures for their album. You're at the wedding

anyway, so you're only gambling some film and proofing costs. It's a gamble you will rarely lose. If you take pictures of ten "extra" people above and beyond the bride and groom, and if each of these people buys only a single 5x7, you can easily add $100 profit to your bottom line.

Before they will buy pictures from you, here's a general idea of what the relatives and friends are looking for:

• **Specific pictures.** Except for parents and grandparents, only a handful of people will pay professional-level prices for straight, formal pictures of bride and groom in front of the altar. What people *will* buy is a single print of them standing with the bride and groom at the reception. This means you have to take these specific pictures before people will buy them.

• **"Good" pictures.** There's no getting around the fact that you're going to be "competing" with amateurs for the extra print market. If Uncle Harry brought his camera to the wedding (and, of course, he will!), then his free snapshots are going to be compared with your "high priced" photography. Your work has to be better-than-good to compete with freebies. This means you have to marshal every ounce of creative skill you have in an effort to make Harry's work look like what it is: Amateur work worth exactly what he's asking. Nothing.

• **Flexibility in ordering.** Once you have done your best to take good, specific pictures, you then have to make it easy for people to order exactly what they want: No more, no less. Naturally, you will want to do everything in your power to make your pictures *and* pricing structure so attractive that they will have little trouble convincing themselves that they need more, *not* less.

Parent Albums

Naturally, the main group of people most likely to buy your pictures after the bride and groom are the parents. If you do your job of giving them the pictures they want, you stand a very good chance of selling them a "Parent Album."

What Parents *Really* Want

Once you have committed yourself to the idea of providing both sets of parents with a group of pictures they will be interested in, *then* you can start determining how to best present and price your selection of "Parent Albums."

In most cases, these are the factors which will influence the decision of whether or not they are in the market for a Parent Album, assuming you've taken pictures they truly want:

• **Total Cost.** How much is the smallest Parent Album you offer? Be semi-sympathetic; parents are just finishing paying off the bills from the wed-

ding, and so aren't anxious to add still another major expense. Since they are under no obligation to buy *any* pictures from you, and could easily settle for the snapshots taken at the wedding, the albums you offer should strive to be priced "reasonably." Not *cheaply*...just reasonably.

Pricing is a balance between almost giving your work away just to sell something, and charging too much and selling nothing. Either one of these extremes will result in limited bottom line profits.

Here, again, it's usually a matter of offering *value*. IF you have taken pictures of important people...IF you have made it hard for them to settle on just a few prints...and IF you put together a Parent Album package which is difficult to bypass, THEN you will make the sale. Parents are not going to spend the money just to have an album.

• **Relative Cost.** How do the prices of albums compare with the prices of individual prints? For example, if the cost *per print* of your smallest Parent Album is $8, while the price for each print purchased individually is $10, then most parents will do some quick arithmetic and see that they can save money by getting an album.

• **What they "did for other children's weddings."** If you're a parent of more than one child, you know about the dangers of showing favoritism. This comes up at weddings, too. If a parent bought a single 5x7 print from another child's wedding, you can be sure the tendency will be to do *exactly* the same for the current wedding.

I've seen this situation time and time again: The parents of an only child will react much differently to photography (i.e., buy more pictures) than will parents whose fifth daughter just got married. It's not a law of nature, but it's close. (The best way to defuse this situation is to make sure you give the parents enough pictures of people *besides* the bride and groom to choose from. A Parent Album of twenty prints of family is a totally different situation than twenty prints of the bride and groom.)

A Different Perspective

An important point to remember about parents is that they are viewing the wedding from a unique perspective. The "feeling" of the pictures they buy is usually quite different from what the bride and groom will select.

For example, a typical Bridal Album will include pictures of the bride and groom getting ready. The bride and groom during the ceremony. The bride and groom dancing, eating, talking with their guests. This album will include "soft" pictures of the bride and groom expressing their feelings towards each other. The main thrust of this album is, quite obviously, the bride and groom; everything, and everybody, else are usually in supporting roles.

Parents, on the other hand, tend to have a more long term, historical view of the day's events. To them, the wedding is a family-wide event. The bride and

groom may be the reason for the gathering—but the wedding is most likely to be seen as one more chapter in the evolving story of "the family," as are births, deaths, anniversaries, graduations, divorces, and the marriages of any other children.

What this means for you and the pictures you will be taking is that the parents will be in the market for only so many pictures of the bride and groom "expressing their love." In addition to that, the parents will want to see pictures of the grandparents, aunts and uncles, friends and anyone else who is an important part of "the family story."

A mistake which is easy to make is asking only the bride and groom what they want in their album—and then assume those pictures will also be what the parents want. *You should make a point of finding out what the parents want.* Even if the bride and groom aren't particularly interested in, say, pictures of Aunt Bessy "who drove 2,720 miles just to come to the wedding," the parents may well be interested since Aunt Bessy is likely one of the parent's sisters. If this wedding is the first time in 15 years that Aunt Bessy has gotten together with her brothers and sisters, then from the parent's viewpoint, this wedding is now an event of historical proportions—and an event requiring a professional photograph to remember properly. Yet, it's often going to be up to you to find out who these "special" people are, and making sure you create salable pictures.

Unless you get the pictures they want, most parents won't even consider a Parent Album. Instead, they will choose a few individual prints of "wedding highlights" from you, and rely on friend's snapshots for the bulk of their photographic coverage. By spending the time on this, the increase in orders from parents can be dramatic. Instead of ordering a single obligatory 8x10 of the bride and groom as a memento, the parents will be more tempted to build an album from all the great pictures you have taken for them. Not always...but often enough that it's definitely worth the effort to ask "what people would *you* like pictures of?"

As usual, it's simply a matter of *finding out what people want,* then giving it to them.

Parent Album Formats And Strategies

Just as with the Bridal Album, you have a lot of flexibility in how many prints you can include in the Parent Album.

Unlike the Bridal Album, the parents have two routes they can go: They can order individual prints, or they can order an album. Some parents know right from the start that they are planning to buy an album for themselves. Most, however, don't even start thinking about it until they have seen the proofs. For these parents, the situation your photography and price list should set up is this:

• You do such a good job taking the pictures that once the parents have seen the Previews, they start making a list of the five...then 10...then 15 prints they want.

• At some point they will realize that they have selected quite a few prints and will begin to wonder what they will do with them. If they have been thinking in terms of loose, individual prints to set on top of the TV, they will suddenly realize that they have chosen "too many" prints.

• This is the point where your Parent Albums should kick in and be noticed. These should be packaged using the idea that they are an ideal way to organize a larger number of prints, that the albums look nice, that they are a convenient way to carry prints from the wedding around to show friends, etc. (Of course, it doesn't hurt either that the Parent Albums make use of "quantity pricing," with the price *per print* cheaper than if the same number of prints was purchased individually. Again: *Value*.)

Basically, then, the Parent Album should be presented as a logical way for a parent wanting more than a few prints to buy them.

Basic Level Parent Albums

If you are in the early stages of establishing your business, you may feel not quite ready to be one of the trendsetters in Parent Album delivery systems. You may elect to play it close to the vest, go with smaller Preview-sized Parent Albums, and hold back on introducing anything beyond something you are sure you can sell.

I can understand that. Therefore, what I'd like to offer is a way for you to have the best of both worlds. You can list two types of Parent Albums on your price list, then let the parents decide which they prefer, Preview-sized or 5x7.

By far, the most popular format for Parent Albums is "proof" sized: 3x5, 4x5 and 5x5. These are an inexpensive size print to have made, the album manufacturers offer many choices in books, and the parents like the fact that the costs are low. Look on most photographer's price lists, and proofs are the default format for Parent Albums. (In this book, I will be using 5x5s in the examples, simply because that's the format I get back from the lab from my 6x6 negatives. If your proofs/Previews will be 3x5 or 4x5, those are the sizes you should substitute for "5x5s.")

Proofs Are Not "Real" Prints

The problem with proof-sized Parent Albums is that they look just like what they are: Nicely packaged *proofs*. They are not "real" prints...or at least not prints worth real money.

From the customer's standpoint a proof is a proof is a proof. A 3x5/4x5/5x5 will *always* be a proof! If one minute they were using this size to order "real"

prints (8x10s, 5x7s, etc.), then the next minute they are not going to be willing to spend "real" money to purchase this size in an album.

Then there is the fact that these sizes are too close to the snapshot size parents see from their own camera, sizes they pay 39¢ to have printed when they drop their film off at the one-hour photo shop. Proofs are largely a commodity item.

In other words, Previews are not *special* enough.

What I see over and over again on most wedding price lists are dynamic Bridal Albums—and wimpy Parent Albums. My question is this: If the parents are a natural market for an album, second only to the bride and groom, *why offer them only albums of practically the smallest prints available from the lab?* While the photography may be spectacular, if people are also using size to determine worth, then it makes little sense to market a major product in a minor size.

The solution to this "problem" is in how you package your work.

The 5x7 Parent Album

I would like to advocate an alternative which circumvents the whole issue of "Preview as Parent Albums:" The 5x7" Parent Album. If you can't beat 'em, bypass 'em. Abandon proofs as the primary format for your Parent Albums, and begin the process of making 5x7s the smallest *finished* print size you offer. Let proofs do the vital job of selling the "finished" prints, yet phase them out of your line-up of "finished" products.

It's amazing how pathetic a proof-sized print can look next to a 5x7. In the larger sized print, people appear almost twice as large, and the 5x7s simply look nicer. If you combine this with the fact that 5x7s don't cost much more than proofs to have made at the lab, yet can be sold at substantially higher prices, it makes sense to go with 5x7s—both from your standpoint, and from the parent's.

Right now you may be telling yourself that you can't possibly offer 5x7 Parent Albums as your minimum size. I bet I know why you are saying that: You can't do it because no other photographer in your area is doing it. Right?

Let me tell you why the other photographers are using proof prints: Because *you* are. That's right. It's not like there is a law which says you can't present your work in a decidedly better format.

What I'd like to suggest is that you turn your competitors' timid nature to your advantage. Instead of joining them in offering the same small prints in Parent Albums, take the lead and make 5x7s your basic size. Give your customers *more*, not more of the same. Set yourself apart. Make your competitors' Parent Albums look anemic by comparison.

You're going to benefit in several ways:

• First, your work can justifiably command a higher price. The prints will be larger, and they will *not* look like snapshots. They won't be compared with proofs. As for the added cost, it's minimal. From most labs, the cost difference between proof sized prints from cut negatives and 5x7s is around 25¢; the same goes for albums. The extra costs can easily be recouped by higher prices.

• Second, your work will simply look better. Proofs are small prints; if your work is good, it will look better printed as 5x7s. Plus, if your competitors' work *is* better than yours, and they are using smaller prints in Parent Albums, you can enhance your work by enlarging it.

• Third, you have crossed a threshold. Proof-sized Parent Albums are a dead-end. Once you have seen how parents react positively to having 5x7 albums available, you'll wonder what took you so long to abandon proofs. The sky *is* the limit.

Of course, the 5x7 format for Parent Albums is not an all-or-nothing situation. You can offer *both* sizes on the same price list. You can take time proving to yourself that this is a size parents will order once they see the advantages, and once you have become used to working with it.

You have a lot to gain. All you are really investing is a few square inches of space on your price list.

Here is how you might structure those two albums:

Model Basic Level Parent Album

5x7" Album:	12 prints—$(*individual* 5x7 price x 12, less 20%)
	16 prints—$(*individual* 5x7 price x 16, less 25%)
	20 prints—$(*individual* 5x7 price x 20, less 30%)
5x5" Album:	16 prints—$(*individual* 5x5 price x 16, less 7%)
	20 prints—$(*individual* 5x5 price x 20, less 10%)
	24 prints—$(*individual* 5x5 price x 24, less 15%)

There are two reasons for beginning the 5x7 album with four fewer prints than the 5x5:

• You will be able to align your prices for the two smallest albums, making the total dollar cost for each about the same. For example, the 12–print 5x7 album would carry roughly the same price as the 16–print 5x5 album. By

making albums available for the same cost, you will give yourself a better chance of getting experience selling the 5x7 albums.

• Once the parents have committed themselves to spending a certain amount of money on an album, then you can subtly bring salesmanship into play in an effort to further demonstrate why they'd never regret spending a bit more on a "nicer" 5x7 album. For example, if the parents in question are leaning towards a 16–print 5x5 album, you would work to help them discover the beauty of the 16–print 5x7 album. Some parents, once they take a closer look at the 5x7 album, will easily talk themselves into bypassing the Preview-sized books just because the 5x7s are a much more impressive size. Of course, this will be the "correct" decision.

The discount percentages I have used in the Model Parent Album are just examples of how prices can be adjusted to steer people in the desired direction. Your degree of generosity is flexible. If you *really* want to incite interest in 5x7 albums and discourage the sale of 5x5 albums, don't allow *any* discount for Parent Albums using the smaller size. Watch, then, as sales of 5x7 albums suddenly take off. How you use prices and print quantities to modify demand for the two formats is up to you. The point is to make the 5x7 albums represent a better *value* than the 5x5.

Naturally, you will be looking for other ways to downplay Previews, and increase the obvious value of 5x7 albums. For instance, you might use a more inexpensive "proof" album cover with the Preview-sized book, and save the best album for the 5x7s. You might point out to parents that 5x7s allow cropping, while Preview-sized prints are printed full frame. (This is especially convincing with the 5x5 format, where there is a lot of excess image which can be advantageously removed in 5x7s. It's part of your job as a professional to make sure parents understand these differences.)

An absolutely valid point you can make in favor or 5x7 albums is that these prints will be newly printed, and color matched—not the recycled proofs you will use if they order Preview-sized Parent Albums. As a photographer serving the Basic Level market, you are entirely justified to control your costs by using any Previews you have available in a Parent Album, having any additional prints needed made later at the lab, then combining the two into a single album. Point out to parents that, at your Basic Level prices, you can't guarantee color match between prints with the Preview-sized albums. "That's why the prices are lower." Make it very clear that this won't be a problem with 5x7 albums since all those prints will be made at one time, and therefore the color match between prints will be consistent. "That's why the prices are higher."

In some ways, it seems to be easier for parents to see the value of 5x7 albums than it is for many Basic Level photographers. A major benefit—perhaps *the* major benefit—of offering 5x7 albums as a second option is that *you* will see that some parents do indeed buy larger albums...even parents from weddings booked using a Basic Level price list. This will help you avoid making the assumption that *all* parents are looking for the cheapest pictures they can find. If

you never tried offering a larger, more expensive option, this is a fact you'd never know.

Note, in the Model Price List, that the prices for albums are based upon the cost of *individual* prints—not the prices you are charging per print in the Bridal Album. (Establishing individual print prices is discussed in a later section of this book.) The discounts are not substantial, but they shouldn't need to be. Keep in mind that in addition to the pictures themselves, the parents are also getting a nice album at no additional charge. Make sure they are aware of what a good deal this represents. If you've taken the pictures they want, you shouldn't have to give your work away in order to sell them.

Mid–Level Parent Albums

There are two ways you can handle Parent Albums as a Mid–Level photographer: As a High End extension of the ideas just outlined in "Basic," or as a simplified version of the High End system you are ultimately aiming for.

The "High Basic" Approach

Hopefully, once you are serving the Mid–Level customer group, you will be ready to abandon Preview-sized Parent Albums. You really don't need to offer these.

Until then, if you'll be keeping Preview-sized Parent Albums, there are several ways you modify the Model Basic Level Parent Album to add profits and subtract value from the smaller albums, while narrowing the gap between these and the 5x7 books:

• **Adjust quantities.** You can increase the minimum number of prints in each listing. If the smallest 5x5 Parent Album is currently 16 prints, make 20 prints your Mid–Level minimum. Up the size of the smallest 5x7 album to 16 prints.

• **Adjust price.** You can raise the price of both albums—*but increase the price of the Preview album faster*. Narrow the difference in price. Eliminate the advantage of the smaller album as a way for parents to save money by going with smaller prints. If the prices are close, you'll sell more larger albums, again, because they are clearly the nicer album. If people question why the prices are so close between the two sizes, just tell them this: "It takes just as much time for the lab to make a 5x5 as a 5x7. The only difference is that for the 5x7, the piece of paper used is two inches longer. The costs for us are basically the same." That is all quite true—as is the fact that it takes you just as much time to take a picture which is made as a 5x5 as a 5x7. Once you are working with Mid–Level customers you can cease selling your work on the basis of cents per square inch.

• **Adjust quality.** You can begin using only finished prints for both albums—and then make sure the customers know that you are not using

original proofs in the Parent Albums. If you were using original Previews as part of Basic Level Parent Albums, you can now more safely charge prices which will allow you to stock Mid–Level Parent Albums with newly printed finished prints. From your standpoint, this will eliminate many of the problems you may have had with color balance between early Previews and later reprints. By letting the customers know that you are taking a stand on quality, you can justify higher prices.

The net effect of these changes is to increase the value of your work and provide ample justification for raising prices over what they were when you were serving the Basic Level customer group.

This next point is important: Once you feel comfortable selling 5x7 Parent Albums, *get rid of every proof-sized album you ever owned.* Trash 'em! Don't have even one to show! Have as your only sample album the best looking 5x7 Parent Album you can put together. If someone should ask what a Preview-sized album looks like, refer them to either their own proof book, or pull a single Preview out of a desk drawer. Ideally, the contrast between the beautiful 5x7s in a nice album, and the "rough" Previews will make it subtly clear that proofs are most definitely at the low end of the scale.

Your objective in this exercise is to quietly sabotage any real interest in the proof-sized album, and direct that interest towards the larger books. The price list will tell the customer that the smaller size is available, but you definitely won't be doing anything to encourage its purchase.

Now, watch what happens. What you will witness is a sudden interest in the larger albums. If that doesn't happen, raise the price of the Preview-sized book. Whatever you do, *don't* lower the prices of the 5x7 albums!

What I would like to see you do is gradually (or rapidly) phase out the smaller albums completely. You don't need them. Make the 5x7 album your minimum offering for parents.

The "Low High" Approach

Once you no longer have a Preview-sized Parent Album on your price list, you have entered the realm of High End pricing. Even if your pricing for Bridal Albums is Mid–Level, your approach to Parent Albums can take on the role of High End at a faster pace.

You do not, however, want to limit your Parent Album customers to a single option. As with Bridal Albums, you want to offer people a *choice.* Now, instead of offering the choice to the low side of the 5x7 album with Previews, you can move to the high side. Let the 5x7 album assume the role as the smallest Parent Album—and set the stage for a new size on the high side.

Here's my suggestion for a format which will appeal to parents:

To your 5x7 albums, add a sprinkling of 8x10s. Create a "combination" album. Nothing complicated, just an effort to once more increase the value of your product.

For most parents, 5x7s are a perfectly adequate size. Some, however, will want to emphasize a few photographs. That's a job for the 8x10s. For example, the parents of the bride may want to have an 8x10 of their daughter in the front of their album. Or, they may want to have an 8x10 of their family picture so that people will be larger in the print than they would have been in a 5x7.

Parents will come up with the reasons; all you do is make the "nicer" albums available. If you don't offer this on your price list, in plain black and white, few will ask. At the very least, one role of the larger album is making straight 5x7 albums look inexpensive by comparison.

Here is how you might structure these two albums on your price list:

Model Mid–Level Parent Album

5x7" Albums: 16 prints—$(*individual* 5x7 price x 16, less 20%)

20 prints—$(*individual* 5x7 price x 20, less 25%)

24 prints—$(*individual* 5x7 price x 24, less 30%)

"Combination" Albums:

2–8x10s and 18—5x7s
$(*individual* price total, less 20%)

4–8x10s and 24–5x7s
$(*individual* price total, less 25%)

6–8x10s and 30–5x7s
$(*individual* price total, less 30%)

As you can see, the thinking is roughly the equivalent of what we did above when pitting Preview albums against 5x7s. The idea is the same: Start with a good product, then make it better and more appealing. The trick is to not start lower than you need to; start high with at least the 5x7 albums.

(One factor you will need to consider is the album cover and pages included with each package. With the all–5x7 album you can offer a book designed for flush mounted prints. For the albums taking 8x10s in addition to 5x7s, you will need a different album format—ideally, one which is obviously nicer. The answer comes in the form of a "reversible" 5x7 album. The pages of

this style album are large enough to accept vertical or horizontal 5x7s, without the viewer having to turn the album sideways to accommodate viewing horizontal prints. This is accomplished by using oversized mats. However, when these mats are not used, the pages of the album are 8x10—or just the right size to accommodate a vertical 8x10.)

High End Parent Albums

Once you see that parents are responding well to your Mid–Level Parent Albums, you can again work to increase the value of your offerings...as well as set the stage for higher prices. Here are a few ideas:

• **Increase the size of the smallest album.** For example, if your smallest Parent Album was 18 prints, make it 20 or 22. Even without raising the price of each print, simply by adding more prints you will be able to charge more.

• **Add more prints to larger albums.** If the difference between your two smallest albums is four prints, then make the difference between your two largest albums *six* or *eight* prints. Instead of albums of 20, 24, 28, and 32 prints, you might try albums of 20, 24, 30, and 38. Combine this with a declining price per print, and you have a powerful incentive for parents to go with the larger albums.

• **Raise prices.** Then too, you can also increase the price of the Parent Albums. The most effective way to do this is to raise the price per print for the smaller albums faster than with the larger books. For example, if on your price list you have Parent Albums of 20, 24, 28, and 32 prints, the price per print in the smallest album might be $10 while the price drops to $8.50 per print by the time the parents are ordering 32 prints.

• **Offer additional ways to upgrade.** There are always other ways to increase orders besides playing with quantities and prices. For example, you can offer nicer album covers—at, of course, an added cost. To your largest album, you might include an 11x14, or an offer to purchase a Wall Print at a reduced price. You could offer an incentive or discount if *both* parents order Parent Albums.

I think you get the idea...you can do practically anything, *as long as it works*. You're not gambling anything. 5x7s and 8x10s are rather inexpensive to have made. This provides a lot of leverage for you in planning your Parent Album strategies. If you find that adding two extra 5x7s to your third largest album doubles the sales of this book, then go for it. The added costs are nothing compared with the potential for increased sales and profits. Again, you are adding to the value of your packages, and making the parents an offer they can't refuse.

My only caution is that you keep your Parent Albums rather simple in structure. If your offers become too complicated, you'll find that many people's

reaction is to do nothing before they'll pick up the phone to call with questions. The last thing you want is for parents to be mentally primed for buying a Parent Album—but then, after trying to decipher your price list, back off and order a single 8x10 to put on top of the TV. If that happens, your pricing strategies are not working to full effect.

Many times, after the wedding, you might not even see the parents and have a chance to explain your packages and how great some of the offers are. The bride and groom will come to pick up the Previews; the chances are pretty slim that they will be listening carefully to the details for Parent Albums.

Model High End Parent Album

5x7" Albums:	20 prints—$(*individual* 5x7 price x 20, less 20%)
	24 prints—$(*individual* 5x7 price x 24, less 25%)
	30 prints—$(*individual* 5x7 price x 30, less 30%)
"Combination" Albums:	
	2–8x10s and 20–5x7s
	$(*individual* price total, less 20%)
	4–8x10s and 26–5x7s
	$(*individual* price total, less 25%)
	6–8x10s and 32–5x7s
	$(*individual* price total, less 30%)

The only shift in this High End album over the model used in the Mid–Level section is that minimum print quantities have been raised. If your prices for "additional", single prints have been raised elsewhere on your price list, then together these will combine into a sizable price increase.

Pricing Parent Albums

The examples I've used in the Model Price Lists for this section are just that: Examples. The formulas are not absolute. They are simply examples of how you can structure your albums and prices, how to offer discounts, etc. Look at the format, not the specifics. If you feel that you'll increase sales by totally reshaping these Parent Albums, but all means do so. These are ideas which have worked well for me; if you find an approach which works better for you in your community, do it!

For this reason, I recommend that you take any of the above ideas which you like and apply them to your price list—no matter what level your Bridal Album is at right now. If you are working the "Basic" end of the market, there is absolutely no reason you can't add 5x7 Parent Albums to your price list. You may not yet be able to price as aggressively as a Mid–Level or High End photographer—but I'm sure your profits will be higher than if you offered only Preview-sized albums on the assumption that is what *all* parents wanted. Don't *assume* anything! Give people a real choice and people will surprise you by getting more than you ever expected—and spending more, too.

The *specific* prices you are able to charge successfully for your Parent Albums are going to be dictated by the price level of your Bridal Albums and the charges you list for individual prints. If your Bridal Albums are inexpensive, you are going to have to keep that in mind when pricing the Parent Albums which accompany them. The same goes for individual print prices.

To set the stage for your pricing, the first thing I would recommend is that you fully investigate what other photographers in your areas are doing. Find out what they are offering, their prices, and then make a subjective determination of whether these photographers are your direct competitors.

The reason for this exercise is the need to learn what the "community standards" are for Parent Albums and individual prints. As I've said, parents are going to be very sensitive to price—more so than are many brides and grooms.

If, after you've checked out what's normal for your area, you see that a typical, middle-of-the road Parent Album is priced at $125 for 20 Preview-sized prints, then use this as your starting point.

Unlike when you were booking the wedding and "competitive pressures" were influencing your price of the Bridal Album, *you now have absolutely no reason to charge lower than "average" prices for Parent Albums!* You were the only high–quality photographer at the wedding, *so you have no competition.* No one can balk if your pricing is "average."

At the same time, why accept average prices for your work when with a little more chutzpah you can command higher prices? This is where the 5x7 albums come into the pricing game.

Chances are, if anyone is using 5x7 albums for parents, they are among your area's "better" photographers. Ride to higher prices on their coattails. Adopt the 5x7 albums, and then use the "better" photographers' pricing for your model. After all, for that sized album, those (higher) prices are the "average." If you were able to charge $125 for 20 Preview-sized prints, you may be able to command $200 simply by having those same negatives printed as 5x7s. I can't think of an easier way to add profits to the bottom line than by marking the "5x7" box on the lab order envelope, rather than the "Preview" size. Go for it!

You do not, however, have to offer *huge* savings to sell Parent Albums. A drop of roughly 20% will be sufficient to generate interest and convince parents

that getting an album is their best option. If you go further into deep discounting territory with your smaller Parent Albums, you won't add substantially to orders—but you will cut your profits on those albums which are purchased, and force yourself into even larger discounts on larger albums. An initial 20% drop is a good balance between safeguarding your profits and giving the parents a "good deal."

Additional Individual Prints

Not everyone ordering prints is going to want an album. For people such as grandparents, aunts and uncles, relatives and assorted friends, a single print or two is generally sufficient.

Individually, these small print orders aren't much. But, *as a group,* they can gang up to produce some of your most impressive profit margins. These prints are sold at "full list price."

Too often, photographers concentrate so heavily on pictures of the bridal couple and their immediate families, that they forget all the other people who might want a professional picture taken of themselves with the bride and groom. (Or, *without* the bride and groom—they just want a nice, *professional* portrait.)

Unlike Bridal and Parent Albums, individual print sales don't depend as heavily upon how well you handle all the pictures as they do on how well you handle individual "picture opportunities."

These are some to the typical opportunities you'll have to sell extra prints to "other people:"

> • **Formal, posed family pictures.** Weddings are a time when families get together—and are generally in a much better mood than they are, say, at funerals. People are dressed up and happy. If this is the first time that everyone has been together in eight years, then any photographer would agree it's a perfect opportunity to get everyone together for a family picture. This should cover both "immediate" and "extended" families. You can include practically anyone who claims to be a relative in these pictures. Doing so costs you nothing, but might well result in a sale.

> • **Candid, semi-posed pictures of friends and relatives with the bride and groom.** These are people who simply want a nice picture to remember an important day in the life of someone they care about. At the reception, this might be a quickly taken picture of the bride with her sorority sisters from college, or the groom with his buddies from the football team. Maybe the bride and groom with the aunt who made the cake. Nothing terribly creative, but the fact that you took the time and got people together for the pictures makes these almost sure sales.

• **People at the wedding who want to take advantage of having access to "professional photography."** Knowing that you are willing to take nice pictures of people besides the bride and groom can bring all kinds of requests for family pictures, individual portraits, groups of friends, etc. People may come up to you and ask to have a picture taken of, for example, their mother "since it's been 15 years since she had a decent picture done." If she has four kids, you've just sold four prints.

Of course, the bride and groom, or the parents, may want copies of these pictures, too—but even if they don't, within reason, still take the picture.

If you want to sell a print to the aunt and uncle of the bride, just make sure you get a nice picture of them *with* the bride. This will be a much more meaningful picture to them (and therefore more salable) than a straight formal portrait of the bride alone in front of the altar. All you have to do, for example, is find out from the bride and groom who their closest relatives and friends are, then locate them and bring them over to the bride and groom to have their picture taken. You just have to get it on film. Chances are good that the wedding couple and the other people in the print might all want a copy or two. Do this a few times at a wedding, and you will see your sales average climb—easily, and all in the name of doing what you were hired to do. *Take pictures.*

To sell these kinds of pictures you need to make it as easy as possible for anyone interested to place their order. This means clearly listing the prices on the price list, making it simple to write an order on the order form. This really isn't a function of pricing so much as it is of offering a nice picture for "impulse buying." The pictures have to be *available.* Cost really isn't an issue since for a single print the total amount spent will be minimal, and important pictures will be ordered as long as the prices are "within reason."

On your price list, you will need two categories of additional prints:

• **Desk Prints:** sizes 8x10 and smaller.

• **Wall Prints:** sizes 11x14 and larger.

After all the options have been listed for people interested in albums, this is the part of the price list for other people wishing to buy a loose, single prints.

Desk Prints

There is no question about whether or not to offer 8x10s and 5x7s. Of course!

For most people, the real question is not *size*. Rather, it's "What's the lowest price I can get a copy of this picture for?" (Or, even more simply, how far can you be talked into going on lowering your prices?)

The first question is usually followed by a second: "Can I buy the proofs?"

People are not dumb. They *know* that proofs are not "real" prints like 5x7s and 8x10s. They *know* that the quality level is not that of the "finished" 5x7s

and 8x10s. They *know* that the proofs are smaller. Adding this together, they know that no rational photographer would dare charge more than a pittance for this puny print. They know that if they can convince you to offer a size suspiciously comparable to their own snapshots, you will literally be forced into selling your snapshot quality prints for a much lower price than what you are asking for your "real" prints.

Thankfully, you're not dumb either. You know that there is absolutely no reason you should put your name on cheap, small prints—whether they are the original Previews, or reprints. And furthermore, there is no reason you should go out of your way to help people save money by selling that kind of work. Not only will you rarely sell any 5x7s and few 8x10s, but the fact that you are willing to sell your work cheaply will undermine all of your other prices. (In that situation, about the only way you'd be able to sell any 5x7s would be to lower their price...which would mean you'd also have to lower 8x10s...which would mean you'd have to keep the Parent Album prices even lower...and, finally, since all these prices are "low," you'd have to keep the price of your Bridal Albums in line too. It's amazing the damage one low price on a price list can do.)

Here's the situation: If you list "Preview"-sized prints on your price list, people will buy them over your other sizes by a margin of 10 to 1. And why not? It's your price list, and right from the day the wedding was booked previews were listed as an available size. Sure they'll buy them! A sale is a sale, right? Sort of...*until you realize that if you don't offer Previews, people will still buy your pictures. Only now, they will buy them as 5x7s.*

What I would suggest is that you make 5x7" prints the smallest size you offer. (Sound familiar?) Don't list Preview-sized prints *anywhere* on your price list. Delete that line. When people ask if they can buy smaller sizes, and they will, simply tell them "5x7s are the smallest size we offer. If you wish to order preview sized prints, you can, but their price is the same as for 5x7s." They will usually decide that 5x7s were what they really wanted after all.

Sure, you *could* offer Preview sizes on your price list. And yes, you *could* charge a lower price for them. I can understand why the customer would want you to take this route, just as I'm sure they would love it if you'd give your work away for free. But from your standpoint it makes no sense to offer sizes smaller than 5x7. It is just not in your own best interests.

Then Again...

Allowing for the fact that some readers will disagree with my anti-proof stance, if you should elect to offer Previews as additional prints, then I would suggest that you protect your profits by keeping their price close to that of your 5x7s. For example, don't charge $5 for a Preview, then list a price of $12 for 5x7s.

A more reasonable alternative would be to charge $10 for the Preview size. This would make the larger 5x7s a better value, and would support their $12 price. It would permit higher prices on Parent Albums. Since the lowest price on

your price list is going to become the benchmark against which all your other prices are compared, you are better off to keep that lowest price high. (It will also make it easier to drop the Previews from your price list the first chance you get.)

Will you lose a few sales by adopting this policy? Sure. But only a few—and fewer yet as you get into the Mid–Level and High End weddings. What you should be looking at is the *overall* profit picture: You will make more money selling ten prints at $10 each than you would by dropping the price to $5 and selling 15 prints. Or 20. Or even 25.

If your objective is to make a profit, there is no substitute for high-yet-reasonable prices. If you have the pictures people want, they will buy them.

Desk Print Pricing

You can apply this same strategy to pricing all your desk prints. You control the price list—along with the sizes offered. Give the customer the pictures *they* want, but list only the sizes you want to sell. Then, charge what the market will bear, keeping in mind that you are looking for profits more than raw volume.

In a sense, the prices you charge for desk prints will depend on the strategies behind your pricing of the Bridal Album.

If, for example, you are using the Bridal Albums as "loss leaders," and are using low prices to get *bookings*—then you will not want to match that low pricing with your desk prints. If you're using the Bridal Album to establish *value*, it's the desk prints and Parent Albums where you will be generating much of your *profits*. This is the type of arrangement you would use for Basic Level weddings, and as you move into the mid–level range. (Also, by keeping your desk print prices a little higher than those in the Bridal Album, you will eliminate any tendency on the part of the customer to try to build an album by buying prints individually.)

On the other hand, if you are organizing a High End price list then the prices of the Bridal Albums will be purposely high; you are using these prices to literally discourage all but the best prospects—people not afraid to spend money on photography. However, while this description may apply to the bride and groom, it may not apply to the friends and relatives who are your market for desk prints. In a High End pricing scenario, you may find that your best profits come from using lower prices for desk prints than were used in the Bridal Album.

This makes economic sense, really. Since the cost of film, proofing and your time has been covered by the Bridal Album price, it's reasonable to charge less for extra prints which don't have any overhead to support other than the cost of the print itself and the folder in which it's delivered.

Again, the best way to determine where your pricing should start is to learn what other photographers have established as "fair" prices in your area for

prints of various sizes. Use these as your pricing floor, then work your way up from there.

What I think you'll find is that the prices most of your competitors are charging are less than they need to be. People would gladly pay more if photographers gave more, even on such a basic issue as print quality.

Let's say that you learn the average price for single 8x10s in your area is $15. For that, the customer gets an average print of average quality. If the customer is lucky, the prints will be printed sharply with good color. They may even be dust-spotted.

If you were to adopt this price, you'd probably end up giving your customers the same quality prints as the other $15/8x10 photographers. They are getting what they paid for.

But what if you were to charge $16? That's only an increase of $1, or 6%. Nobody is going to even notice that. What about $17? That's only a jump of 13%—again, not much. People might notice, *but if the pictures are good, they will happily pay it.*

If it's important to you to deliver quality work, I would advise you to charge the $17—then split the $2 difference between yourself and the customer. Keep one dollar for yourself, but spend the other dollar on a better grade print from the lab. Look on your lab's price list. One dollar per print can practically double the quality level you'll get. The color and print finishing will be better. Everything will be better—including the way you look as a professional photographer in your community.

Build a reputation based on quality, and soon enough you'll be able to charge $18, or $20, or more for those 8x10s. Same thinking for your 5x7s, which, of course, are the smallest size you list.

Multiple Prints From The Same Picture

One question which will also come up quickly: "Is the price cheaper if I order more than one copy of the same picture?"

That's a reasonable question. On the surface, it would appear logical to have a higher price for the "first print" from a negative, then lower prices for "duplicate" prints made at the same time. After all, your prices from the lab for multiple prints may be lower, and in the game of selling it's a time-honored tactic to "pass along the savings."

Here's how you might set up such a program: The single print price for 5x7s might be $12. If two or more prints are ordered from the same negative, at the same time, the price is $10. (As opposed to just listing a price of $12 per 5x7. Period.)

Here's how such a pricing system might be structured:

DESK PRINTS (Individual orders, not part of albums. Textured, delivered in folders.)

	First Print	2–5 prints	6 or more
8x10"	$16.00	14.00	13.00
5x7"	12.00	10.00	9.00

There is only one problem with this system: While trying to be "reasonable," you would also set up a two-tiered pricing system. And with it, you'd open the proverbial Can of Worms.

Let me throw out a couple scenarios:

• Does the discount apply only when one person is placing the multiple order, or does everyone benefit who orders a popular print? If Aunt Mary orders two copies of print #1 and gets the $10 price, what happens with Uncle Bob's single print order for the same print? Does he pay $12, or can he benefit from Mary's order and pay only $10? Inquiring minds want to know.

If you don't allow the discount and have Bob pay $12 for the same print Mary is paying $10 apiece for, he's is not going to be too happy when he finds out. He knows his print was made at the same time hers was. He wants his rightful, God-given discount!

If, on the other hand, you let Bob ride along on Mary's discount, what's going to happen if Mary changes her order to another print? She liked print #1 and ordered two copies. Bob saw an opportunity to save $2, so he ordered #1, too. One week later, after much deliberation, and after Bob has already placed his order, Mary changes her mind and switches her order to two copies of print #2. (She thinks nephew George's smile is better in that one.) She's keeping her discount, but what about Bob's now lone print order from print #1? The final order as you receive it shows that no one else ordered from that pose; is Bob paying the $10 he thought he was, or are you going to "surprise" him with a bill for $12? Good luck.

• What about Parent Album prints? Do those prints count towards the total quantity used to figure the discount, or is the discount only for multiple prints ordered as Desk Prints?

• How will *you* track which prints are at full price, and which are discounted? If one wedding order is going to be made up of scores of prints going for various prices, you are going to need a computer to track all those variable prices.

As you can see, this kind of pricing arrangement can get out of control quickly. While discounting based upon quantities may be an idea which works well in grocery stores when people are buying 6-packs of Pepsi, it's not an approach which translates well into the world of wedding photography.

I have attempted multiple print discounting on only one occasion; see my Price List #14 in the Appendix. For the reasons just stated, it lasted only through that one short–lived price list. While I structured it differently than in the above model, what I did accomplish was opening a Pandora's Box of questions from customers now interesting in multiple print discounts. Never again.

Since there are very few good reasons for using discounts for "duplicate" prints, my advice is to simplify your life and use a single price for each print size. If someone orders five prints from a single negative, have the price the same as if they had ordered only one. In the above example, if the price per 5x7 was a straight $12, Aunt Mary would have ordered her two prints for $24 and Uncle Bob his for $12. They would be happy, you would be happier—and your total sales on those three prints would be $6 more than if you'd offered a discount.

Discounts? Who needs 'em? *Simplify!*

Don't Haggle Over Prices!

This would be a good point at which to stop for a second and mention a favorite gripe of mine: That, as a group, we photographers are "too nice."

I occasionally suffer from this ailment—and I always regret it. In the above example, the efforts to "pass along the savings" led to Pandemonium in placing orders. You don't need that, your business doesn't need it, either.

But who sets up the prices and policies? You do. Who is the *only* person who can change the pricing structure for your photography? You are.

A key ingredient to making your business and pricing system pain-free and enjoyable is learning to say "no." If your prices and policies are fair to begin with, you can honestly look people in the eye and tell them that "No, those are the prices for my work. 5x7s are $xxx each, even if you order two or more." You won't get tantrums. You won't lose orders. You don't have to modify your prices and policies each time a customer questions them. Say it politely, but just say "no."

If, in your business, you let the customers shred your price list and "insist" on changes and modifications, it will never end. They will run you into the ground with their "special requests." By just saying "no," you can let everyone know that the price on your price list is the one they will be charged. No discussion. No haggling.

The "philosophy" I have adopted in my business is this: The customer is in charge of the *photography*, I am in charge of the *business*. They can request pictures be taken a certain way, tell me where to be at what time, or whatever. I

will do my best to serve them. In exchange, they are going to follow my business policies. Those are non-negotiable. When they book their wedding with me, my policies are the ones we will use—not theirs. In other words, I'm not going to let them run my business.

If you adopt this approach, what you'll gain is immediate control of your business. If people see that you're a "real" businessperson who knows the value of your work and expects to be paid that price, most pressure to modify prices will cease. Make this clear from the first moment you talk prices, even before the wedding is booked. Set the tone and let them know you'll discuss anything relating to the *photography*, but that you are the person in charge of the *business*. There is absolutely no way you can let the customer dictate your prices.

I can't overemphasize the importance of this kind of thinking. You'll be amazed at how much more pleasant it is to work with people once you eliminate the haggling over price.

Wall Prints

A beautiful, framed photograph to hang on the wall of their new home is a dream of *every* bride and groom.

The only problem with this dream is that it's not a high priority item for most couples. They've just spent a small fortune on their wedding, they've bought a first class wedding album from an excellent photographer, and now are facing the prospect of possibly buying new furniture, a refrigerator, and having the car tuned. "A wall portrait would be nice, but it can wait." It's not a necessity at this point.

Don't you just *love* a challenge? If so, you're going to enjoy selling Wall Prints: Sizes 11x14 and larger, preferably 16x20+.

A Deal They Can't Refuse

I would like to be able to book to you that selling Wall Prints at full list price is easy. That's not the case. There is more to selling these prints than simply listing them on the price list, even when those prices are low. Try as I might in my own business, I have found the most consistent success comes when I use the "carrot and stick" approach to Wall Print sales.

I make my couples *work* for their Wall Prints. I don't give them away. I don't use low prices. Instead, I use *high* prices on my price list—then I offer to cut the price somewhat if they will help me in return. I make them earn the right to a lower price.

Here's how you can apply this line of thinking:

Assume you have photographed two weddings using two different price lists. On the first, you list 16x20s at $95. That's about three times what you'll

pay for them at most labs, so your profits will be "acceptable." On the second price list, 16x20s are listed at $150. (Forget for a moment the question of whether or not these prices fit in with the prices listed for albums and other loose prints.)

When the first couple comes in to pick up their Previews, you show them samples of your Wall Prints, explain what a great bargain your prices are, and wait for their reaction. There is none. They see the price on the price list, know they can always order a print later, and so do nothing. Why should they? You haven't given them a *reason* to react.

For your second wedding, you are employing a different tactic. The $150 price for 16x20 automatically labels this print as "valuable." You show your samples, watch the couple salivate...*then you lay out your offer.*

...IF the couple shows their Previews to everyone in the family and helps generate an added $250 in extra print sales, THEN you will help them buy the Wall Print for $50 less than list price.

...IF the couple adds five pages of 8x10s to their album, THEN you will let them buy the 16x20 for $50 off.

...IF both sets of parents order Parent Albums, THEN you will reward the couple for their help by crediting them $50 towards the purchase of their cherished 16x20.

You can come up with any reward you want, but the net effect of using the IF/THEN Incentive Program is a) you've protected the value of your large prints, b) you've enlisted the couple in helping you generate orders, and c) you've sold more prints and made more money than you would have if you'd taken the easy route and just cut the price.

Put all of those together, and you're using the Wall Prints as an engine to drive the sales of all your other products. It works, and it works well.

Wall Print Pricing

I trust I've just offered an adequate rationale for keeping Wall Print prices high. If you produce photography which screams to be enlarged into Wall Print proportions, then lay out a reasonable plan for the couple, you will have their attention.

As always, the specific prices you list will need to seem *logical* based upon all the other prices on your price list. You cannot, for example, hope to sell very many $350 16x20s if your Bridal Albums are $99.95, and your 5x7s top out at $7.50. People will know your Wall Print prices are artificially high, and they'll just laugh at any "bonus" program you present. Then, they'll get mad.

To establish a reasonable pricing structure for Wall Prints, start by checking out what other photographers are charging for their Wall Prints. Ignore those

who are giving their work away (a common problem for wedding photographers) and use as your gauge those pros who are realistic in their pricing. Find the range of prices which best defines your community's expectations vis à vis your quality level. Then, for your prices, go to the upper end of that range. Use those prices as your starting point.

Then, introduce an incentive and let the couples earn a slightly lower price. Be prepared, however, for some fine tuning in this area. It takes awhile to balance the quality of your work, your sales skills and your prices.

Packaging Wall Prints

If you hope to get top dollar for your Wall Prints, you have to make them look like they are worth the higher prices you are asking. Besides the normal requirements of producing a good negative which can be printed well in larger sizes, and selecting a lab which can do a good job, you can add value to your Wall Prints in several ways:

> • **Mount the prints.** At the very least, you must have prints 11x14 and larger mounted. No customer in their right mind will pay professional prices for prints which come back looking like the ones they got for $9.95 from the department store "studio." Mounting protects the print and adds "bulk." You *want* that print to feel different than an unmounted 5x7 or 8x10. If you don't have a mount press, you can either mount the print yourself using a "cold mount" adhesive system, or let the lab do the mounting. (I prefer the latter. If the lab does the mounting, and if they botch the job, then they have to pay for the reprinting. If I attempted the mounting and screwed up, I'd have to pay for the new print.) Either way, the cost is only a few dollars per print.

> • **Deliver dust-spotted prints.** Again, it's a sign of your professionalism that you dust spot your work. Amateurs may not notice the difference, but a professional should. As the prints get larger, the problem of dust becomes more acute. If you don't do spotting, order a grade of print from your lab which includes this service.

If you deliver mounted, dust-spotted prints to your customers, you will be giving them what they expect from a professional. Yet why stop there? There are a few additional steps you can take which will help take your work beyond the ordinary—and justify higher prices.

A good way to increase profits from Wall Prints is by offering a variety of print finishes. One of the worst mistakes you can make, profit-wise, is to simply deliver a Wall Print "as is," from the lab. The Wall Prints you deliver to your customers are going to become the centerpieces of their home's decor...at least until they're replaced by baby pictures in a few years. In the meantime, quite a few people will see those prints. You want them to be impressed.

In my studio, for many years I offered only one grade of Wall Print: Mounted, with a "spray texture" finish. This was a very nice finish, but because it was the only one offered the customer never thought much about it. When they purchased a Wall Print, that finish is what they got. I used this single finish for all my Wall Print orders, weddings and portraits alike.

I finally woke up to the potential of multiple print finishes as a sales tool not from my wedding photography, but from early efforts to increase studio portrait profits with sales to high school seniors. My then-current approach to selling Wall Print to this group of customers seemed rather stagnant and uninspired, so I figured I had nothing to lose by testing a few new theories.

This is what I came up with:

• **Straight lacquer spray.** This we call the "Classic" finish, and it's simply a sprayed print with a smooth finish. Because most prints have some degree of dust spotting or artwork to cover, I will not deliver a Wall Print without a lacquer finish, and this was the most basic option. This is the "entry level" Wall Print finish.

• **Spray texture.** This is our "Regency" finish. Again, it's a sprayed print— but now with an additional layer of "spray" texture. Adding this texture only takes a few minutes; it also adds about 25% to the selling price. (This is the finish I had been using previously for all Wall Prints.)

• **Canvas mounted.** This is our "Heirloom" finish, and it is indeed impressive. The print is mounted on artist's canvas at the lab and stretched tight across a "stretcher frame." The best feature of this print size is that the lab does all the work—it's simply a matter of marking the order for this type of mounting on the lab order form. All we have to do is add a single coat of Lustre spray. It costs more from the lab, but that cost is easily absorbed by the fact that Heirloom prints are priced 50% higher than our Regency prints.

This is nothing more than a classic Good/Better/Best option package like zillions of retailers use, and that I'd read about in marketing books from other industries. It's an approach which can help sell almost any product, whether that's Wall Prints of wedding photography, auto tires at Sears, or coffee makers at Kmart. Anytime customers are given a choice, most will elect to play it safe by choosing the middle option. The rest will split between the cheaper and more expensive choices. As long as the differences between options are obvious and logical, it's an approach to selling which *always* seems to work.

I just wish I'd paid attention sooner to how people (myself included) buy items like tires and coffee makers. My efforts to jump-start senior Wall Print sales, when coupled with giving people reasonable choices, worked just like the marketing books said it would. Sales increased, and profits soared. Once I saw how offering people a simple choice increased sales of Wall Prints to seniors, I scrambled to make up for lost time by quickly adding these print finishes to our wedding photography price list.

The results were even better than I'd seen with seniors. Why? Because people generally take wedding pictures more seriously than they do high school senior pictures, and so will spend more on different finishes.

It's amazing what people will do when presented with a good range of options.

Do It Yourself

While the lab can be paid to do practically anything you want, I would advise you to learn as much as you can about print finishing so you can take on some of these jobs yourself.

One good reason is that you'll save money. Each of the above services add expense. If you're not that busy, you should have the time to invest in learning dust spotting, print mounting, and spraying. It's good to know these skills even if you won't always be doing the work yourself.

As you get busier, you may want to hand some of these jobs back to your lab. Of course, you'll pay for this service—but not having to worry about it any more is oftentimes worth the expense. In my case, the jobs I jettisoned the quickest were routine dust–spotting and print mounting. I dislike both and would rather pay someone to do it for me. (I've never tried doing my own negative and print retouching. That's an art in itself. Unless you have the skill and/or patience, leave that work to a professional retouching artist.) I'm sure you'll also find that you make more dollars by selling your services as a photographer, than by trying to save pennies by trying to do it all.

The one job I will recommend that you perform is print spraying. Since it's your name going on the print, you need to maintain the control that comes with being the final Quality Control person. As long as the print is not yet sprayed, you can quickly fix the inevitable dust spot that was missed in earlier stages of production. Once the print has been sprayed, spotting becomes a real chore.

Newspaper Prints

The black and white prints you will supply for the local newspapers are really a service item, not a profit center.

However, to avoid the possibility of people viewing these prints as a loophole for getting free prints, I recommend yet another simple approach:

Include one black and white print, free, in your packages. You don't need to specify a size, just use whatever size the newspapers in your area prefer.

Then, if the bride and groom want to send pictures to additional newspapers, charge $10–12 per additional print.

If, before the wedding, you are told that they will be needing three prints for papers, one will be at no charge and two will have to be billed.

I would also stress that you be the one to pick that print, based upon your "professional opinion" as to which will reproduce best with ink on newsprint. As a service item, it's not worth your time to get involved in discussions about which print would look nicest. When the Previews come back from the lab, select the picture you want, make a Panalure print(s), and simply hand the prints to the couple when they come to pick up their Previews. No muss, no fuss.

7

Three "Must Have" Support Products

As a photographer, your major concern is selling photographs. Naturally. Yet there is no reason why you—or your profits—should stop there. There are a number of other products and services which you can offer your brides, items which can add substantially to your orders.

The prints you sell should be delivered into the customer's hands in one of three ways:

• In an *album*, such as the bride and groom will receive—and hopefully, the parents.

• In *frames*. Most often, this will be for any sizes you sell as "Wall Prints"— 11x14 and larger.

• In *folders*. These will be the smaller prints which have been ordered individually, which are not part of albums.

It's magical, for example, how a stack of loose prints just back from the lab can be transformed into an heirloom-quality collection of photographs which will bring tears to the eyes of the bride (and maybe the groom)—just by insert-

ing those prints into a good looking album. If "beauty is in the eye of the pay-ing customer," then you owe it to yourself to make sure your prints are deliv-ered in a way which enhances the beauty of your work—and doesn't detract from it.

There is absolutely no way you can get away with delivering loose, naked prints...and still be considered a "professional." Amateurs deliver their work in brown paper bags.

It's very possible to view albums, folders and frames as basic expenses. If you do that, you'd be right: These items do cost money to provide. Their cost does add quite a bit to what you are paying to produce and deliver your prod-ucts. They are part of your "cost of goods sold."

That's one way to look at it. The other approach would be to view these supplemental items as potential profit centers. Or, at the very least, as a way to add value to your work and make sure it looks its best and is worth the higher prices you may not otherwise be able to charge.

Albums

There are two ways you can approach the issue of selecting the albums you'll be including with your packages:

• **Short term:** That once the couple picks up their pictures and album, you're done with that wedding. If the album looks good for as long as it takes them to walk from your front door to their car, then you have ful-filled your end of the bargain. What happens to the album after that is *their* problem.

• **Long term:** That the bride and groom will *always* be your customers. Even after they have picked up their finished album, it's important to you that they continue to be happy with their pictures *and* the album.

Looks like an easy choice, doesn't it? Of course you want do right by your customers.

The problem is that a good–*looking* album isn't always a *good* album. Don't judge an album only by it's cover.

Allow me to pose a question all photographers will understand: Would you send your wedding film to a drugstore whose prices are low—but whose prints will begin fading in two years? Assuming you plan on staying in town for more than 103 weeks, would you attempt to build a business delivering prints which will self-destruct? I doubt it.

It's no different with albums. Albums are as much a part of what you are selling as your prints. You owe it to yourself—and your customers—to make sure that your products are *good*. Short-term *and* long-term.

Exploding Albums

I'm embarrassed to admit that when I first began photographing weddings, I didn't include any albums with my packages. None. Prints were literally delivered in a bag—and I then told the customer that they could go to a local stationary store and select their own album.

It didn't take long before customers were informing me that this simply was not the way things were done. I quickly learned that I needed to include some sort of albums.

In keeping with my Basic Level thinking, my initial response was that I could help couples *save money* if I supplied the cheapest albums I could find. I found some pretty cheap ones at those same stationary stores. For about a year, I proudly delivered my pictures in these albums. As long as my prices were on the inexpensive side, I saw no reason to change.

Then one day I got a call from a couple who wanted to show me what their album looked like as they were approaching their second anniversary. They brought their "album" in a box, which was about the only way they could carry it. The glue holding the pages together had given out and the album was literally coming apart at the seams. The album was now "loose leaf." There was no way this album was designed to last to even their fifth anniversary, let alone their 50th.

Thinking as much about my own self-interests as about the couple's, my thankfully intelligent reaction was to "cheerfully" replace their album...but this time with a "real" album, which I bought from another photographer.

What bothered me most about this episode wasn't this one wedding, but the scores of other weddings I'd delivered using those exploding albums. I wondered what *those* albums looked like. Here I was trying to build a business based on "timeless quality," and the albums were self-destructing almost as soon as the couple's check cleared the bank. I was quite sure that these albums were not helping my business.

The lesson I learned: People may think they want to save money, and they don't mind if the quality isn't absolutely "first rate." They can live with that. But, they don't want to pay for junk.

This applies to any level of wedding photography, from Basic to High End. If you are deliberating about albums, my recommendation is that you establish a minimum criteria that the album *must* be well made—even if it's plain. Don't select an album which looks good, but which is poorly made and won't withstand being passed around your community. You'll live to regret it—and it won't take that long, either.

The Money Side Of Albums

The issue of which albums to use is purely one of *money*. It's not like your own photography, which might take you years to master before you're delivering a truly high quality product. With albums, if you're willing to write the check, you can have "the best" albums delivered by UPS to your door within days.

How are you to know which albums are a good choice? By talking with other *good* photographers in your area. Ask questions. Or, just hit the streets and find out who is using what albums by talking with people who have used these photographers. Either way, you need to begin learning which albums from which manufacturers meet your quality–based standards.

Once you have assembled a list of quality-oriented manufacturers, get their catalogs.

Most manufacturers offer various grades of albums. They are in business too, and if there are photographers clamoring for inexpensive albums, these companies exist to meet that demand. Those "budget" albums may be fine for some of your competitors, but my advice is to bypass the low-end albums and concentrate only on those styles which you have learned are better made and will withstand rough handling.

Is this going to cost you more money? Yep. Is it going to be worth it? Absolutely! Who is going to pay for it? *The customer!*

This is not a cost you have to absorb yourself. You most definitely will want to add the cost to your price—then make sure your customers know that you are taking a stand for quality, *and it's to their benefit.* Just as you should be letting your customers know that you are not sending your film to the corner drugstore for processing, you should make it known that the albums you use were chosen because of quality first, price second.

Selecting The Right Album Style(s)

When you send for catalogs from various album manufacturers, you will notice there are basically two approaches used.

With the first, you order cases of album "parts": Covers, pages and mats. These you stock on a shelf in your office and assemble as needed. You're buying albums in bulk.

The second method of ordering albums is on a one-at-a-time schedule. The couple will return their Previews and once you have laid out the way the album will be put together, you order those specific pages and covers. These are custom albums.

If you like the idea of offering two types of albums, here is what I would suggest:

• In your packages, automatically include an album type you can stock. It's much easier to pull pages and covers off a shelf than it is to order each album individually. If the couple doesn't tell you otherwise, this is the album in which their photographs will be delivered.

• On a separate price list, offer your "High End" album. Make this one of those which are ordered on a per-wedding basis. This way, you will have to stock only one line of albums—while selling two. (Of course, your sample albums will highlight your better albums.)

Again, let me re-emphasize that the difference between the albums should not be *quality*. Both albums should be well made and able to withstand years of handling. Instead, the differences should be based on *style*: How nice the albums look, how "fancy" they are when compared with each other.

Album Upgrades

While the cost of an album should be built into your package cost, there is no reason you can't offer an album upgrade to customers willing to pay for it.

For example, if your packages automatically include a "nice" album with a "simulated leather" cover, why not make available an album using a *genuine* leather cover? Or albums with a wood cover? Or nicer pages? Or gold embossing of the couple's names or monograms?

The point is to offer people a choice. If you offer only one quality grade, then couples won't think twice about whether the album included is good, bad or ugly. But by presenting them with a choice, you are making them think about what you are offering—and asking them to make a decision. For most couples, when they have to *think* about something, they will decide that they really don't want the cheapest and will go with something "better."

This is an interesting phenomenon. While originally a couple may have selected you because of your combination of "professional quality" and "reasonable prices" (i.e., you were cheap), once they have chosen you they will then be much more willing to add to the "basics" in an effort to make the album look as good as they can afford.

It's the same thing that people do when buying a car: They may select a model with a low "base price," but after adding extras like stereo, air conditioning, etc. they have maybe doubled the actual amount of money they are paying.

Photographers fall prey to this tendency, too. We pick the $600 camera over the one costing $900 in an effort to save money—then proceed to run amok through the camera store adding $5,000 in lenses and accessories we just can't live without. Later, once we see firsthand why the $900 camera was better, we sell the $5,600 worth of not–as–good equipment for $2,000, then take that money, add another $6,000, and proceed to purchase the equipment we should have bought in the first place. Sound familiar? It does to me.

Put this tendency to work for you. Don't sell just "stripped down" wedding albums. Don't assume that just because when the couple first came to you and stressed the importance of keeping within their budget that this is what they will still be thinking after the wedding is over and they are making choices about their album they will have to live with for fifty years.

Show them why one album is superior to another. Then, be prepared to give it to them. They'll be happier. You'll be happier. As I said, it's only a matter of ordering the better album from the manufacturer.

A benefit of this approach is you'll become accustomed to offering, and *selling*, options based on quality, not cost. Seeing people gladly pay a higher price for a quality product will help you apply this thinking to the prices for your *photography*.

Pricing Album Upgrades

In keeping with the theory that packages should include everything needed to deliver a finished product, my recommendation is that you add an album automatically to your packages and make them a part of the first price you quote. I'm simply not in favor of nickel-and-dimeing people to death with extra costs.

If, however, the couple decides to take advantage of the album *upgrade* you offer, then you can begin quoting prices for "albums only."

The most straightforward way to price albums is as à la carte: By the page, and by the cover. I suggest that you multiply your costs by at least two, preferably three. If the couple's album requires 20 pages (for 40–8x10 prints) and a cover, and if your cost for pages is $3 each and $30 for the cover, then this album will be priced out at around $180.

Expensive? Yes—but it's also a custom ordered, top-of-the line product. This isn't K-Mart territory. These albums are not your Blue Light Special.

What you don't want to do is give your albums away "at cost." Take into account the *time* you are spending explaining these albums, plus the *time* you spend laying out the book and placing a single order. When you add it all up, you'll see that doubling your cost will cover your costs, cover your time, and produce a profit in line with that this album is your "best."

I would also suggest you collect payment for the album at the time the order is placed. The last thing you need is to spend your money on an album cover inscribed with the names "Bob and Mary"—and then have Bob and Mary decide later they don't really want that album after all. You'll avoid this kind of situation by simply getting the money up front.

Use Albums To Showcase Your Talents

The anguish which often accompanies writing a large order to an album company can quickly be minimized if you view every album you deliver as a sales tool for your business.

Once a couple takes delivery their album, those pictures are going to be taken to work, to school, and to the homes of every friend and relative they can find. A lot of people are going to be looking at your work...*people who may well be in the market for a photographer.*

Make sure your name is plainly visible on each album, and you have the ultimate marketing tool: Satisfied customers who can back up all the great things they are saying about you with a good looking album full of beautiful prints which they paid you to produce. What more could you want?

Frames

It's a fact of life as a professional that you will need decent frames in which to display your work. You'll need good looking frames for the Wall Prints you display in the area where you meet with customers, and you'll need nice frames for the displays you should be working to put up in such wedding related businesses as bakeries, floral shops, dress stores, etc.

These displays represent a *promotional* expense, part of doing business and presenting yourself as a professional.

What about *selling* frames? That's an entirely different situation.

Selling frames is a natural source of added income for your business. Since people will be buying frames anyway for some of the prints not delivered in albums, you might as well be the one to sell these frames to them. It doesn't hurt profits at all to sell someone a $75 11x14—then a $50+ frame to display it in. In theory, frame sales represent "easy money."

In practice, however, frame sales can be a money sink hole if not handled correctly.

Risky Business

Selling frames is not as easy as you might think, for one very important reason: It's hard to sell them if you don't stock them. And stocking them requires inventory. And inventory is overhead. And overhead is cash out of your pocket.

What people want is selection: You have to offer a range of frame styles and sizes which will appeal to a variety of different customer tastes. Multiply the number of different frames by the number of print sizes, and you can see that selling frames from stock can be an expensive undertaking before you've even made your first sale.

There are several reasons why you should not simply jump into frame sales, stock a wide selection of frames, and attempt to be all things to all people by offering anything and everything your customers might want:

• Your taste in frames might be different than your customers'. If you order frames based upon what *you* like, and your customers disagree, you could well find yourself with a lot of money tied up in inventory you will never sell—or have to literally give away just to get rid of it and clear storage area. That's a waste of money, time and effort.

• Frames are easily damaged—especially the larger frames for Wall Prints which don't come in "gift" boxes, as do most frames 8x10 and smaller. Unless you have a lot of well protected space available for storing frames, you'll be amazed at how easy it is to destroy a salable frame with a small nick or scratch. Those frames become your display frames, or firewood.

• Frames take up space. A lot of it. Even a minimal assortment of frames can take up the end of a room, area you can probably put to better and more profitable use.

What all of this means is that you should approach frame sales carefully. If you have never sold frames before on any kind of organized basis, here are some pointers which you might use to help avoid most of the above problems—and make an immediate profit from this sideline:

• Talk with the frame companies about what styles are popular and have them send you catalogs. By asking their opinion, looking at the frames your friends have in their homes (plus looking in the windows of local studio photographers), you can start to educate yourself about what frame styles are popular in your area.

• Check out other suppliers of frames, such as department stores and greeting card shops. See what they are offering, and at what prices. Popular styles are usually mimicked by several manufacturers. Checking out the competition will help you decide what frames to offer, and which to avoid. For example, if a local department store has an entire department devoted to good looking, discounted frames in 8x10 and smaller sizes, you may have trouble getting the prices you need to make this end of the market worth your time. On the other hand, you may notice that no one in your community is selling decent wall frames except other professional photographers. There's your market: You can offer nice frames to your customers at full "list" price.

• Once you have surveyed the market and made a few educated guesses about which frames you think will be popular with your customers, then from these select a few which *you* like. *Someone* has to make a decision about which frames you'll carry. You are the best judge of what frames look best with your pictures. Use these frames for your display prints, where

they will be out in front of your customers and you can watch their reactions. *For the time being, don't order any additional frames.*

• Now, here's the important part. When a customer expresses an interest in buying a frame, show them your display frames, discuss their preferences and home decor, *then get out the catalogs.* Look at the pictures. Go over the styles available. Take the customer's order. As soon as the customer leaves, call or mail in your order to the frame manufacturer. (Eventually you will want to set up an Open Account with your suppliers and be billed monthly. In the meantime, put your order on a Visa or Master Card.) You'll have your frame(s) before the prints are back from the lab.

This approach represents practically "risk free" frame sales. It involves no inventory, and no investment. (Granted, you'll lose a few sales—and the sales you do make will cost you more since it's more expensive to order frames one at a time instead of in bulk. However, the sales you do make will represent a genuine profit. This is very much preferable to having $800 tied up in inventory, damaging $200 worth, having another $100 worth which people either don't like or is the wrong size...and then selling one $50 frame.)

• As you begin to get a feel for frames and what people will buy, then you can start stocking frames. By then you will know whether your customers prefer natural wood frames, or gold, or white. You will *know* whether people will buy $75 frames from you, or whether they prefer to buy their frames somewhere else. Or, just as important, whether you are good at selling expensive frames, or have your best results with inexpensive styles.

I don't mean to come across in the above as negative on frame sales. Not at all. It's just that *stocking* frames are not a *requirement* for success in wedding photography. You don't need to lose money while you learn about frame sales and selling. You can take your time and gradually decide what you want to do. (When you send in an order for $500 worth of frames, I guarantee you'll be more than a little curious about your chances of actually *selling* these frames.) Take your time.

My Approach To Frame Sales: Keeping It Simple

The approach used at my studio is one of stocking only a limited number of *proven* frame styles. Over the years, we have narrowed our stocking frames down to three styles: An inexpensive light oak frame, and two nicer dark oak frames which people have bought year after year. We *stock* these only in 11x14 and 16x20, for a total of six styles. We keep two on hand for each. Anything else is ordered only after the customer has placed a firm order and paid a deposit.

We use the display prints on the walls to show other styles of frames which we don't stock, but can order. The sample frames I have on my studio walls are in excellent condition, and if a customer expresses an interest, and wants to buy *now*, I will simply use one of these frames. We then reorder from the supplier if

it's a frame we want to keep available; in the meantime, the sample print is placed in another frame.

Frame Pricing

While you can definitely charge any price that the market will bear, a good place to start with setting prices is to multiply the cost of the frame as listed in the catalog by 2.5. If a frame is listed for $10, it would sell for $25; that would allow roughly $5 for shipping, and $10 for profit.

If the customer doesn't like your selection of frames and/or your pricing, I would recommend too that you cheerfully refer them to a frame dealer in town who can supply them with what they want. Don't try to sell your customers something they don't want. Not only will they resist, but you can undermine what good will you've built up via your photography—which is, after all, your primary product.

Folders

Since not all of your photographs are going to be delivered in frames or albums, you will need to have a way of delivering smaller prints (8x10, 5x7, and "Preview" sizes if you'll be offering them). You shouldn't deliver prints "as is," the way they come back from the lab. Naked.

The generally accepted procedure is to deliver these prints in paper "mounts," a.k.a. "folders." These are included as a part of the print cost to the customer. While you will want these mounts to look good and compliment your work, it's not necessary for these folders to be the best and most expensive available. Unless your print prices are high enough to carry the added cost, I'd say it's absolutely acceptable to go with the best looking, moderately priced mount you can find. Mounts are not inexpensive. For example, a Mid–Level folder for 8x10s can cost 80¢ apiece. That represents maybe 25-35% of the cost you are paying to have the print made at the lab.

For this reason, there's little point in spending a lot of money on folders beyond selecting a "nice" style. (If you are determined to spend money, use excess cash on a better grade of print from your lab. There, 50¢ can be turned into a noticeable—and lasting—improvement.)

Most frame and album distributors also handle mounts. Ask them for prices *and samples.*

8

Tracking Income, Expenses, And Profits

So far, the thrust of this book has been the *thinking* behind the prices you'll attach to your wedding photography. That, and how to structure your price list to make using it straightforward and effective, both for you and your customers.

As you can tell from what you've read, my bias is largely that you earn the right to progressively higher prices by delivering ever-improving quality and service to the people buying your photography. Do that, and the brides of the world will not only beat a path to your door—but they'll pay a higher price just to move to the front of the line.

Keeping More Of What You Make

Yet even "high" prices don't automatically guarantee a profit. Why? Because you don't get to keep all the money people pay you for your products and services. Providing a quality product is expensive. While it's easier to make a profit when prices are high, it's also alarmingly easy to spend so much money producing and supporting the product that even high prices can't cover all the bills. This can make for an ugly situation.

If you want to keep your bottom line beautifully in the black, you need to think about more than just *prices*. You need to think about *profits*—which means paying some serious attention to *expenses*. Until you start thinking how each relates to the others within your overall pricing structure, you can easily fool yourself into fantasizing that you're making money, when in reality you're going broke.

Breaking Down Expenses

There's more to tracking expenses than examining your checkbook to see which side of a zero balance you land on at the end of each month. Yet, there's nothing difficult about it. You track *income,* don't you? Well, tracking *expenses* is the same idea, only in reverse.

To better understand where that money is going, and to determine if it's being well spent, it's worthwhile to assign categories to all your costs. Most expenses can be dropped into one of these three groups:

Direct Cost Of Actual Products

Every wedding you book requires dollars to complete. There will be film, processing and proofing, finished prints, albums, frames and folders. There will also be possible costs of retouching, print artwork, mounting, lacquer spray, etc. These are your *direct* costs.

This is the money you spend directly to produce a finished collection of wedding pictures. (It's also the money you would *not* spend if you did not photograph a particular wedding.)

Indirect Cost Of Supporting Your Business

While you'll spend money to photograph a specific wedding, it also takes money just to stay in business. Like any businessperson, you'll be spending money "behind the scenes" to support your business, be available when the phone rings, and have what you need to complete the assignments.

These *indirect* costs typically include such necessities as rent, utilities, phone, photo equipment, printing for price lists and other forms, wages, more photo equipment, office equipment and supplies, accounting fees, taxes, repairs, auto expenses, insurance—plus all the other nickel and dime expenses you'll find listed in your checkbook.

Cost Of Attracting New Business

No matter how great your business is today, the only way you can be sure it will remain as good, or better, tomorrow is by consciously getting out into your community and locating the next group of customers. There are a lot of ways to do it, but there's no escaping the fact that you've got to promote and

advertise your services. Just like everything else in business, achieving these results doesn't come cheap.

These *marketing* costs might include such items as display prints, Yellow Pages advertising, brochures and printed material, mailing costs, etc. (This would also be the place to include such expenses as books, tapes, seminars—the money you spend to polish your skills, and position your business as the able-bodied supplier of a *professional* product. It's all seed money for *future* growth.)

Vital Signs

It's easy to discount some of the above expenses and not consider them "real" costs. For example, you might tell yourself that you were going to buy that Hasselblad anyway. Or, that the miles you put on your car "taking care of business" aren't enough to bother with and log.

That's a dangerous attitude! It's an amateur's attitude. What makes this loose style of record keeping dangerous is that you'll end up making life and death decisions for your business based upon incomplete data. At best, your profits may be less than they should be. At worst, your business may be hemorrhaging and dying from a thousand "minor" wounds. Either way, your success will be less than it might have been if you'd been more protective of profits.

Here's how this situation might unfold:

Let's assume that right now you are doing photography part-time. You're working hard to build your business, but have a full-time job during the week which is paying the rent and groceries. You dream of the day you'll be able to tell your boss to "take this job and shove it."

As you become busier, you see money pouring into your bank account. You're doing great. You look at what people are paying you, compare that income with the total on your lab bill and decide that you are making enough money to "go full-time." You quit your job and hang out your shingle.

Here's where the fun begins. Now, all your expenses—business and home—*must* be covered with your photography income. Now, whether you like it or not, you'll learn exactly how much it costs to operate your business. If you were right in your earlier assessment of your bottom line, you'll make it. If you guessed wrong, and if you can't concoct a cure quickly, it won't be long before you'll be licking your wounds and asking for your old job back. The postmortem: Those dollars you ignored earlier ended up murdering your business.

The reason I'm including this rather bleak example is that over the last 20 years, I've witnessed this scenario play itself out quite a few times in my town. I've watched as week-end pros slowly built their businesses, then triumphantly make their move into full-time. They lasted awhile, then quickly sank from view. Gone. In practically every case, their photography was salable. What did them in were the realities of generating all their income with a camera. It proved more complicated than they thought. They gave it a good shot, but

when the absolutely due and payable costs were drained from their bottom lines, these photographers discovered they'd been kidding themselves about how much money they were making. By the time they figured it out, it was too late.

I've talked with some of these photographers, and it wasn't fun at all listening as they described how they *almost* made it as professionals. From what they told me, it was obvious that much of the blame fell not on their photography, or their determination—but on the numbers they'd used initially to locate the point when they would really start turning a profit. They misjudged, and failed. It happens all the time.

Beyond The Point Of True Return

Transforming your skills as a photographer into a successful, long term operation demands a consistent, steady flow of profits. *Period!* Profitability doesn't come easily. Not only do you have to work for it, but you have to know it when you see it—and where to look for it.

For the sake of this discussion, let's call the moment you first achieve true profitability the "Point of True Return." Roughly, here are the stages your business will go through as you approach, meet, and then pass this point:

• If your business is operating *below* the Point of True Return, then the money required for growth is coming out of your pocket. You are subsidizing your product—and literally paying for the privilege of photographing each wedding you attend. It's not a good way to stay in business very long...unless you've got *really* deep pockets.

• If you're prices are *at* the Point of True Return, then you're just barely covering costs and starting to make money for yourself. You're surviving...but can't afford to make *any* mistakes.

• If your prices are such that you're consistently operating *above* the Point of True Return, then you are not only covering costs and taking money home, but you've also got some breathing room when it comes to trying new ideas, experimenting, and planning strategies for the future. This "extra" money is what provides the power to propel your business into the future.

Again, the money necessary to move your business forward should be coming from what your customers are paying for your photography. *You should not be spending your own money to cover these costs.* NO! Your customers *should* pay these costs, not you. The dollars spent to build and support your business are legitimate business costs. There's no reason for you to take money from your own pocket to subsidize the work you are delivering to your customers.

But to control these costs, you've got to know what they are.

Line By Line:
The "Wedding Income Log"

There's only one way to know what it costs you to deliver wedding photography to your customers: You've got to track expenses. You've got to have an organized system for *accurately* monitoring not only where your money is coming from, but where it's going. You can't guess. You've got to *know*. How well you do is going to have a direct impact on the prices you can profitably charge.

Since the money coming into your business' checkbook originates with individual assignments, the place to start understanding the costs involved is by tracking the expense vs. income totals for each wedding you photograph.

On the next page is a sample copy of a form which offers a way to itemize the ebb and flow of money from each of your weddings: The Wedding Income Log. Its purpose is to supply a centralized location for gathering the income and expense information from a single wedding. While there are many ways to track this data, the format used here parallels the structure of the packages we've been talking about in this book.

Form Format

The Wedding Income Log is a simple form. It's not meant to track *everything* about every order, as you would when itemizing an invoice for a customer. Rather, it's designed to provide an overview of the highlights of each wedding from a monetary standpoint.

The actual form* measures a universal 8½x11". This size was chosen because it's standard, is large enough to allow space for writing down all the necessary information, and, with a pass through a 3-hole punch, can be stored in a standard 3-ring binder.

Since it's an internal form, and not something your customers will see, there's no point in spending money to have it printed commercially. A photocopy will be fine. (Better yet, if you opt to design your own version of the Wedding Income Log, do it on a computer. That way, can update and print out individual copies as you fine tune the format and the areas you want to track.)

Subdividing The Wedding

The guts of the Wedding Income Log is a grid of rows and columns. The rows offer a way to break the total order into sub-groups; the columns provide a space to list the income and expenses associated with each group of orders.

* A *blank* copy of this form has been reproduced in the back of this book. It's for you to photocopy or take to your printer, have copies made, and use—at least until the time you devise a version of the Wedding Income Log which *exactly* matches how you sell *your* wedding photography.

Wedding Income Log

Wedding _____ Date _____ Day of Week _____

File # _____ Price List # _____ Location _____ Date Booked _____

© 1992 shp

	Income	Cost	Gross Profit	Mark Up
Bride & Groom	$	$	$	
____ rolls 120 film @ $ ____ /roll				%
____ Print Bridal Album @ Booked				
SUB-TOTAL BRIDAL ALBUM @ BOOKED				
____ Add'l Hours @ $ ____ /hr.				
Add'l Prints for Bridal Album				
_____ Previews @ Set	Other			
Bride & Groom's Totals				
Parents				
____ Print Parent Album/Bride				
____ Print Parent Album/Groom	Other			
Parent's Totals				
Friends/Family				
Friends/Family Totals				
Miscellaneous				
Reorders				

The Bottom Line	$	$	$	%
	Total Income	Total Cost	Total Gross Profit	Average Mark Up

Hours...

Invested Before Wedding _____

Invested On Wedding Day _____

Invested After Wedding _____

Total Hours to Complete _____

Hourly Gross Income From This Wedding

$

Notes

Form for tracking total production costs from a single wedding.

Vital Statistics

At the top of the Wedding Income Log are the usual spaces for writing down the basic facts about the wedding: Names, wedding date, and file number. In addition, there are spaces for noting the day of the week the wedding took place, the price list used, the date the wedding was originally booked, and even the church. (You'll see later in this chapter how to use this kind of information to learn more about what's going on in your business.)

Customers, By Category

While you may elect to organize your own customers into different groupings, here's a breakdown of the categories shown on this book's version of the Wedding Income Log—along with a summary of each layer:

• **Bride and Groom's Order:** This series of rows has been divided into two parts: The Bridal Album *as originally booked*, and any additional items purchased and added later.

It's worthwhile to keep the booking and post-wedding areas separate because it's the original Bridal Album which should bear the cost of film, proofing, and album covers. What orders come in later are really a different order, and one you'll want to track individually.

The area labeled "Other" might include such non–album, unlisted purchases as Wall Print(s), extra individual prints, etc.

• **Parents' Orders:** This layer should be used to log anything that you know was ordered by the parents, for the parents. In addition to the hoped-for sale of dual Parent Albums, orders to list would be loose prints, Wall Prints, etc. If the parents buy the Previews, those would be listed here.

• **Friends and Family:** This group of random prints are those ordered by anyone not part of the immediate family. (You'll track these prints as a group, not by the individual names of everyone who placed orders.)

• **Miscellaneous:** This area of the form is meant to serve as a catchall for anything not covered in the other categories. (It's best to keep some orders separate from others. For example, this might be a good place to track any gift print orders from the bride and groom to couples in the wedding party. You'd don't want these orders to become buried, and lost, among all the other orders.)

• **Reorders:** Even though prints ordered after the original order has been placed can be credited to one of the above groups, you'll find it easier to keep reorders separate. It makes record keeping easier, and it gives you a better idea what part reorders play in your ultimate sales and profits.

Taken together, the totals for all the rows should account for *every* print ordered from a particular wedding.

Four Columns of Numbers

Running vertically through the customer categories are four columns, each meant to supply useful and informative details about the slice of the wedding it intersects. This is where you'll disassemble the wedding along *money* lines:

• **Income:** This column represents the total amount of money you are paid to deliver all the prints, albums, etc. listed in the order.

• **Cost:** This is the money you spend to deliver each group of products.

• **Gross Profit:** This figure is the difference between the dollars listed in the Income column, and those listed as Costs. Since you're tracking everything by group, the individual rows of Gross Profit represent how much you make with each piece of your product pie.

(Remember, this column tracks *gross* profit, not *net* profit. These dollars are the money you have left after paying direct product costs, which you'll next use to cover rent, utilities, insurance, employees, etc. In other words, this money may be labeled *profit*—but it's not yours to keep. You might say you're the temporary custodian of Other People's Money.)

• **Mark Up:** The final column is the Gross Profit figure shown as a percentage of Income. It represents another way to view the same information.

Although it takes awhile for all the information to accumulate as you work your way through each assignment, once you've figured and filled in the blanks on the Wedding Income Log, you'll have a page of detailed, specific information telling you where the money came from—and where it went.

The Bottom Line

Below the columns of numbers is one final row—the infamous Bottom Line. The numbers logged in as the assignment winds down are the "final score" you've been anticipating since you first booked the wedding. They tell you, overall, whether you won or lost.

This row of final numbers is important, yet hardly the whole story. The real value of the Bottom Line shows up over time. The numbers you'll amass from a series of weddings represent the dollar-by-dollar sales history of your wedding business. Collect a year's worth, or even a *month's* worth, and you possess valuable information unique to your business.

My own view of the Bottom Line is that it's really the least *interesting* area on the Wedding Income Log. It's anticlimactic. On a daily basis, if you become a hard-core student of the numbers your business generates, I think you'll find your attention shifting to where the action is: The individual numbers which feed into the Bottom Line. That's where the battles are fought, in the rows and columns. It's absolutely true that if you concentrate on making those numbers the best the best they can be, the Bottom Line will take care of itself.

What's Your Time Worth?

The Wedding Income Log could end with the Bottom Line—but it doesn't. The reasoning is that in spite of all the talk about *dollars*, we haven't yet given much space to the issue of *time*: The hours invested not only at the wedding, but all those *other* hours you spend before and after the event just doing what needs to be done to run a business.

Reality Check

Hopefully, you're not charting your income per wedding by looking only at the amount of time spent at a wedding, behind their camera, running film.

If so, you're not alone. Quite a few photographers suffer from delusions of grandeur...such as when telling "other people" how much money they make as wedding photographers. "Oh," they tell their slack jawed co-workers at their weekday job, "I get $1,000 for five hours work on a Saturday afternoon. Let's see, I guess that does work out to $200 per hour. Not bad. I keep this job just to have something to do the rest of the week."

Now, if you're guilty of these fabrications, then—just between you and me—that's OK. But let's not kid ourselves. Any photographer reading this book who has done more than five weddings knows that the Easy Money Myth is just that: Wishful thinking. While your civilian co-workers may buy this story and give you all the respect due a certified Artist/Entrepreneur, you can't afford to believe those stories yourself. Not totally.

If you haven't yet seriously added up all the time you put into business, here are a few of the blocks of time you might want to monitor:

• **Phone time.** You're going to spend a lot of time on the phone. You'll get inquiries, you'll have to call people. You'll be setting up meetings. You'll be calling your suppliers. You'll be calling your accountant.

• **Meeting time.** You'll meet with couples to book the dates, to talk with them before the wedding, to deliver Previews after the wedding, to place their order, and to deliver their final print orders. This should take into account not only the amount of time spent sitting across the table from customers, but also the time you spend *preparing* for the meeting.

Look at it this way: If you have a late appointment scheduled, that's probably all you will be able to do that evening—even if the meeting lasts only an hour. Plus, don't forget that you won't book every couple who meets with you; that non-productive time should be included in your tally.

• **Production time.** You'll need to order supplies, send film to the lab, organize Previews into albums, take orders, give orders, organize orders, and put albums together. Then there is the amount of time you spend simply running your business: Errands, trips to the bank, polishing furniture, bookkeeping, etc. It adds up.

Most of the time you spend running your business is "non-billable." Overall, you will probably spend between 25 and 35 real hours per wedding on *all* the details. Add to that the time you'll spend *thinking* about your business, and you'll see that what you thought was a part-time business is actually taking up every waking hour of your day.

But, you probably already knew that.

Keeping you honest with yourself is the purpose of the area in the lower left corner of the Wedding Income Log. It's where you're going to write down not only the time you spend taking pictures, but also the other hours which apply to the wedding in question. When you've finished an order and delivered the albums and prints, you're going to total those hours—and write them down.

Then there's the box labeled "Hourly Gross Income From This Wedding." It's meant to give you a single, specific dollars-per-hour figure to measure time spent vs. income received from each wedding you photograph. If nothing else, it should sober you up to the realities of your pricing structure—especially when you remember that it reflects only gross income, not net. Much of that money racing through your bank account still isn't yours to keep and take home.

Now, about that "$200 an hour" you were bragging about earlier...

Note Worthy

The small patch of open space labeled "Notes" is for writing down anything about a wedding which you suspect may be worth remembering.

You never know what might become important. For example, you may read an article in one of the photo magazines about how to improve Wall Print sales. You decide to test the idea when you deliver your next wedding's proofs to the bride and groom. After the delivery, write down your thoughts about how the presentation went in the Notes section. Later, when the order comes back, if you see that the idea resulted in a certified Wall Print sale, you'll know it's an idea worth trying again. If it works a second time, then you know it's time to add the technique to your battery of *proven* sales boosters.

If you don't write your brainstorms down *someplace*, you might forget what ideas you've tried, or even which weddings were your experimental testing sites. You should *always* be testing new ideas, seeing what works and what doesn't. By attaching notes to the wedding while the ideas are fresh, and the order is in progress, you stand a better chance of spotting any evolving patterns. These breakthrough ideas can relate to pricing, how you present and deliver your photography, patterns you notice in the buying habits of different groups. Whatever. The point is not just to have them, but to remember—and use—them.

Of course, if your ideas come so fast and hard that you need extra space to catalog them, there's always the blank backside of the Wedding Income Log.

Gross Profit Is Only The Mid–Point

Before we go any further, I want to again emphasize *strongly* that the Wedding Income Log is meant only to itemize, and summarize, the income and expenses from a single wedding. It stops at the point of *gross* profit.

It's not tracking *net* profit. It's not telling you how much money you're making from your entire business—or whether you're making any money at all.

That's an extremely important distinction.

It might help to remember that the Wedding Income Log is the only place you'll be tracking wedding *income*. All the money entering your business via weddings passes through this form. All your business' *expenses* don't. In other words, the Gross Profit figure listed on the Bottom Line relates only to individual weddings. On it's way to becoming net profit, some of that money will be siphoned off by such "other" expenses as rent, payroll, advertising, taxes, etc. It's not until these bills have been paid that you get to keep *any* money for yourself. (As a business owner, you're *always* the last one paid. Remember that, and the rationale behind this chapter, and the entire *book*, will fall into place quickly.)

Managing The Spread

To make sure you have enough money to cover all your bills, and pay yourself, you must learn how to mine the Wedding Income Log. Having nicely organized rows and columns of numbers doesn't count for much unless you know what to do with them. By themselves, they tell you little. When teamed with the numbers from the rest of your business, they can tell you a lot.

While every businessperson/photographer has to cultivate his or her own method of integrating the information on the Wedding Income Log into their overall businesses, if you're not sure where to start, you may find it worthwhile to think in terms of two competing, opposite-but-equal arenas:

• **The Inflow Side:** This is where money enters your business. You control (if that's the right word) the money coming in with a combination of pricing, merchandising, and sales techniques. Of course, you want to keep these numbers high.

• **The Outflow Side:** This is where money exits your business to cover all your costs, both direct and indirect. Beyond just the task of keeping costs under control, you must do so while at the same time delivering a quality product. That's often a challenge in itself.

As the numbers align themselves in different corners, the distance between the two is something you could respectfully call "The Spread." It's this middle

ground which represents gross profit margins. The further apart income and expenses stay, the better—as long as it's the income figure which is larger.

This idea is really nothing new. It's just a rephrasing of the old adage, "Buy Low, Sell High." That concept holds as true in the business of photography as anyplace else. The trick is taking a solid theory, and making it work in practice.

Maximizing Income

The place to start is on the income side. With an assignment as emotionally charged to buyers as weddings, it's infinitely easier to boost profits by adding dollars to sales, than shaving pennies from costs.

Be careful, though, with the idea that boosting profits is just a matter of adding extra digits to your prices, or multiplying your lab bill by three. You have to do more than *quote* high(er) prices; you have to *sell* them. (Any photographer can type up a price list stating that "Coverages begin at $3,000," take it to a printer, and—*voilà!*—have an official price list to present to the next bride who walks through the door. That's easy—and it will impress other photographers who see it. Whether a bride will write a check for that amount...well, that's another matter entirely. It's easy, too, to become a high priced, *unemployed* wedding photographer.)

Before you do any impulsive typing, your first steps should be building a foundation strong enough to support the higher prices you must charge to deliver a quality product. There's no way around it: Quality costs money, and it should be a part of your selling price. However, quality should drive prices—not vice versa. You can't suddenly, and without reason, add to prices and then expect people to pay. It doesn't work that way. The quality has to come first.

The process of producing a product which people will know is worth your asking price is not an easy one. It's a trial-and-error process that takes planning. It takes work. It's also the only way to build a business which can thrive and grow, in spite of the fact that you may not have "the lowest prices in town."

Here are some of the areas which, if carefully managed, will generate the cash you'll need to finance your move to the High End of your wedding market.

Build A Name Brides Can Trust

Your reputation is your most important income-generating tool. Your reputation will determine who hires you, and what they are willing to pay. It's the foundation of everything your community will permit you to do as a photographer. Since you're hired *before* you take the pictures, your reputation is really the *only* thing you have to sell. Everything else is follow-through.

You build a reputation by treating people right. Even when your photography is Great!, if people are displeased with how you handled them and their concerns, they will unflinchingly tell everyone they know how far short you fell of their expectations. When showing your pictures to family and friends, they

will preface their comments about "the photographer" with something like, "Yes, the pictures are nice, *but...*" That *but* will undo everything good about your photography, and will kill your chances of getting hired by anyone listening who is, or will be, in the market for a photographer. It's the kiss of death.

It's not an exaggeration to say that if you treat people poorly, and build a negative reputation, it will become harder and harder to book weddings. That's not the way it should be; it's definitely not the way win friends and influence people. Everything you do in your business should be designed to impress people—not only with you and your photography, but with how smart they were to hire you. Get your community thinking that way about you, and the process of booking weddings will get easier with every wedding you photograph.

Sound Sharp, Look Sharp

Before a bride meets with you, but after she's heard good things about you, she's going to be curious. She'll want to start learning more herself. She's going to want to meet, in person, this photographer everyone is saying all those wonderful things about.

From the moment she first calls you on the phone, through the first meeting, and right up to the point when she hands you the deposit check, she will be sizing you up, looking for clues. She'll be searching for the answer to the question, "Can I trust this photographer with *my* wedding?" Only a part of what she's analyzing will relate directly to your photography. Much of what catches her eye and makes an impression will center on what she knows from other parts of her life: What your office/home/studio looks like, the way you present your photography, whether you're polite or not, whether you listen to what she's telling you, how you dress. It all has to add up to the "right" answer, which is, "Yes, from what I've seen, I do believe I *can* trust this photographer with my wedding."

Assuming the bride likes your photography, oftentimes it's these other factors which will be the swing vote determining whether you're in the running to get hired—or whether your name will be crossed off her list. If you want a shot at the job, *everything* about your business must back up your own modest claims that you're every bit as good as everyone says you are.

Pile On The Value

What's going to win you the assignment is that the bride will look at all she's seen, then compare it with the price you're asking. If you want yours to be the winning bid, you must make sure your product is packed with *value.*

Value is easy to define: It's giving people more than they're paying for. That's not the same as being cheap. (For example, supplying $5,000 worth of photography and service for only $3,000—that's *value.* It's a bargain. If you deliver only $300 worth in exchange for $500, that's *not* a bargain. That's a rip-off. Brides do indeed know the difference.)

There are lots of ways you can add value to your product line-up. Some cost money, many don't.

For starters, you can increase the artistic content of your photography. By mastering those techniques which make your work stand out from other photographers', you'll make your work worth more by comparison.

You should make sure that the people and companies supplying you with prints, albums, frames, etc. are helping you create a quality image. Everyone on your team must be as committed to protecting your reputation as you are.

You also need to learn to package and price. That's what the bulk of this book has been about. Whether you adopt the specific ideas I've offered isn't as important as, when you talk with a bride, that the packages and prices you present make sense—*to her.* She's the one writing the checks, so hers is the only opinion that truly counts.

Master Sales

As you become better at assembling all the pieces into a finished product, you must learn how to sell it. Selling is absolutely critical. When you're in business, *any* business, selling is what you do. Period.

Great sales averages *can* be built from average weddings. It's done one print at a time, time after time.

If you've ever wondered how some photographers achieve their $2,000+ *average* sales, *it's because they know how to sell.* They know how to translate raw photography into a finished, *purchased* product. How? They find out what people want, get it on film, and then package, present and price those photographs in such a way that people can't help but buy.

In fact, you're doing your customers, and yourself, a disservice if you take the pictures they want—then fail to make the sale. What good is your greatest picture if it sits unsold in your negative file? You literally owe it to your customers to help them move your pictures from their wedding into their homes.

If you want to make the most of your skills with a camera, you must buy into the idea that nothing happens until you've got the sale. *Nothing.*

Pieces Of The Puzzle

In a nutshell, the above summarizes some of what you can do to increase the income-generating power of your photography. Build a better product, then sell it at a fair price. Your community will welcome you with open arms!

A very real benefit of paying attention to all the details, and mastering them, is that by removing any restrictions, your prices will be free to rise. And, as they rise, you'll be in a better position to not only provide better quality—but you'll also be lengthening the distance between income and costs.

Investment Grade Expenses

As you strengthen the income-generating potential of your photography, you can't afford to ignore the fact that your ultimate objective is profits. While sales are a necessary first step to profits, achieving healthy sales means only that you've solved *half* the puzzle. The other half is controlling costs. While fattening your business' income side, you should work just as hard to keep the expense side sleek and lean.

Any talk about expenses is really about spending money wisely, about making every dollar count. Spend smart, and the dollars coming into your business as sales stand a better chance of staying in your pocket as profit.

Building Dollars From Nickels And Dimes

As mentioned earlier, when talking about the Wedding Income Log and individual weddings, the only way to know what's going on in your business is to track the numbers. You're going to do that for individual assignments. You're going to do it for your business as a whole.

The accepted term for this practice of tracking numbers is *accounting**. It's nothing more than defining categories for income and expenses, then dropping the numbers into the proper slots. Every dollar entering and exiting your business should be identified and logged. Chances are you're doing some of this already, even if it's only to keep the IRS happy. If so, that's not enough.

Strength In Numbers

The trick to accounting is not in constructing an accurate set of books and ledgers. It's *understanding* what you've got when you're done. It's knowing how to read those numbers, and hearing what they're telling you about how you're running your business.

Then, it's knowing what to *do* with them.

Beyond merely discovering whether you're making money or not, the reason you're going to all this trouble is to establish a financial history of your business. Just as a baseball team keeps statistics to compare one year's effort against the next, you're going to use your business' stats as a way to measure your performance on a weekly, monthly, quarterly, and annual basis. The numbers you're producing now are going highlight those areas where you're doing a good job, and those where you can use improvement.

* It's not possible, in a book such as this, to get into an in-depth discussion on the basics of accounting. It's not difficult to arrive at a functional understanding of accounting—and it's much simpler than what you've already gone through to learn the basics of photography. If you need to learn more, *invest* some time and a few dollars in a book on the subject; bookstores are full of them. As much as anything you do as a businessperson, this investment will pay big dividends.

Every Picture Tells A Story

If you're like many photographers, numbers make more sense when you can *see* them as *pictures*. These days, that's not hard to do, thanks to computers and their routine ability to turn numbers into charts and graphs.

Beginning on the opposite page, I've reproduced four charts and graphs of the type I use to make sense of my own business. Although the numbers I've used to build these illustrations are fictitious*, the formulas and ideas behind them are most assuredly "the real thing."

The reason I've chosen these four examples is because they've proven themselves to be very useful to me in understanding the numbers underlying my own photography. From the business standpoint, they provide a quick and accurate snapshot of how my photography is performing in the marketplace.

When scanning these examples, you'll notice that they are not strictly based upon "standard accounting practices." That's no problem. I have my computer generate more traditional formats when, say, working on taxes. The charts shown here are for "internal use only," meaning that while they may not make sense to the IRS, they mean something to me. Since I must have a clear idea of how my business' money is performing, I need to do whatever I can to gather, and display, this information. And, it's the same for you.

Computer Corner

As much as I would enjoy spending the next dozen pages talking about computers, in a book such as this it's not necessary. From the standpoint of running your business, computers are just another tool. These days, they are also an accessible tool. They're cheap and powerful. The accounting, database, and spreadsheet software to drive them can do just about anything you want.

In short, computers can help you organize and decipher your business. To be sure, there's a learning curve involved—but it's a short one, as long as you take it easy and don't try to master the machines in one sitting. If you're not yet convinced, let me put it this way: If you've got the guts to take a camera and a few rolls of film to a wedding, and have built your skills to the point where people are willing to pay you to do it, then you'll have no problems learning computers. It really is that easy. Honest.

If you're into computers, and are curious about how the charts shown here were done, they come from an Apple *Macintosh*. The program used to crunch the numbers and generate the graphs is Microsoft's spreadsheet program, *Excel*.

Enough said. Now, on to the numbers...the *important* part. For better or worse, you're going to pretend the numbers used are *your* numbers.

* Just as the numbers are fictional, they are also NOT meant to serve as any kind of guide for interpreting your own business' numbers. They are just illustrations; nothing more, nothing less.

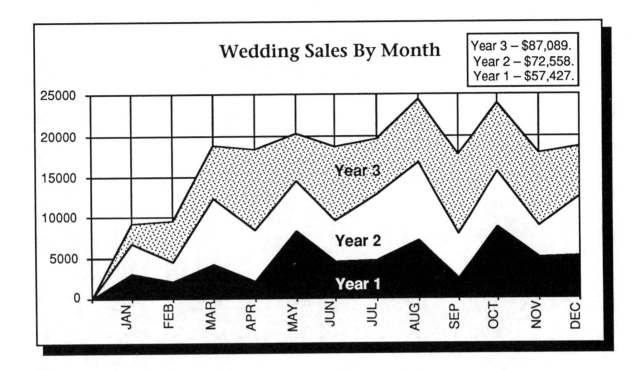

Wedding Sales By Month

This graph's job is comparing sales, by month, over a multi-year period. Since each month has its own sales "personality," the best way to get to know each month is to lay the numbers on top of each other and see how they compare.

In the above graph, the column of numbers on the left represents the *total* sales by month for the three years shown. For example, the three-year total for January is about $9,000, while the three-year total for June is $18,500.

The value of this graph is in illustrating the sales patterns of your business. You'll notice that the shape of each year's line is roughly the same; the same hills and valleys repeat themselves annually. You can easily compare the same months from different years to *see* the progress you're making. (In this example, it's obvious you've been getting better at attracting February sales, while September seems to be a perennial problem. That knowledge should give you something to work on in your *fourth* year.)

You may find this chart more helpful if you use it to track *final* sales figures, not just monthly cash flow. Wait until all the money is in from a month's assignments, then go back and total the sales from all the assignments you photographed—no matter when you actually received the money. This will give you a more accurate picture of how sales are faring, and keep you from being whipsawed by the whims of when money actually changes hands. (For example, say a bride is scheduled to bring you a check for $2,500 on the 31st of the month. She doesn't come in until the next day. If you're tracking cash flow, that one day delay will force a shift in income for both months. If you're tracking that money by *assignment date*, it won't make any difference in the graph.)

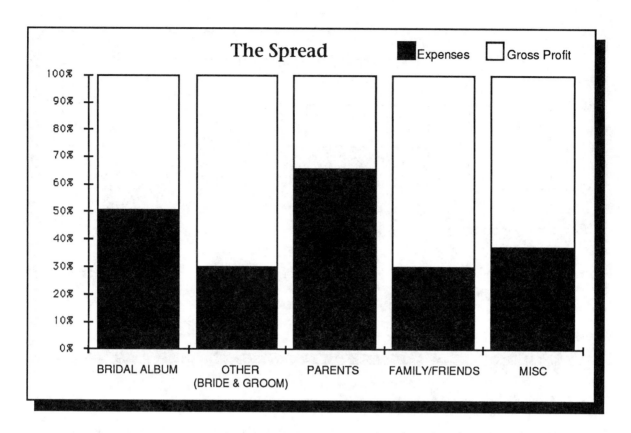

The Spread

This chart is used to illustrate the relationship between income, expenses and profits from a single wedding, using the categories on the Wedding Income Log.

The height of each bar pictured is not a dollar amount, but rather a uniform 100% of the sale for that category. This equalizes everything. The black area at the bottom of each column represent costs; the white area remaining at the top is gross profit. What you see is cost as a percentage of sales.

This information is a helpful indicator of how much it's costing to produce your product line-up. In this chart, the one-time cost of film, processing, and proofing is borne by the Bridal Album, which keeps the ratio of income to expenses at a high 50%. Profits gain ground with all the other categories—with the glaring exception of the Parents' orders. What happened? Well, upon close examination, you see that while parents spent nice dollar amounts, you are also giving them a lot for their money. In relation to your other pricing, too much. It looks like it's time to reevaluate the amount you're spending, or your prices.

Variations of this chart would be simple to set up for other assignment types, or even your entire business. For example, if you're doing children's portraits, families, high school seniors, sports teams, etc. you could build this type of graph to evaluate which are the most profitable. If one category is an obvious loser, you'd have good cause to either rethink pricing, or get out of that market and apply your energies where your efforts produce a better return.

| | 4Q YEAR1 | | 4Q YEAR2 | | 4Q YEAR3 | |
	INCOME: $78,897		INCOME: $93,006		INCOME: $79,006	
	Expense	%	Expense	%	Expense	%
Studio Costs	$3,649	4.63%	$3,442	3.70%	$3,983	5.04%
Computers	$1,376	1.74%	$3,140	3.38%	$1,365	1.73%
Salaries & Wages	$23,197	29.40%	$25,064	26.95%	$18,094	22.90%
Bus. Taxes	$3,164	4.01%	$3,951	4.25%	$2,705	3.42%
Lab Costs	$18,335	23.24%	$25,028	26.91%	$20,707	26.21%
Retouching	$1,700	2.15%	$4,598	4.94%	$3,278	4.15%
Photo Supplies	$4,636	5.88%	$4,358	4.69%	$4,994	6.32%
Studio Equipment	$1,217	1.54%	$754	0.81%	$400	0.51%
Auto Expenses	$498	0.63%	$1,280	1.38%	$1,268	1.60%
Education	$337	0.43%	$634	0.68%	$520	0.66%
Adv & Promotion	$2,375	3.01%	$2,476	2.66%	$3,432	4.34%
Postage & Printing	$1,342	1.70%	$996	1.07%	$1,360	1.72%
Bank Chgs	$126	0.16%	$278	0.30%	$204	0.26%
Misc. Expenses	$374	0.47%	$462	0.50%	$334	0.42%
Total Expenses	$62,326		$76,461		$62,644	
Sales/Expense %		127%		122%		126%
Net Profit %	$16,571	21%	$16,545	18%	$16,362	21%

Income/Expense/Profit Percentages

There are dozens of numbers to watch on a business-wide level. Although you'll be tracking *dollars* in your ledger, another important set of numbers to watch is the *percentages*. Watch the ratios. It's very helpful to establish a general range that's acceptable, then watch for signs that your rate of spending is outpacing your ability to generate cash. This is critical stuff!

In this example, you're comparing expenses for three years' 4th Quarters. You're monitoring expenses as a percentage of sales by category. You're also computing the ratios of sales to expenses, plus the overall net profit for your business. (Your salary is included as a part of "Salaries & Wages.")

The above numbers provide some interesting information. Notice how, in Year2, while you sold more photography, you spent more on a percentage basis to do it. As a result, net profits were *less* than for the previous year. There may be good reasons for this, but it's information you must be aware of and watch. In Year3, if you weren't fully aware that income was moving down, and if you kept spending money at the rate of Year2, you'd be in for a rude shock. That's less likely to happen if you stay on top of the situation with a model like this.

The data used to build this spreadsheet is the same as you should be tracking on a daily, or at least weekly, basis. If the numbers are getting out of whack, you want to know quickly so you can start figuring out what to do to correct it. If you're using a computer and a good accounting or spreadsheet program, ratios and percentages such as these can be generated instantly.

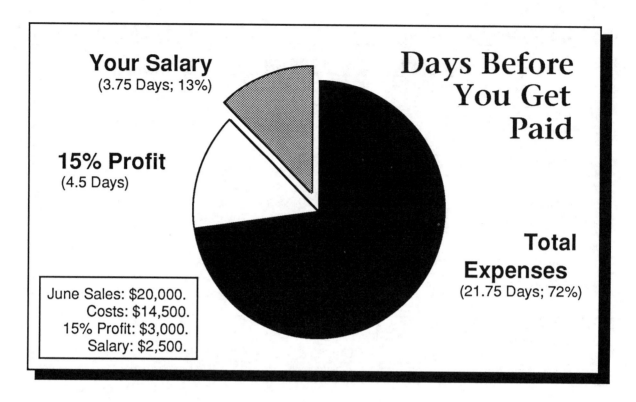

Your Salary
(3.75 Days; 13%)

Days Before You Get Paid

15% Profit
(4.5 Days)

**Total
Expenses**
(21.75 Days; 72%)

June Sales: $20,000.
Costs: $14,500.
15% Profit: $3,000.
Salary: $2,500.

Days Before You Get Paid

This is a chart I'm sure you'll come to love *and* hate. Its purpose: To illustrate the number of days you work each month supporting your business, then how long until you (finally) claim your first slice of the sales pie. Try this scenario:

You just wrapped up June, and logged total sales of $20,000. The month had 30 days, or average sales of $666 per day. Expenses grabbed $14,500. You've committed yourself to the idea that the business requires 15% profit to grow; for June, that's a $3,000 bite out of sales. What's left? $2,500. That's the amount you get to take home. That works out to 13¢ on the sales dollar.

Looking at these numbers another way, and assuming you work the photographers' typical 12-hour day, every day, you worked until 5 p.m. on June 21st just to cover expenses. Then you worked until 11 a.m. on the 26th to bank your 15% profit. It wasn't until that day at 11:01 that you were making *any* money for yourself. This joyful period lasted not quite four days.

Since time waits for no one, these figures can be ruthless. The sobering aspect of the numbers behind this chart is how it's entirely possible to run out of month before you start taking *any* money home. That's depressing. Fear can be a great motivator—and knowing how few days are *your* days can convert you into a true believer in the goal of getting the most out of each month...before it's time to start over. From scratch.

The true value of a chart such as this is its ability to keep you focused on the dual objectives of keeping expenses low, and sales high. It works.

Scanning the Wedding Income Log
For Clues To Future Profits

As interesting as it is to watch your business' numbers translate themselves into pretty pictures on a computer screen, there comes a time when you need to turn off the computer—and face the real question: How are you going to use what you're seeing to make a difference in the numbers staring back at you *next* year? The computer tells you what you've *done*; now, what are you going *to do*?

As usual, you'll guess. But, this time, with a clearer idea of your business' finances provided by the Wedding Income Log, you'll guess...*smarter*.

On the following page is a fictional Wedding Income Log from an assignment you've just (supposedly) completed. In this section, you're going to dissect this order to better understand how it evolved. Then, you'll study each part, looking for new ideas which can translate themselves into increased sales.

Pricing Preliminaries

To clarify some of what you'll be reading in the next few pages, here is a listing of both the costs and selling prices used to compute the individual totals listed on the sample Wedding Income Log:

- **Film, Developing and Proofing:** $3.50 per 120 size roll. Developing: $1.75. Proofing, $.75 per print. Total cost per 12 exposure roll: $14.25.

- **Bridal Album Cover, Pages, and Prints:** Cover alone: $40; pages and mats, $3 per 8x10 page. 8x10s cost $3.25 from the lab. (Selling price to the bride and groom for the as-booked 56–8x10 Bridal Album: $900.)

- **Additional Hours:** Using the ideas outlined elsewhere in this book, the hourly rate is based upon the cost per print in your smallest wedding coverage. In this case, the bride and groom are paying $900 for 56–8x10 prints, or $16.07 per print. The cost per additional hour is the cost 8–8x10s. This means you add $128.57 for each hour you stay past the booked time limit.

- **The Previews.** This is an optional purchase for the bride and groom. The 18 rolls of 120 film produced 216 proofs. Of these, you show only 180. You sell your Previews as a set, at a rate of $3.50 per print. To increase the likelihood that the Previews will be purchased, you charge people for only 80% of the proofs. For this wedding, you will then give the bride and groom all 180 proofs, but charge them for only 144. That, briefly, is how you arrived at a total income of $504. (The cost to you is *nothing*, since all proofing costs are covered in the Bridal Album's price. You can't assume you'll sell the Previews...but you'll take the money if you do.)

- **Parent Album Cover, Pages and Prints:** Cover alone: $25; pages and mats, $2 per page. The cost per 5x7 from your lab is $1.75. (The selling price of a 24–5x7 Parent Album is $300.)

Wedding Income Log

Wedding **B. Craven + M. Rhodes** Date **8/15/92** Day of Week **SAT.**

File # **92-23** Price List # **5 hr.** Location **St. Ansel's** Date Booked **10-10-91**

© 1992 shp

	Income	Cost	Gross Profit	Mark Up
Bride & Groom	$	$	$	%
18 rolls 120 film @ $ **14.25** /roll	—Ø—	256.50	—Ø—	—Ø—
56 Print Bridal Album @ Booked	900.	390.	253.50	231 %
SUB-TOTAL BRIDAL ALBUM @ BOOKED	900.	646.50	253.50	139 %
2 Add'l Hours @ $ **128.57** /hr.	257.14	100.	157.14	257 %
1 FREE 8X10 ~Add'l Prints for Bridal Album	—Ø—	6.25	(6.25)	—Ø—
180 Previews @ Set	504.	—Ø—	504.	N/A
3 - 5x5 pages *Other*	108.	24.	84.	450 %
1 - 11x14 FREE	—Ø—	13.	(13.00)	—Ø—
Bride & Groom's Totals	1,769.14	789.75	979.39	224 %
Parents				
24 Print Parent Album/Bride	275.	115.	160.	2.39 %
1-8x10 Print Parent Album/Groom *Other*	100.	26.	74.	385 %
5-5x7				
1 - 11x14 B.P.	60.	13.	47.	462 %
Parent's Totals	435.	154.	281.	282 %
Friends/Family				
2-8x10, 6-5x7	140.	26.	114.	538 %
CANVAS 8-8x10, 12-5x7	380.	71.	309.	535 %
Friends/Family Totals	520.	97.	423.	536 %
Miscellaneous				
5 Folios Ɔ W.P.	99.75	22.50	77.25	443 %
Reorders	175.	32.75	142.25	534 %
4 - 8x10 5 - 5x7				
The Bottom Line	$2,998.89	$1,096.00	$1,902.89	274 %
	Total Income	Total Cost	Total Gross Profit	Average Mark Up

Hours...

Invested Before Wedding **4**

Invested On Wedding Day **10**

Invested After Wedding **12**

Total Hours to Complete 26

Hourly Gross Income From This Wedding

$ **73.19**

Notes

- TOOK CANVAS BKg.

- STARTED THINKING SEQUENCES.

Form for tracking total production costs from a single wedding.

• **Gift Folios:** This product includes 2–5x5 prints in a single book-like folder. The cost is $2 for the folder itself, and $1.25 per 5x5 print. (The selling price per complete Folio is $19.95.)

• **Individual Prints:** The selling price for 5x7s is $15; your costs are $1.75 for the print, $1 for the paper folder. For 8x10s, costs are $3.25 for the print, $1.50 for the folder; the selling price is $25. For 11x14s, costs are $9 for the print, plus $4 for mounting; the selling price is $80.

These figures are *roughly* typical of the costs you'd expect to pay for these services. Or, as the lawyers would say, "Prices may vary." As for the *selling* prices, well, let's just say the quoted figures are within the realm of reason.

Under The Microscope

Naturally, when you want to see how you fared with this wedding, your eye goes right to the Bottom Line. It's impressive. You're pleased. The Wedding Income Log illustrates how you booked a wedding at $900 in October, then deftly built it into a total sale of $2,998.89. Most photographers would be happy with these numbers...or at least wouldn't complain.

Yet you know you can do better. As pleased as you are with the numbers, you know that some very good photography is going unsold and/or undersold. You know you're a long way from exhausting your options. You know that $2,999 isn't the end of the rainbow.

To that end, let's look at this sample wedding not as a single order, but as a series of interrelated individual orders. Let's see what it's made of—and look for how it can point the way to improved sales in the future. As you'll see, each group of people buying pictures has their own reasons for wanting to spend money on your photography. The better you understand those reasons, the better your chances of producing the pictures these people will want to buy—and *will* buy.

The Bride and Groom's Order

As always, the process of selling wedding photography begins with the bride and groom. At this wedding, Bob and Mary are the two people who invited you to their wedding, and made all the other sales possible.

As booked, the Bridal Album committed to by Bob and Mary cost $900. For that, they reserved your services for five hours on their wedding day, and later would receive an album including 56–8x10s. Beyond that, it was understood that any additional sales rested solely upon your performance behind the camera—and whether you produced additional images they were willing to buy.

Additional Time

At the wedding, whether or not you get that selection of pictures is dependent upon your being there when things happen.

As is often the case, Bob and Mary misjudged the amount of time they would eventually need you in attendance taking pictures. Last October, when they first hired you, five hours had seemed like "plenty of time." At the wedding, once the music began and the guests started talking, the clock kept ticking—and your five hours expired just before Bob and Mary were to cut the cake. You knew there were still pictures which needed taking.

Not to worry. You knew this might happen, and had carefully outlined your policies regarding "additional time." As you'd explained when you first talked with Mary about how you handle extra time, as long as your schedule was free, you'd be available to stay "as long as you need me." For Bob and Mary, that offer translated into an on-the-spot request that you stay two extra hours.

As per your price list, your policy is to add 8–8x10s to your coverage for each hour you stay beyond the booked time limit. The cost to the couple: $128.57 per hour, or 256.14 total for the two hours you were asked to stay. Those two hours helped turn a $900 basic Bridal Album into one now contributing $1,157 to your total sale. They also added 16–8x10s to Bob and Mary's Bridal Album. (For a more complete explanation of this approach to handling extra time, refer to Chapter 4 in this book. For a copy of a "real" price list using these ideas, see Price List #5/3 in the Appendix.)

Extra, Smaller Prints For the Bridal Album

Beyond the 72–8x10s now included in the Bridal Album, when the time came to place their order, Bob and Mary weren't particularly interested in adding still more prints to the album as 8x10s. They did, however, want to find a way to bring more of the secondary, less important pictures into their album: Grandparents being seated at the start of the ceremony, "fun" pictures of people talking, dancing and generally goofing around at the reception. You took a lot of good pictures, just like you said you would.

When Bob and Mary asked how they might accomplish this, you offered a money-saving solution: Instead of 8x10s, add extra pages of 5x5 prints, priced at a reasonable $36 per page of four prints. This sounded reasonable; it saved money, and it added sizing variety to the album. To prove that they found this offer acceptable, Bob and Mary purchased three 5x5 pages (12 prints) for $108. (Since those three new pages would mean the Bridal Album would have an *odd* number of pages [72+3=75], you offered to give Bob and Mary an extra 8x10...just to keep the album orderly. They appreciated your thoughtfulness and attention to detail.)

All together, the 72–8x10s and 12–5x5s brings the total amount spent for the pictures delivered between the covers of the Bridal Album to a healthy $1,265. That's respectable. But, Bob and Mary aren't finished yet.

Selling The Previews

Apparently, you did such a *superb* job with the photography that Bob and Mary wanted to buy literally every picture you took. In other words, they wanted to buy the Previews. They got their wish by purchasing the entire set of 180 prints, as a set. As per your policy, they received all 180 Previews, but paid for only 80% (144 prints). Your price per Preview is $3.50, which made the total sale $504.

You are very aware that if Bob and Mary hadn't purchased the proofs, they would have been used primarily as ordering aids for selecting the "real" prints, then filed away and forgotten. By setting in motion and fair and reasonable way for them to *buy* those prints, the happy couple happily paid you $504 to take the Previews home to enjoy.

Wall Print As Incentive

The 11x14 listed on the Wedding Income Log with zero income and a cost of $13 represents the print you offered to give Bob and Mary if they purchased their set of Previews when they returned the proofs, on time. They accepted, and you have them the print. The cost was minimal. It added value and immediacy, helped motivate them to act, and it helped cement the sale. Sometimes, it seems, you have to give to get.

The Future

From Bob and Mary's standpoint, their Bridal Album represents quite a bit of value. Originally, they'd agreed to pay $900 for 56 prints. When they picked up the finished order, they had a total of 265 prints for less than twice the money budgeted. It was more than they'd planned to spend—yet, in the end, they also walked away carrying almost five times as many prints. They're happy. And, because they're happy, you're happy. This is as it should be.

Quite understandably, you're pleased with the performance of the basic Bridal Album package structure you're using. It helps book good weddings, covers additional time well, and offers enough buying opportunities that as long as the pictures are worth buying, they'll likely be bought.

Selling the Previews as a complete set has proven to be an especially worthwhile exercise. Previously, proofs were seen as expense; now, they've become a solid profit center. Since you're selling the proofs a consistent 40% of time, the money coming in covers film and proofing costs from 100% of your weddings. That's made it easier to justify taking more pictures and/or experimenting with new ideas—which, in turn, has increased the overall value of your services and helped make you *the* photographer brides call first.

However, you've targeted two areas where improvements can be made:

• The add-on 5x5 pages are working out to be a good way for couples to add additional extra prints to their Bridal Album. They like the fact that

the smaller prints add sizing variety to their album, and help move more prints into their album at a cost lower than what it would be if buying still more 8x10s. (And to think you used to give those 5x5s away! For *free*!)

Still, you'd like to see more couples adding more 5x5 pages. Right now, your average is three or four pages per wedding. You'd like to see five or six. You've seen how, quite often, the pictures which find their way onto these pages are *sequences*—groups of pictures which logically belong together: Parents and grandparents being seated before the wedding, the bride and groom individually with each of their bridesmaids and ushers, cutting the cake, the garter and bouquet toss, dancing, pictures with close friends and family, etc. To make the sale of these multi-print pages more likely, at future weddings you vow to pay more attention to the flow of events, rather than trying for the one "decisive moment."

Your resolve is reinforced by the fact that even if you don't sell these 5x5 pages for the Bridal Album, you stand a good chance of selling these pictures as part of the Preview set. Either way, you've made a sale.

• The second area you want to improve upon is Wall Print sales. Looking at the Wedding Income Log, you see that you need to do more in way of *selling* your photography in these impressive (and profitable) larger sizes. You know from talking with couples that a Wall Print from their wedding is something they'd "love to have." You want them to have them! Above all, you'd like to see Wall Prints doing more than serving just as promotional items for selling Preview sets.

If it's true, as you've read, that "you sell what you show*," then from now on you're going to make a stronger effort to show—then sell—Wall Prints. Your plan calls for taking some of the money you're making from smaller prints (i.e., those sets of Previews) and reinvest it in upgrading your Wall Print samples. Those smallish 11x14s on the walls of your office are going to be reprinted *not* as 16x20s—but 20x24s! At least! You want those 11x14s to look like postage stamps.

You're also going to let your brides know of your plans. When you meet with a bride before her wedding, you'll point to your stunning displays—then let her know that, "At *your* wedding I plan to take pictures which will blossom into Wall Prints every bit as lovely as those you see from these weddings. In fact, from what you've told me of your plans and how nice the wedding will be, you should have *several* great images to choose from!" After the wedding, you're going to help these brides visualize their favorite pictures as Wall Prints by using an opaque projector to project the proofs into frames. You're going to get serious about Wall Print sales.

* It is true! (And, it's true for assignments other than weddings. If an important part of your business is portraiture, then you're naturally interested in selling Wall Portraits: 16x20s, 20x24s, 24x30s, etc. For some great ideas on making Wall Portraits a consistent part of your sales mix, check out the new video from incite!, *Movin' Up to Wall Portraits*. See the back of this book for details.)

These two ideas look like good places to start in your efforts to improve sales to the bride and groom. There'll be more ideas. You know that as you become more attuned to the information on the Wedding Income Log, you'll start uncovering both large and small opportunities to build sales. Over time, one print at a time, you're going to build your sales averages for the Bridal Album by making sure you give couples what they want in an easily purchasable format. That's really why they're hiring you, isn't it...to *buy* photography?

The Parents' Order

Everything from Bob and Mary's wedding was handled in a typical fashion: You gave the proofs to Mary; she showed to her parents, Bob, Bob's parents and anyone else who might be interested. Then, she returned the proofs and the print selections for the Bridal Album—plus the extra orders people had marked on the order forms in the proof book. It was business as usual.

The first group of "additional" orders came from the two sets of parents. Here's how those orders broke down:

Albums and Desk Prints

Mary's parents placed a nice order for a 24–print 5x7 album. In return, they gave you a check for $275. (That's not a bad order considering that, at the wedding, you were so busy following Bob and Mary around that you only spoke briefly with Mary's mom, and haven't talked with her since.)

Bob's parents ordered just about what you expected. Minimal. You didn't say more than ten words (all of which were "Smile!") at the wedding,, so you're not terrifically surprised they didn't get an album. Still, the handful of prints they ordered totaled $100. You'll take it.

Wall Prints For Parents

The one surprise was that Mary's parents ordered an 11x14 Wall Print.

After you delivered the proofs to Mary, and explained how she and Bob would receive an 11x14 if they purchased the set of Previews, it wasn't long before you got a call from Mary. "Mom likes the pictures," she said, "and she wanted me to call you about the 'big print.' She wants one, too. She wanted me to find out what the price would be if she got exactly the same picture in that same size?" You're a good sport, so you agreed to knock off $20—as long as the two 11x14s were ordered at the same time. It was an easy $60 sale.

All in all, the parents' orders were very straightforward. The grand total: $435. Nothing to brag about at your next local association meeting, but still a welcome boost for the Income column on your Wedding Income Log.

Second Impressions

If you didn't have the Wedding Income Log to refer back to, and if I asked you the question, "How did *profits* from the parents' orders compare with those from the booked Bridal Album?", I'll bet you'd look at the $435 in orders from Bob and Mary's parents, look at the $900 Bridal Album, and say, "Oh, they were about half as much."

I'm happy to tell you you're wrong. You're wrong because you made the photographers' classic mistake of confusing gross sales with net profits. Look back at the sample Wedding Income Log from Bob and Mary's wedding. Forget the Income column and instead move your eyes over the one that's second from the right, the one labeled Gross Profit. That's the IMPORTANT column! Profit-wise, you made *more* money on the $435 parents' orders than you did on the original $900 Bridal Album. If you don't believe me, look again.

Why the huge difference? Simple. We're talking about *profits*—the money left over after you've paid direct expenses. While the up-front costs of film and proofing were covered by the Bridal Album, the *only* costs incurred to deliver the parents' orders were those directly tied to their *guaranteed* orders. This meant your total costs for delivering the parents' orders were much less than for the original Bridal Album. (It didn't hurt either that because you were the only professional photographer at the wedding, your prices for the parents' orders didn't suffer the same competitive pressures as do your $900 Bridal Album—whose price you committed to when Mary was still shopping around, and still could have chosen another photographer besides you.)

What does all this have to with anything? Simpler yet. It means that since you're making most of your profits from orders other than the Bridal Album, and since nobody is more likely to spend money than the parents, then you'd better start paying serious attention to these fine people.

Now are you going to start talking more before, during, and after the wedding with the parents?

The Future

Bob and Mary's wedding is history, so there aren't many options available for salvaging the situation with their parents. But, there's always the *next* wedding...which, by the way, is coming up this Saturday! Here's a list of the things you're going to do to give yourself the best chance of achieving stellar sales with these lucky parents:

• Tomorrow, you're going to call both sets of parents from Saturday's wedding. If you haven't met, you're going to introduce yourself. If you have met, you're going to *re*introduce yourself. Either way, you'll move quickly to the purpose of your call: Making it clear to them that you'll be at the wedding not only to only take pictures of their offspring—but you'll be there for them, too. You want the parents to feel comfortable at the wedding coming up to you, pointing you and your camera at anyone and ev-

erybody they feel are Important People, and actively suggesting ideas for pictures they'd "love to have".

You'll tell both sets of parents that between now and Saturday, your "assignment for them" is to make a list of people they want to see in your pictures. Let them know that even if the bride and groom aren't especially interested in these people, that 1) you'll still be glad to take the pictures, 2) that taking these requested pictures won't cut down on the number of pictures you're taking for the bride and groom, and 3) that they are under no obligation to buy the pictures just because they requested them.

(This really is the most effective way for you to increase orders from parents. The trick to selling Parent Albums is not an endless variety of pictures of bride and groom, but of all the *other* people at the wedding. For the bride and groom, this may be "Their Day," but for parents it's often "Family Day." What's important to them is how the wedding is bringing together all the Important People in their lives to help celebrate this marriage. It's those people you want to make sure you get in your pictures. Those people are going to help you sell Parent Albums and *lots* of other prints.)

Again, you're very aware that even if these pictures don't result in new orders for individual prints, the fact that you've taken them increases the value of the Preview set. You wouldn't mind moving your sales of Preview sets up from 40% to 50%.

• Now that you're committed to the idea of encouraging, then producing, a larger variety of pictures specifically for the parents, at the same time you want to make it easier for them to *purchase* those images. In other words, you want to sell more of your larger Parent Albums.

One way to make the sale is to build an offer that's hard to resist. You know that most parents really would like to own a beautiful album from their child's wedding. You also suspect that most would enjoy a Wall Print. Why not combine the two desires into an irresistible offer? Keep your smaller Parent Albums intact, as is, for parents on a budget. Then, with your mid-sized and larger Parent Albums, include 11x14s and 16x20s. If the value is there in your pricing, the orders will follow. (To maintain order, you should have these offers hinge upon the requirement that both the Parent Album and the Wall Print must be ordered at the same time as the rest of orders from the wedding.)

With each of these ideas, all you're really doing is finding ways to serve the parents better. You're asking what pictures they want, taking them, and then making it easy for the parents to buy those pictures. That's all any parent can ask of the photographer. I can guarantee that if you do this for parents, more will not only *buy* the pictures—but they'll also thank you for being so attentive to their needs, and not ignoring them. They'll love you for it.

They'll also tell all their friends…who just happen to have sons and daughters. When those kids start planning *their* weddings, these parents are going to

want to make sure that the photographer at the wedding is someone who won't treat them simply as walking checkbooks. In other words, they're going to call *you*.

Friends and Family Orders

This layer of the Wedding Income Log is starting to show increased activity. In the past, these orders were welcome—yet never really understood, or pursued. Now, you're beginning to know where these orders are coming from, and why.

From Bob and Mary's wedding, you saw a jump in the orders from people other than the Bob and Mary, and their immediate families. You saw orders from people named "Aunt Sophia," "Robert," or "Jim and Lisa," whose orders sprinkled themselves throughout the proof book's order pages. Individually, these were small orders. Together, they added up to a sizable chunk of cash. $520 to be exact. These prints were purchased at "full list price," which made them some of your most profitable orders.

Why this sudden burst of activity? Six months ago, the friends and family merely served as background fodder for your *real* pictures—that endless stream of images of brides and grooms. Everything else was an afterthought. No more. Now, as you proved to yourself again with Bob and Mary's wedding, you're getting the pictures you need of the bride and groom—then quickly finding out more about all those *other* happy, nicely dressed people.

The Wedding Income Log tells the story. For Bob and Mary's wedding, you broke the Friends and Family orders down into two groups:

• Sales of random, candid prints to people like you've always taken them: Posing with the bride and groom, at their tables, as impromptu groups, dancing, etc. You're trying harder to make sure the people in these pictures are "important," but, really, these are just professional-level snapshots.

• You've also started tracking sales of a new type of photograph: Those taken in front of a painted canvas background you've recently started taking to weddings. You're curious whether it's worth the effort, and you're going to let the numbers on the Log do the talking.

Your efforts to *think* your way through these pictures is clearly paying off. Taking these miscellaneous pictures is something Mary had specifically asked for when she first talked with you. What's different now over your previous approach is that rather than casually wandering around snapping random pictures just to "look busy," you're pulling aside the most important of the Important People, and using the canvas background to create well-planned, well-executed *portraits*. You hoped this would lead to an increase in sales. And, as the Log proves, they *are* selling.

Mary summed it up for you when she brought back the Previews, and all those orders for the pictures of the grandparents: "My parents have been trying

for years to get my grandparents to go someplace and have a *real* portrait taken. They'd never do it...and they aren't getting any younger. When my sister, Julie, got married last year, her photographer lined Gram and Gramps up in front of a brick wall and took a few snapshots. The pictures you took are so much nicer. Everyone was just thrilled! My mom, and all her brothers and sisters, were so pleased that they not only got copies for themselves, but also for all the grandchildren. She told me to be sure to say 'Thank you!' " To which you humbly bow your head and reply, "Tell her it was no problem at all."

Those pictures of Gram and Gramps, which took you all of four minutes to take, accounted for over half of the sales from pictures taken using the canvas background.

Suddenly, you're starting to like the pictures you take at the reception.

The Future

The 536% figure you see under Mark Up on the Wedding Income Log for the Friends and Family sales is definitely making an impression. Up until recently, you didn't fully appreciate the number of orders which could be generated by all the "other people" at a wedding.

You'll never underestimate these people again. At the same time, you realize that while the bride and groom, and the parents, can absorb only so many pictures—the potential sales from Friends and Family is literally limitless.

Here are some of the ideas you've come up with (so far) to do an even better job of serving these newly important folks:

• Never again are you going to wait to be asked to take "real portraits" of the grandparents—or anyone else. In fact, you're going to adopt this rule of thumb: If someone is wearing a corsage or boutonnière, that's a good enough clue that they're worth watching. Once thus identified, you're going to politely march them in front of canvas background, and honor them with a photograph. A real, *professional* photograph. You fully expect that these few minutes will be time well spent.

• Beginning with your next wedding, instead of sitting down to eat those warm coldcuts, you're going to pack a granola bar in your camera bag and learn to eat on the run. You need the energy—but more importantly, you need to take more pictures. If time is money, and if you're scheduled to be at a wedding for a set number of hours, then those free coldcuts can quickly become the most expensive meal you've ever stopped to eat.

• Speaking of time, when you're first talking with a bride and groom, you're going to start stressing the value of time. "I know how to create a lot of great pictures," you'll say, *"but I need to be at the wedding to do it.* That's why it's so important to make sure the package you select includes as many hours as you'll really need me." This is absolutely true...both for the pictures you'll be taking for the Bridal Album, and also for the pictures you'll

be taking for the parents, and everyone else. You plan on being busy, but you still need a reasonable amount of time with which to operate. (If it looks like it's going to be a particularly good wedding, you've decided you might even volunteer to include an extra hour, free, as booking incentive. It costs you little, and now that you're learning how to invest those minutes uncovering more pictures to sell, that "free time" should contribute nicely to your bottom line. You're easy.)

• Finally, you're going to start making a habit of *studying* the Wedding Income Log. You want to attune yourself to what sells, and what doesn't. Out of the thousands of pictures which you could take at a wedding, you want to know which stand the best chance of being purchased. The buying habits of people at past weddings can tell you a lot about how people at future weddings will respond.

All of this is pretty basic stuff. It's just a rehash of the maxim, "find a need, and fill it." That's what you're doing at the wedding. That's what you're being *paid* to do: Find the pictures, and take them. It's really a game of Know & Sell. Your first obligation is to the bride and groom, followed by the parents. After that, it's up to you to discover all those *other* pictures which can be taken, then, once on film, will be appreciated enough that they'll be purchased.

Miscellaneous

There's one last group of original orders remaining to be tallied. You're tracking it separately on the Wedding Income Log, just to prove to yourself that it's working out as another *proven* long term winner.

Gift Folios

The specific product is something new you're calling "Gift Folios." These are sets of two 5x5s, in a nice leatherette folder, which you're positioning as gifts from the bride and groom to each person in the wedding party. Bob and Mary's wedding weighed in with a total of five couples, or a potential sale of ten Folios. The selling price has been kept to a reasonable $19.95.

You'd brought up the Folio idea to Bob and Mary weeks before the wedding, making sure they knew about it before they wrote checks at the jewelry story for cheap necklaces and cufflinks. You explained that your Folios would make great, *personalized* gifts, at a comparable price. You showed them sample Folios from other weddings. They liked the idea then, and at the wedding you made sure you took pictures of Mary with each bridesmaid, and Bob with each usher. The stage was set for the sale.

When the proofs were ready and the tired couple came in to pick them up, you pointed out these pictures and reminded them of the Folios. You told Mary that if the Folios were ordered that day, you could have the finished Folios ready to present to the couples when she returned the Previews and all the orders in two weeks.

Bob wasn't too thrilled with the idea; he'd decided to give his buddies customized beer mugs. Mary, naturally, thought the Folios were a great idea. After looking over the Previews, she made her choices, and ordered her five Folios. Since you treat Folios as separate orders which are paid for when they're delivered, you had Mary write you a check for $99.75.

A large part of what you like about the Folio concept is that it allows you not only to make an extra sale, but it delivers your photography into the hands of every bridesmaid (plus an occasional groomsman) in the wedding party. It's paid advertising—only this time you're the one getting paid. You know that over the next year or two, matrimonial fever will strike several of these young people. You also know that because you did a great job for Bob and Mary, and because you'll clearly imprint your name on each Folio, your phone number stands a good chance of being the first one dialed as these ex-bridesmaids and ushers begin their search for their own wedding photographer.

Multiplied by the number of couples you photograph at weddings in a year, you see that Folios have the potential to add booster rockets to your other advertising efforts. Every little bit helps, and this one is about as easy at it gets.

Reorders

After the initial orders were delivered to Bob and Mary, it took only a few days for the reorders to start coming in, but they did. This good-sized, $175 handful of prints were the direct result of another in a growing series of good ideas you've had recently: Inserting a reorder form with each order to make it less easy for people to forget how much they wanted to own some of your photographs.

This idea came about as a response to comments you'd heard as people talked about placing orders. When Mary returned with the Previews to let you know what the first round of orders would be, even she told you that some people didn't order because they "wanted to see how the pictures turned out first". In the past, you rarely heard from these people. Now, with your reorder system in place, you're starting to see results—and checks. The reorder forms will also catch people who never had a chance to see the Previews as they made their first trip through the city.

Your reorder system was simple to set up. So that people could identify the prints, you added *numbers* to the back of each print leaving your office. You then included a note with each order inviting people to reorder directly from you, and telling them it was no problem at all.

To keep the process moving, you provided a date four weeks after the original orders were delivered for reorders to be placed. You included a printed, self-addressed envelope along with the reorder form. You asked that the reorders be pre-paid.

To keep the system manageable on your end, you told people in the note that all orders from a single wedding would be printed as a group. During the

time checks and orders are coming in, you keep them separate. At the four week mark, the wedding is "closed," and all the reorders from a single wedding are sent to the lab together.

Granted, this is something of a bother for you. Then again, it makes it fun to go out to the mailbox and find checks mixed in with the bills. They haven't quite balanced each other out yet, but you're working on it.

Bottom Line Time

Because you've done such a masterful job with all of the above, the Bottom Line from Bob and Mary's wedding has pretty much taken care of itself. Instead of looking only for a "Big Order!," as you used to do, you've learned now to watch each segment of the order individually...and let the Bottom Line fall where it might. It's been falling pretty high lately. The concept of mega-orders is not so mysterious anymore, either. You're not ending up with one large check, but small pile of smaller checks from many different people.

Now that the mystery is gone from what it takes to build large sales, you're going to have some serious fun with wedding sales. You're seeing that the deeper you dig, the more opportunities present themselves. Just think how sales will again multiply as some of your newest ideas start to perfect themselves and kick in! You're really learning to make every hour, at every wedding, count.

Speaking of hours, you've rediscovered the concept of the "hourly wage." At the bottom of the Wedding Income Log, in the lower left-hand corner, you've noted that from Bob and Mary's wedding you generated a *gross profit* per hour of $73.19. By anyone's standards, especially photographers', that's darned impressive. I'm impressed!

What you like most about this hourly figure is that it's a single number. It's absolute. It equalizes all weddings, and it's the best way you've found yet of comparing any wedding to any *other* wedding. (It's also proven to you that while you make more dollars, total, from larger weddings, on an hourly basis you do better with the shorter events. Correcting that imbalance gives you yet another project to work on over the next year.)

You're confident. You fully expect that next year at this time, you'll pull up your new sets of charts and graphs—and chuckle. You'll look back on Bob and Mary's wedding, and their $2,999 order, and wonder how you could have ever afforded to do a weddings for less than $3,000.

You'll never get everything perfect, but can make a lot more money—and generate a lot more fun—trying.

The Big Picture

So far, the information we've been studying has come straight from the Wedding Income Log generated by a single wedding, Bob and Mary's. It's made for some interesting reading and speculating. It's been informative. But, it doesn't tell the whole story.

For a fresh perspective, let's back up a bit and take our eyes off Bob and Mary's wedding. Instead, let's gather together the Logs from a year's worth of weddings. All of them—the big and small, the good and the not-so-good.

Rather than looking only at the dollar amounts and percentages which have accumulated at the bottom of the Log, the area we're going to look at is the *upper* section—the small, seemingly unimportant, area where you wrote wedding dates, days of the week, date booked, churches, and price list numbers. As mentioned earlier in this chapter, these simple details pack tons of powerful information...once you move beyond individual weddings, and start looking at the Big Picture.

Looking For Trends

To simplify the process, and to skip ahead a bit, what you've done is compile this information into a few rather interesting groupings. After some study, here's what you're noticing:

• You see, on average, that you're booking summer weddings quite early—often before Christmas. You see, too, because you're tracking these phone calls, that you're getting a lot of inquiries for these same dates *after* Christmas. This observation tells you something: Maybe you've got more demand than supply. It starts to dawn on you that part of the reason you're booking so early is because you prices are so "reasonable." You start to wonder about the brides you're being forced to turn away. "Maybe," you ask yourself, "a few of those brides would pay more for my photography than the bride's I'm working with now?" Hmmmm...

• You next compare your sales averages by price list. "I wonder," you ask, "what the effect was on sales averages when I dropped my four-hour package during the busy summer season, and instead used five hours as my minimum?" Wow! The answer jumps right off the page: A year ago, you did quite a few smaller summer weddings, with a relatively low sales average. By increasing the minimum to five hours, you lost some calls, but you were booked by the time the dates rolled around—and averages from these weddings were up over 30%. Now that's interesting!

• You move on to comparing sales averages from Friday/Sunday weddings, with those booked for Saturdays. What you see surprises you. While packages are generally smaller, they're definitely worthwhile. On an hourly basis, make more from these smaller weddings than from the larger, longer

Saturday affairs. You vow that when people call you about these "off-days" that you'll be a bit more attentive.

• Out of curiosity, and just because your computer database makes it easy, you decide to do a quick comparison of sales averages *by church*. This starts out as not much more than a computer exercise, but quickly becomes much more. For the most part, there's no real difference; sales are about the same for most churches. Except for one church: St. Ansel's. The averages from weddings performed there literally jump off the chart. If you were a sociologist, you might be interested in the whys and wherefores. As a photographer, all you want to find out is who these people are—and position yourself as their "designated photographer." This is some information you weren't expecting—but it's something you'll definitely be following up on.

While these examples are fictional—they're not far-fetched. In fact, buried within your files from the wedding you've *really* photographed over the last year are bits and pieces of information every bit as illuminating as what you've just uncovered. It's a lot like prospecting. There are nuggets of data lurking in the most unobvious places. All you have to do is dig them out, sift through them, and figure out how to use them. Half the fun is in the discovery; the other half is cashing in.

Using Costs to Set Prices

After all you've just read, about now you may be getting ready to ask, "What about setting prices? Aren't selling prices supposed to *somehow* be tied to costs? Isn't that what this chapter is about? Isn't there some number I can multiply costs by to arrive at the correct selling price? Steve, *what is that number?*"

I understand your concern. If you're looking for pricing formulas, try this: Take the circumference of the first 8x10 print in your latest Bridal Album, and divide by 4.7. Multiply that number by the focal length of the lens you used to take the picture. Add your lab cost. Then, subtract your lab cost. Finally, multiply whatever number remains by the price of rice in China.

Hey! What's the problem? You asked for "a number" didn't you? You asked for "a multiple"? Well, what's wrong with the number you got? Whatever it is, I'm sure "your" number is just as good as the numbers other photographers produce as their answers to the same question—and believe me, *we all ask this question!*

Seriously, folks. I don't mean to make light of your question. It's just that I believe that this whole idea of "multiples" and "pricing formulas" is brain dead. I've never figured what the cost of a print has to do with it's value to the customer—and therefore it's *true,* correct selling price.

Sounds Semi–Logical, But...

Let me explain. In a typical application of this Price-Equals-Multiple-Of-Cost Formula, a photographer will look at what it costs, say, to have an 8x10 printed at his or her lab of choice. Let's say that cost is $4. If the Formula calls for a 3X mark-up, then in this case the "correct" selling price of that 8x10 would be $12. An amazing, and depressing, number of pros use this approach to set their prices. (Not you, I hope.)

In theory (at least the version that I've heard) the idea here is that a third of the selling price is destined to cover the cost of the finished prints. Another third is allocated to pay all the remaining costs of taking the pictures (film, proofing, albums, etc.), plus the costs of running the business (rent, equipment, insurance, etc.). Then, magically, the final third is "profit" (the money the photographer gets to keep).

If you ask me, that last third looks like it's going be getting pretty thin.

Anyway, the idea sounds good, no? It's neat and clean. It's "scientific". Unfortunately, it's a theory with no less than 12,733 holes in it.

Personally, I think it's a crock. I could rant and rave on this subject, but I'm going to restrain myself. Rather, I'm going to recruit six photographers from the audience, three of whom are going to sacrifice their good names in an effort to dissuade you from basing *your* prices too heavily upon production costs:

• Susan and Ed are both excellent photographers. Sue, however, is careful to watch her costs; she leaves her motor drive at home, and makes sure everything is "right" before releasing the shutter. She doesn't need quantity to achieve quality. Ed, on the other hand, believes that if he "takes enough pictures, some are bound to 'turn out'". Ed shoots a lot of film—twice as much as Sue. In the end, however, only half of Ed's pictures are presented to his brides; the other half are edited out. *Questions:* Does the fact that Ed spends twice as much on film and proofing mean his work should be priced higher than Sue's, or simply that he's spending money needlessly?

• Bill and John send their negatives to the same lab. Bill has mastered his craft; his negatives are perfectly exposed and composed. As a result, he uses straight machine prints and gets beautiful results. John? Well, he doesn't yet have it all under control. His negatives are poorly exposed, off center and generally in need of serious custom printing—and even then his quality doesn't come close to Bill's. John's lab bill, however, is *triple* Bill's. *Questions:* Since John's costs are three times higher, should he set his prices three times as high as Bill's? More importantly, is his photography *worth* three times as much as Bill's? Would any bride in her right mind pay three times as much to hire John as her photographer, if both Bill and John were available for her wedding date? (This is *not* a trick question.)

• Bob and Tom are photographers in the same town. Bob has a full-time studio in an expensive uptown location; Tom works part-time out of his

home. Both produce what local brides describe as "good wedding photography," and most brides would be pleased with the work of either photographer. Their *prices*, however, aren't even close. Bob's prices are more than twice those of Tom—and with good reason. With his higher costs, Bob has no other choice but to charge more. *Questions:* Because the quality is similar, should Bob and Tom's photography be priced the same? Or, should Bob *lower* his prices and absorb his higher overhead? Or, should Tom *raise* his prices to capitalize on the fact that he's learned how to produce quality work at a minimal cost? Is there are "correct" answer, or a "correct" price?

Now, how would *you* answer these admitted leading questions? Hopefully, you agree that the smartest thing any photographer can do is learn how to produce excellent, high-value work inexpensively...then let the brides "set" the prices by what they're willing to pay by looking at the pictures, *not* your lab bill.

On the outside chance that you're still clinging to the idea that cost multiples offer the "best answer" to your own pricing questions, why not try this tactic with your next wedding: Load up your truck with 438 rolls of film—then expose every frame. Have each proof printed as a custom, hand-crafted print. Have every negative printed as an 11x14. Use the most expensive album(s) you can find. *Why worry about costs?* Do everything you can to run up your costs into the thousands of dollars!

Then, to arrive at a "guaranteed 'correct' price," get out your 9-digit calculator and multiply those sky high costs by a conservative 3X. You'll be rich!

Because you followed The Official 3X Formula, the bride will automatically be happy and satisfied. She won't even blink, right? Not likely. In fact, if you attempted to justify to her how you arrived at your selling price, she'd likely describe the Formula as "crazy." I'd have to agree.

The point is this: The out-of-pocket costs of producing salable photography really have very little to do with the *value* of those pictures to the customer. Aren't they the Important People in your business? Aren't they the people who ultimately decide whether your work is "worth it"? Aren't they the people paying you?

If you're paying more attention to costs than you are to your customers, then you're looking for answers to your pricing questions on the wrong side of the equation. Your brides have no idea what it costs you to produce their pictures. More importantly, *they don't care!* Not really. When a bride shops for a photographer, she'll look at your work and your prices. She'll also look at your competitors' work and prices. Then, she'll compare. Finally, she'll make a choice based upon what she perceives is the best value. That's all she's really interested in. Period!

Keeping Costs In Their Place

None of this to say that costs don't have a place in your pricing. They can, and *should*, have a role: Not to set the *selling* price, but to set a *floor* for pricing.

You absolutely do need a reference price which you know is as low as you can go and still make money.

This "reference price" is your break-even point. If you can sell your work for more than this price, you'll turn a profit from the assignment. If you drop your price below this point "just to get the job" then you'll lose money.

You need to know your break-even point. You need to know, on average, what it costs you to photograph a wedding. You need to know everything about what it costs you to be in business as a professional photographer: You need to know whether, given the volume of work you're doing, your prices are supplying the money you need to cover your expenses and make a profit.

If you can learn to produce quality work inexpensively, you'll have a lot of room to maneuver with your pricing. Hopefully, you'll elect to keep your prices high enough that you can afford to keep improving—but ultimately, it's your decision. Brides will keep you from going too high; only you can restrain yourself from pricing your own work too low.

Pricing accurately is not an easy process. It takes years to acquire a "feel" for what people think your photography is worth—and therefore what they are willing to pay. But, I have feeling that you, like me, got into photography not to learn how to produce work cheaply for a lowball price—but to be paid to get better. And better.

Drawing Your Own Conclusions

To show you how even simple shifts in the balance between expenses and prices can produce dramatic results, let's build one last fictional example.

This time, you're going to look at the numbers your weddings have generated over the past year.

The final tallies tell you that, after all the bills have been paid, *including your salary*, your business achieved its' targeted 15% profit. This means that for every $1,000 in sales, the business banked a clear $150. Now that you have a real number which reflects what actually happened in your business, you have a tangible target to improve upon during the *next* 12 months.

Thinking positive, you decide to *double* net profits. (There's nothing wrong with setting high goals!) Here's how you might attack the challenge:

• You can achieve part of your goal by adding to sales, either by increasing prices directly, or by learning to sell more effectively. Preferably both. If you can bring in $1,075 in sales for the same $850 cost as the previous year's $1,000, you're halfway to doubling profits.

• You might reach the rest of your goal by trimming $75 off expenses per $1,000 in sales. If expenses (including your salary) were 85% of sales, or $850 per $1,000, then your new target is $775. (This is more difficult than

adding to sales, but it can be done. It's mostly a matter of making every penny spent accountable to profits. If an expense doesn't help increase profits, it's time to rethink whether you should be spending that money.)

If you can achieve *both* goals, your expenses will total a lower $775 for a higher $1,075 in sales. That's a difference of $300—or a doubling of the previous year's $150. *Please note:* To double those profits, *you did not have to double your sales.* All it took was some modest goal-setting over a 365-day year, plus some good execution. Those kind of profits are closer than you think. (When you consider how many of your expenses are fixed and not tied to sales, you can again see the logic of getting those expenses paid off early in the month—and having that many more days to make more money as profit, and for yourself. Heck! You might even give yourself a raise!)

It should also be noted how easy it would be to cut your original $150 profit by half. That's only $75 per $1,000 in sales—which ain't a lot. If you get careless with expenses, or fail to capitalize on sales opportunities, you might find yourself working just as hard for a lot less money. All other things being equal, if your profits eroded to $75 per $1,000 sales, you would have to *double* your wedding volume just to stay even dollar-wise. In other words, you'd have to do four (4) times as many weddings at a profit of $75 per $1,000 in sales as you'd have to do if you fine-tuned the performance of your current volume to a rate of $300 per $1,000. The difference between the two extremes is only $225.

That's the reason *every* dollar counts.

That's the reason it's so important to track income, expenses, and profits.

9

Sizing Up
Your Competition

Before you start typing up what you think will be the perfect wedding price list, get out your phone book. Turn to the Yellow Pages, to the heading "Photographers–Portrait." Look over the listings. On those few pages are the wedding photographers you're up against.

Some of your competitors may have been in business for years, others may just be getting started. Some are great photographers now, some are going to be great once they've had a few more years experience. Some are average, or worse.

Like it or not, you and your business have a place in this mix. That's the bad news.

The good news is that new businesses or old, good photographers or bad—*all of your competitors are overrated*. None are invincible. All of them can be beaten...or, at least, given a run for their market.

In any market, there is *always* room for new blood, new ideas—room *at the top*.

Competition As Sport

There are two ways you can look at competition: As *sport*, or as *war*.

Either approach can be used to build a profitable business. However, I am a strong advocate of making competition a positive force in your business. Competition is *not* a dirty word! Channeled properly, the power of playing hard and playing to win can propel you, your business and your profits to levels you never would have achieved otherwise. Your competitors are the guys who are going to push you to push your business to new heights.

While throughout most of this book the emphasis has been on improving your own playing skills and sharpening your pricing strategies, in this section I want to take a look at the other teams and how you can combine your strengths with their weaknesses to improve your chances of having a championship season.

How? If you can learn all you can about how other pros think and act, you can come up with a "game plan" which will give you a good chance of coming out the winner. Rather than ignoring them and pretending your competitors don't exist, you can finesse your way past them with a combination of guts, cunning, skill and long range strategic planning.

Three Ways To Compete

Central to your competitive efforts is going to be how you view your competitors. Basically, you've got three choices:

• **Low Road.** Take the low road, and every competing photographer is scum trying to wreck your business and force you into bankruptcy. They are the enemy and it's "kill or be killed." In terms of business strategy, this route usually distills down to a siege mentality. It also can often lead to a situation of paying more attention to what the competition is doing than to what the customer wants.

• **High Road.** Take the high road, and every other photographer is a "worthy" competitor. You both know that you're each playing to win and not asking for any favors, but the competition is dignified. It's a matter of *respect*. This is photography's equivalent of a boxing match: You shake hands and don't punch below the belt...then proceed to bloody the other guy. "May the best man win." Strategically, the high road would mean working hard to do the best job you can for the customer—and just incidentally clobbering the competition.

• **No Road.** Take no road, and you just sit there buffeted by the competition going on around you. This is the road taken by an alarmingly high percentage of photographers. They are in business, which means they are supposedly vying for the attention of the customer—yet they are afraid to compete. Since they do nothing, these photographers have little control

over their own businesses. They get what's left after the more aggressive photographers have chewed over the market.

Each of these approaches can be used to build a business. While I'm an advocate of taking the "high road," I'll admit that the "low road" can lead to profits, too. At least with both, the photographer is doing something. It's the "no road" photographer who is going to have trouble the quickest.

Competitors Can Help Each Other

If you are absolutely new to wedding photography in your area, then the market you are entering has already been established by other photographers. They have set the standards, the current pricing structure, and generally defined what "wedding photography" is to residents of your community.

If you're the new kid on the block, here's what's going to happen:

At first, you will be just another wedding freelancer in the eyes of more established pros. These "wedding wannabes" come and go. If your business has staying power, the longtime pros will finally recognize that you are "for real." They'll start watching you. If you keep gaining on them, eventually they will have no choice but to admit that you exist and that you are now a part of the local competitive landscape.

Of course, the better you get, the more they will wish you never were born. Yet if you play fair, produce good work and "prove yourself," eventually you will be admitted into the "inner circle." It takes awhile, but it's worth it.

Once you have the grudging respect of your competitors, strange things happen. If you've been good about referring couples to other photographers, gradually you'll see that they are referring couples to you. If you've been helpful with your "constructive criticism" of another photographer's work and offer genuinely useful tips about how it can be improved, you'll have those photographers sharing their ideas with you.

Other advantages:

If you get sick on a day you need to photograph a wedding, it's good to have people you can call to help you out. You'll "owe them one."

If a primary lens breaks down, it's helpful to be on friendly terms with another photographer using the same equipment who might lend you his lens. If you're not on good terms, he'd just laugh as you begged.

If you're having trouble with your lab, a friend will point you in the direction of a better lab. Or help you track down nicer frames and albums.

It's entirely possible to be competitors *and* friends. It's networking. It's a do-it-yourself trade association where you and other "good guys" band together to combine strengths. While even a friendly competitor might not answer

"strategic" questions about pricing or marketing plans, there are scores of other facets to wedding photography which can be freely discussed.

Of course, you'll still work like hell to get every wedding you can.

"Real Life" Competition

I might as well warn you: As hard as you might try to be a worthy competitor and play a fair and friendly game, it's a sad fact that not everyone is going to see things in the same way.

Much of it will depend on how hard you compete. If you limit your competitiveness to passing out business cards and a listing in the Yellow Pages, other photographers will remain calm and not feel threatened. Become ambitious and aggressive, and you'll notice a swift shift in attitude—at least on the part of photographers who prefer a milquetoast competitive atmosphere.

The point I want to stress is that your competitors would love it if you just sat by your phone. You can't do that! If you do, you are letting them run your business. Whether it's how your price and package your photography, or how hard you work to get displays in wedding–related stores, you owe it to yourself and your customers to do the best you can at all times. As they say, you're running a business—not a popularity contest. Your business is really between you and *your* customers. Keep your eyes firmly on your customers' needs, and your energies focused on improving your photography and service. Let the other guy spend his time worrying more about you than his customers. When that happens, and if it goes on long enough, eventually you'll bypass him and leave him muttering to himself—and wondering why all of "his" customers are going to you.

Tracking Down The
Competitive Information You Need

Enough theory. If you're anxious to let the games begin, have I got a deal for you!

You're going to get married!

That's right! And, of course, you need a wedding photographer. Which means you will need to call the wedding photographers in your Yellow Pages for information on prices, packages and all the things any bride and groom needs to know.

You're going to be doing some "market research" and "competitive analysis."

On Your Mark...

You'll need to pick a date. Go with a Saturday about eight or nine months in the future. Jot down the name of a church, a reception hall, and a ceremony time. You'll also need a name for yourself and your fiancee. Also, write down the address and Zip code of a friend or relative living in another part of town. (You won't need a phone number for this exercise. Your attitude will be that you are "just shopping" and "don't call us, we'll call you.")

Get Set...

You will be calling 1) any photographers you have heard of in relation to wedding photography, 2) any photographer with a display ad listing "wedding photography," and 3) any photographers listed whose address or prefix places them within your immediate market area.

Go!

Start dialing the phone. When the photographer or receptionist answers, all you need in the way of a prepared script are the words "How much are your wedding pictures."

As soon as you utter those words, stop talking. Let the person on the other end take the conversation from there. After all, you're just someone who recently became engaged—and don't know the first thing about wedding pictures. Right?

What Are You Waiting For?

Haven't picked up the phone yet? C'mon!

This is an exercise which you should do immediately. I realize you haven't had much time to think about what you're going to say, etc.—but that doesn't matter. Most couples calling photographers don't know what they're asking, either.

It's easy to put off making these calls until you think you're "ready." Don't. You'll never be more ready than you are now.

I guarantee that after you've made a few of these calls, you'll get into it. I'll also promise you that in the first 30 minutes you will learn more about wedding photography in your area than you'll ever learn by talking with other photographers. With these calls, the photographers are relating to you as a potential customer—and you'll see them at their best, or worst. It's amazingly educational.

What You're Looking To Learn

Obviously, you're wanting to know prices—just like every other person planning a wedding on a budget.

There are also several other points of business you will want to make sure are covered in this *first* conversation:

• You'll want to know the "phone" packages of these photographers, their base packages and what is included in the way of sizes and quantities.

• You'll want to know how many pictures are included in their albums. How much time they spend at the wedding.

Don't worry about "knowing too much" or "sounding like a photographer." Just stay calm. Ask money- and quantity-oriented questions. That's really all you should be *asking*. Beyond that, just sit back and see how good a job the photographer does of working to impress you.

As much as specific information, what you want to pay attention to is the *impression* the photographer makes. Or, fails to make. If you were getting married, *based upon this one conversation* would you feel comfortable making an appointment to learn more? If the photographer impresses you enough to accomplish that, then he or she has succeeded on the phone. Put a star next to any photographer's name who does a great job of using the phone effectively.

As you go down your list of names, you'll feel more comfortable with the entire project. By the time you're done, you will have a snapshot of your wedding photography market—the same one brides will see when they get out their Yellow Pages and begin the process of elimination and investigation.

Once you have made a subjective decision about which photographers are doing a good job, call them back. Reintroduce yourself, say you've "been calling around" and now have some specific questions. If there's anything else you want to learn about pricing, time, packages, Parent Albums, policies, etc., now is the time to ask.

Follow Up Move(s)

Once you have made your phone calls, you're going to continue with the process of learning more about these other photographers—just as a bride would.

• **Look at displays.** In the evening, go look in studio windows. Start forming an opinion of who is doing a good job, and which photographers aren't. If you know of displays that photographers have in bakeries, florist shops, dress stores, card shops, etc. go see them. (These are favorite showplaces for home-based wedding photographers who don't have studio windows for couples to peek into.)

Remember, the work you see on display is these photographers' *best* work. It's not their *average*. There's usually a huge difference between the great picture you see on display in the dress store and the photography delivered to last Saturday's couple. If the product doesn't live up to its advertising, you want to know about it.

• **Look at "real" albums.** This is where you will begin to get your truest picture of other photographers' capabilities. These are albums that couples have paid for, not sample albums in stores.

To find these albums, all you have to do is ask your friends, neighbors and co-workers who took their wedding pictures. Ask to see their albums. As much as possible, try to locate albums from *recent* weddings.

• **Talk with people!** As you look at albums and displays, make a point of asking questions...*nice*, seemingly innocent questions. For example, if you go into a bakery with a display by Photographer X, introduce yourself and let the bakery owner know that you're "just getting interested in wedding photography." Buy a jelly donut. Casually ask what his customers say about the pictures.

Don't mention the fact that you're eyeing his wall with the eventual intention of replacing the other photographer's pictures with your own. Instead, ask if he'd mind if you gave him smaller pictures of his cakes that you photograph at your weddings. (Of course he won't mind!)

Chances are that you'll get into a nice friendly conversation about weddings, wedding cakes, wedding photography, and other wedding photographers. You won't be interrogating the bakery owner; you'll be talking about something which interests both of you. You might even get an invitation to bring some of your business cards to set out on the counter, maybe even to show him a few of your pictures. (Be sure to include pictures of *cakes*.) At the very least you will have made a friend in the wedding business, and a contact.

The same friendly, I'm-determined-to-learn attitude is one you can apply to any conversation you have with couples who were customers of various photographers. This is where you'll learn what the "other guys" are *really* like! While the bakery owner will likely be guarded in his comments about other wedding professionals, that won't be the case when a bride is talking. If a photographer screwed up a wedding, or delivered snapshot quality photography, you can be sure the simple question "Who took your wedding pictures?" will unleash all the gory details. (If you can see the offending album, so much the better. Yet just listening to people talk about photographers is educational, and entertaining.)

If you're just starting your business, you'll find that people are amazingly willing to assist you in getting your business going. They will want to make sure you do it right, so they will happily tell you what other photographers are doing wrong. In this Age of the Entrepreneur, people will cheer you on as you work to build your business. Listen to what they say! They are giving you the customer's viewpoint—the only one which *really* counts.

• **Get price lists and literature.** It's important to see other photographer's *actual* paperwork. It's one thing to jot down notes from a phone conversation about prices and policies; it's another to see precisely how the photographer himself presents this information.

As you might guess, price lists are the central pieces of paper you'll hope to locate. It's important not just to see the dollar and cents amounts, but also to get an idea of how other photographers are presenting themselves and their work to their customers. Just as it is for you, the price list is where the artistic and business sides meet. You want to see how your competitors view *themselves*.

When you study a competitor's price list, you'll want to decipher his *strategy*. Is he making his money on low prices and volume, or on low volume and high prices? How do his lower packages correlate with his higher packages; where is the *value*?

If you've learned as much as you can about your competitors by talking with people and looking at pictures, when you go over the prices you'll begin to formulate an idea of how much people are willing to pay in your community for that level of quality and service. Just as you will be, each of your competitors is governed by the marketplace. The more you know about how the paying customer responds to various photographers, the easier will be your job of positioning your business within your market.

How do you get these price lists? In various ways. People you know who've worked with other photographers may still have their copies of the price lists. A couple booking with you may have picked up price lists from other photographers; since they won't be needing them, ask them to give these price lists to you for "educational purposes." It never hurts to ask. Also, during your calls to other photographers you might ask if they will send you a copy of their price list. Some will, some won't. (This is the reason you wrote down your friend's address earlier.)

Information Sets Real Parameters

The information you gather in these "various ways" is going to help you just as much as anything you'll read in this book. These calls and conversations will help you organize *competitive* packages, establish a beginning range of *competitive* prices if you need that, and start letting you know who you are competing against—and who you can ignore. You need a "feel for the market," and the time you invest investigating your competitors will be some of the best time you spend.

Now, when you hear the names of these photographers you'll have some idea of who they are. They'll become more than just names listed in the Yellow Pages.

You can bet, too, that as *your* business grows and *you* become a name they're hearing, you'll get calls from them—and help them plan *their* weddings. They will want to know *your* prices. Consider it part of the game. Consider it a compliment.

The fact is you don't need to reinvent wedding photography. Whether you find your best ideas in this book or on the price lists of other photographers

doesn't matter. As long as you end up using *good* ideas. Of course, you aren't going to run a competitor's price list through the copy machine with your name at the top. You'll find a good idea here, and another one over there. Even if your price list and strategies end up being taken straight from what five other photographers are doing, the way you assemble it, present it and sell it is going to be totally different than what any one of them is doing.

Don't forget, too, that none of your competitors invented wedding photography. They got their ideas just as you are: From seeing what other photographers were doing, and then picking what they thought would work best for them.

In other words, don't worry about making good use of good ideas—no matter where you find them. Ideas are in the public domain.

How To Sabotage Your Own Business

I must admit how I am continually intrigued at some of the stories I hear from couples who come to talk with me, then tell me why they are avoiding other photographers—reasons which usually have very little to do with the photography itself.

Invariably, these stories revolve around *service*. Or, more accurately, a lack of it. From my joke file, here are a few ways in which you too can alienate your potential customers and/or limit growth within your wedding market:

• **Don't follow through on promises.** If you say you're going to stay five hours, but then after four hours announce that you have to leave because of "another commitment," you're going to alienate *a lot* of people. You might make more money now by, for example, booking two weddings back to back—yet as word spreads through your community about your tactics, in the future there will be a lot of couples who will not even consider you for their photographer. They won't even dial your number. One major foul-up like this can take years to eliminate from peoples' minds.

• **Be "all business."** While weddings may be what *you* do every Saturday, for most couples this is a new experience. Couples want to believe that you are interested in their wedding, their feelings. People expect high pressure selling when they are buying, say, a car; it's not what they want to see leveled at them for something as deeply important as their wedding. Business is business, yet I think you'll find politeness and fair play are more potent sales tools in this environment than a "sign on the dotted line" attitude.

• **Or, be "no business."** There is a flip side to being "all business," and that's being "no business." Couples want to entrust their photography to a professional, someone who knows more than they do about what they want and need—and how to give it to them. If you come across as totally disorganized with no firm policies and lots of unanswered questions, peo-

ple will be nervous about working with you. After all, this is precisely the reason they are calling professionals, and not asking Uncle Harry to take their pictures.

• **Have a reputation for being rude and pushy.** This is so common it amazes me. I have heard so many stories about photographers who dominate weddings and rush couples around that it's no wonder many people expect photographers to be a "necessary evil." At the wedding they may say nothing to the photographer, and just wait for the guy to leave. If 500 people have witnessed the photographer in action, ruining a wedding, it's doubtful any amount of great photography is going to undo the damage. (And besides, most guests at a wedding will never see the pictures. They'll only remember watching the wedding of a friend or relative go down the tubes for the sake of "a few more pictures.")

• **Take months to deliver prints.** If you're so busy chasing new business that you ignore the people you've already photographed, then you're 1) too busy, and 2) taking one step forward and two steps back. Again, people will comment to everyone they know about how poor the service is. I've heard stories about couples waiting over a year for their albums. People want their pictures! Don't give people reasons to spend the next 10 months telling everyone they know "what a lousy job [insert your name here] is doing."

I could go on and on, but I think you get the picture. The fact is, you can easily do more damage to your own business than any competitor ever could. It's one thing to compete with other photographers and do battle in the name of free enterprise. It's quite another to aim at the competition, then proceed to shoot yourself in the foot because you didn't take care of the *customer*.

What does all of this have to do with pricing? Everything! You may be the world's greatest wedding photographer, yet if you go about providing those pictures in ways which alienate people and maybe even ruin the wedding itself, you have seriously undermined the *value* of anything you might put on film. People may love your photography, yet not many people will hire you...unless you're so cheap that you've brought your prices down to the same low level as your service.

I'm speaking here from experience: I've booked scores of weddings which would have otherwise gone to competitors—if they hadn't sabotaged their good photography with a reputation for treating people poorly. They've helped my business a lot over the years. Even when my prices have been noticeably higher, people have been willing to pay more just to avoid the possibility that "some jerk photographer" will mess up their wedding.

Your reputation is money in the bank! Do whatever you need to do to protect it. Ignoring service is like doing a masterful job of photographing a wedding...then seeing afterwards that your flash sync wasn't set on "X." *Everything* has to work.

10

Polish Your Image
With Strong Graphics

When the bride called for information, you were superb. Over the phone, your voice smoothly conveyed the impression that you cared about producing great pictures from her wedding. You sounded like someone she'd enjoy working with. She liked what she heard, so she made an appointment to meet with you to look at albums and talk specifically about prices.

When she arrived, you demonstrated your photographic prowess with sample albums and prints which could have only been created by an artist. She loved them! She loved you! She felt blessed to be living in the same community as the world's greatest wedding photographer.

Then, she uttered those magic words: "Can I see your price list?"

The moment of truth. Your photography's great, but...

Up to this point you've done everything right. Are you really going to go from exquisite pictures to a homemade price list which looks...*ugly?*

Only One Chance For A Good First Impression

Stop the clock for a second. Let's talk for a minute about the price list itself: The piece of paper you'll show the bride. Your "printed material."

The "look and feel" of your business is especially critical when you are first meeting with a couple. Everything they see should prove that you are indeed a professional. You don't have the assignment yet. You want that first impression to be a strong one.

Right now, get out your current wedding price list. Then, go to your collection of catalogs for cameras and equipment. Find a few price lists.

Put *your* price list next to *their* price list. How do they compare?

Does your price list itself help your business, or hurt it? Does it add to the confidence level, or detract? Does your price list look like the work of a perfectionist, or the class project from the high school computer literacy program?

If your price list looks like something you'd expect to see at a flea market, then it's time to rethink the way you present your prices and packages. Don't dilute the power of your photography with weak graphics. You should be using every option available to reinforce the idea that you and your business are absolutely focused on producing a quality product. A product which isn't necessarily going to be inexpensive, but it's going to be *good*.

Another point to consider: How are you going to look to someone who didn't accompany the couple to their visit with you, someone who hasn't met you and seen your pictures? The bride's father, for example. He's important. After all, as the bride will tell you, "Daddy's paying for it." Dad didn't see the pictures, so all he may have to go by is the price list the bride takes home. Naturally, Dad will be looking at the prices, but he's also going to be looking at the price list for some indication of what kind of business you run.

It's not going to hurt your chances of getting the wedding if Dad can look at your price list and see that you aren't some "weirdo" photographer who is going to show up at his daughter's wedding wearing torn jeans and T-shirts. He's heard *those* stories.

Graphics Is Easy...Let Someone Else Do It

The great thing about "printed matter" is that it's easy to make it look good. (Not necessarily great, simply *good*. Professional.)

How? By letting someone else do it, if you're not a graphic artist yourself.

Who says you have to do the layout yourself? Just as people will be hiring you to take their wedding pictures because they are not professional photographers, you should be looking for someone who can deliver professional graphics work for you. It's not like your photography, where you have to learn every-

thing about it yourself—a process which could take years. Your price list is not your product.

There are scores of sources for competent graphic arts help. The printer you work with will be able to do layout, typesetting and paste-up. Professional graphic artists will be listed in the Yellow Pages. Or, you might find someone in the art or printing department at a local junior college or high school who could do the work. Maybe you could make a trade: Your skills as a photographer for theirs as a graphic artist. Either way, it doesn't have to be terribly expensive, yet it's an expense which is definitely justified. Call it an investment.

The secret is "creative emulation." You can learn a lot about graphics simply by paying attention to how other industries present themselves to the buying public. Collect price lists and layouts which you find appealing and which can be adapted to your business. If you come across a price list which you like, take it to your printer and tell him to copy the basic layout—but insert your information.

You can also use as the basis for your price lists those from other photographers in *distant* communities. Emulate the structure, copy some of the wording—then add your prices and packages.

If you decide to do your own graphics work, it's not difficult to master. You can either do it the "old fashioned" way and order type and paste it up by hand, or you can go with the new computer technology of laser printers and page layout software. The new way is definitely preferable.

(For an example of the power of computer-aided graphics, just look closely at this book. It's totally the product of the Apple Macintosh computer, as is price list "#5/3" in the back of this book. If you don't know much about "desktop publishing," visit a local computer store and have them demonstrate "page-layout software" and "laser printers." Use those buzzwords, and they will know exactly what you are talking about. I guarantee you'll be amazed, even if you don't know how much easier these tools are than the "old way." If you aren't interested in buying the equipment yourself, they should be able to point you in the direction of someone who knows how to make this stuff sing—and who can help you look good on paper.)

Look "Expensive"

Your objective with any graphics undertaking, whether it's your price list or supporting material, is to look more expensive than you really are.

For example, if everything about your photography, your business, your price list tells the couple that you should cost at least $1,000+, then imagine how pleasantly surprised they will be to look at the prices and see that you're "only" $900.

Conversely, imagine how difficult it will be to convince them that you are worth even $700 if they think "something isn't right" because your crummy looking price list doesn't "match" your nice looking pictures.

Good looking price lists are not reserved solely for "expensive" photographers. There is absolutely no reason an inexpensive set of prices can't be printed on a nice price list. In fact, if you are just getting into weddings and/or haven't yet built your reputation, having a truly professional looking price list is going to be an easily attainable advantage you'll have over other, more established competitors.

Forms Follow Function

Just as important as how nice your price list looks is the fact that it works. A beautiful price list which nobody understands is useless.

When setting up your price list's *structure*, the emphasis should be on making all the information accessible to the customer. The way you organize packages, present albums, handle time—all of these should be clearly set down on the page.

The secret is simplicity. A couple should be able to pick up your price list and instantly understand what you are offering, and what the cost will be. Your price list is working against you if you notice people staring at the paper—then asking you to explain what they just read.

You want to make it easy for them to hire you, not difficult!

(For some examples of price lists which are difficult to decipher, you need look no further than this book's Appendix. Specifically, look at price lists #3 and #14.)

Good Graphics Are A Positive Addiction

Once you become attuned to typesetting and good graphics, and their powers of persuasion, you'll never go back to typewritten price lists or dot-matrix printouts. You'll become a graphics junkie.

Examples abound...

Each year I take part in a "Bridal Faire" organized by a major department store in our local mall. The main draw is the fashion show, but in an effort to increase attendance, other wedding-related merchants are invited to participate. There are tables set up for merchants offering various products and services: Bakeries, florists, cutlery, housewares, china, dresses, tuxedos, etc. I'm "the photographer." Once the fashion show is over, the couples swarm around the tables, some ask questions but most just look and pick up whatever literature is set out. They then take their bag of brochures and price lists home; if they have questions, they can call the merchants at another time for a more personalized showing.

What's interesting is to see how the printed material from the "locals" compares with the "nationals." At the tables staffed by representatives of "name brand" products, the literature is usually slick, four-color, lavishly produced. No

expense is spared to make sure the piece of paper the bride picks up will show the product at its best.

At the tables of local merchants, what literature there is is usually either hand-written and photocopied, typewritten and photocopied, or computer printed and photocopied. In both, the information is there on paper, but the difference in "look and feel" between the two groups is dramatic.

Where do I fit in? In the middle. Since I don't have the advertising budget of a Cuisinart or Noritake china, I operate on a more modest scale. But "modest" does not have to mean "cheap." I have printed material which is typeset and nicely printed, and I do have a four-color 4x9" postcard featuring my wedding photography. It's not a lot, but it's good. I try to follow the example of the national retailers who are not going to let a poorly produced price list undermine everything else they are doing right with their businesses. I want everything I present to the customer to say "professional."

That's not to say that a beautifully printed price list is going to make or break your business. It's not. In fact, there are a lot of photographers who are living proof that a business can thrive in spite of poor graphics.

My argument is that good-looking price lists and other printed material can compliment good photography and make everything about the business reek of professionalism. It's a matter of balance and paying attention to details. And it's details which make the difference.

11

If At First
You Don't Succeed...

We've covered a lot of territory in this book.

It would be great if I could tell you that all of the above is based on scientific investigation, is repeatable, and guaranteed.

I can't.

How did I come up with these specific strategies, packages, prices, etc.? Basically, I guessed—and I listened. I did just what *you* are doing now: Found out what other photographers had done and started forming opinions about what would work for me in my community. Then, I would try these ideas on couples when they called, and I listened for their reaction. If they liked what I was telling them and I photographed the wedding, I noted that. If they didn't like what I was telling them and I never heard from them again, I noted that, too. In my first year or two of business I was literally changing packages and prices with almost every phone call I received. Gradually, I zeroed in on a set of packages which sounded good over the phone, were easy to book from, and which generated a good profit.

In other words, I gained hands-on *experience*.

Did I make a lot of mistakes? Sure. Did I lose scores of weddings I would have loved to have? Absolutely! And, now, am I still losing weddings and making mistakes? Yep—I am right along with every other photographer in the world. But, I'm making far fewer mistakes than I used to.

The point I want to make sure I get across is that you're never going to find the "perfect pricing strategy." What you should find, and what I hope this book will help you find *quicker*, is a group of packages which get your business moving in a highly profitable direction without too many missteps.

Three Steps To Success

The best way to plan for success is to admit that you'll make mistakes.

As a sort of preview of what you're in for as you work to implement new ideas and test new strategies, here are the three stages you'll likely experience:

• **Step One:** If you are working on a totally new idea, you should plan for success as well as you can—then just do it! Don't agonize. Don't worry at this stage about achieving *total* success. Above all, don't wait until conditions are "just right." They never will be. Just jump in with both feet and do your best.

The results will likely be lackluster. Partly right, but mostly wrong.

Take your lumps and keep your eyes open! Take notes. You'll start to see opportunities and recognize what you could have done better. You're not failing—what you're doing is research in preparation for Step Two.

• **Step Two:** When the dust clears, move quickly to correct the most blatant mistakes. Plug the leaks. At the same time, use the lessons you've learned from surviving Step One to test drive new and better ideas.

The difference between Steps One and Two is *experience*.

Now, instead of simply *wild* guesses, your guesses will be educated. The further you get into Step Two territory, the more you'll be able to anticipate problems and recognize opportunities—in both cases, *before* they are upon you.

(Within the context of wedding pricing and strategies, it's in Step Two that you'll begin to feel comfortable with the idea of wedding pricing and strategies. You'll have fewer sleepless nights, fewer knots in your stomach. The pieces are starting to fall into place, *and you're understanding why*. The mystery of wedding pricing will be gone, and you'll have enough hands-on experience that you'll be able to see what needs to be done—and know how to do it. You may not be in absolute control yet, but you're getting closer. Step Two is where the practice begins to pay off in better scores. You'll start to hit your stride.)

• **Step Three:** This is the payoff. By the time you get to Step Three, you're essentially the master of your own fate. You've paid your dues, learned the lessons and now can comfortably navigate through your local photographic market. You can "read" your customers.

The best way I can describe a Step Three environment is to say that your business is now between you and your customers. You know how to deliver what they want, and they know you are the photographer to call. You own your corner of the market.

Of course, this is a never-ending process. You may go through all three steps within the Mid–Level market, then start again when you set your sights on the High End weddings, customers, and pricing structure. That's what makes this business such a challenge and adventure.

In many ways, these three steps have been the basis for this entire book. I very much recommend that you give yourself at least three chances to get your pricing under control. Most important, don't hesitate for too long, waiting until you know everything. Once you get the hang of it—and I hope this book makes the process easier—you'll find that Building a Profitable Pricing Strategy is primarily a matter of setting your standards high, finding out what your customers want, delivering on your promises—then using prices which make the entire effort worthwhile.

Appendix:

Evolution Of A Pricing Strategy

Throughout this book my objective has been to offer ideas that you can use to structure a strong pricing strategy for your wedding business. I've made a lot of assumptions about your business—and have made quite a few suggestions.

In this Appendix I want to shift gears.

To give you an idea of how my own strategies have evolved in wedding pricing, in this section I'm including several of the "watershed" price lists I've used over the years. I dug through every box I could find, and out of over 50 various old price lists, those printed here show most clearly the major epochal shifts in my approach to pricing my own wedding photography.

These price lists represent the experience I've amassed over 18+ years and 640 weddings. I hope that, combined with the information in the book, the following will further clarify your own thinking—and help you avoid most of the mistakes I made because I didn't know any better.

Basic Level Price Lists (pre–1979)

The first four years of my business were very much a period of learning, experimenting and trying to figure out what wedding photography was all about. In 1973 I could have told you about the Zone System, Ansel Adams or anything you wanted to know about black and white photography. *Color* film? I'd never used it. Flash? Same thing; I was from the "available light" school of photography and had always prided myself on being able to get the picture without resorting to flash—even if it meant pushing Tri–X to 3200 ASA. Labs? I'd always done my own black and white printing. Not only had I never used a commercial lab, but I barely knew the industry existed. I had only a vague idea of what "proofs" were, how to specify cropping, or how to take pictures which could be printed "straight" without all the burning and dodging I was used to doing. What I learned real fast was that Ansel Adams had never been a wedding photographer.

I photographed my first *professional* wedding (i.e., for someone who wasn't a friend or relative) in March, 1974. The total order was $136. I was ecstatic. I liked the extra money, liked the challenge and was soon busy most week–ends at weddings. I kept my full-time job until September, 1975 when I quit to go full-time in photography.

What made the decision to become a full-time pro easier was 1) my wife, Mabel, was a full–time elementary school teacher, 2) we didn't yet have any children, and 3) *before* I quit my job I made sure I had the equipment I needed. Combined with the fact that I was working from my home, this meant I was under very little pressure to produce zillions of dollars in income. I was doing weddings "for the fun of it" and had no clear idea that I was in the beginning stages of building a "real" business.

My thinking on pricing at the time was to compare my income from photography with what I had been making from my "real job" as a warehouse fork-lift driver. If I was making more than $6 per hour selling pictures, I was doing OK. I had very little idea of what studios and other more established pros were charging—and since my pictures were rather basic, I didn't yet put myself in the same league as the "real" pros.

The picture I want to paint about my business' origins is that when people started asking me to take color pictures for them, I had a lot to learn—*quickly*. Pricing and profits were not yet top priorities. I was more concerned with getting decent pictures, and not embarrassing myself. To give you an idea of my priorities at the time, for my vacation during the summer of 1975 I used the money I saved from weddings and my other "professional" photography to attend an Ansel Adams Workshop in Yosemite for a week. That was *real* photography; weddings, etc. were fun and games.

As hard as I tried, I wasn't able to find copies of any of the price lists I used prior to about 1977. Part of the reason: It took me awhile to see the wisdom of using a *printed* price list. For the first year or two, my approach to pricing was to

verbally explain my prices, take notes, and then hope that after the wedding people would remember our conversation the same way I did. (Please don't ask me to explain this downright *stupid* system. I still can't believe it took me as long as it did to finally get around to typing up a "real" price list. The only thing I can figure is that I was so thrilled that people were willing to pay me at all, I didn't want to "ruin it" by coming across like a gung-ho businessman. I guess I was still close enough to my hippie youth that I had trouble adapting to the image of myself as a businessperson asking people to "sign on the dotted line.")

I do, however, remember an early ad for my wedding photography which I ran in the local paper: One column wide, one inch high. In it, I let the community know I was available to take wedding pictures, and would charge "$69.50 for 36 pictures." Those 36 prints were 5x5 proofs, and no album was included. I remember this ad because it ran on a Sunday, and I stayed home all day waiting for the phone to ring. It never did.

steve herzog

BASIC WEDDING COVERAGES

6 - 8x10's & 24 - 5x5's (limit of 3 hours) $200.00

12 - 8x10's & 32 - 5x5's (limit of 5 hours) 255.00

16 - 8x10's & 48 - 5x5's (no specific time limit) 315.00

All of the above coverages include a white "TAP" wedding album. If
Art Leather albums are desired, add $25 to coverage selected; these
albums are available in a wide selection of cover colors.

CUSTOM WEDDING PACKAGES

12 - 8x10's & 32 - 5x5's
1 - 11x14" wall print
2 - 24 print parent albums - $425.00 (savings of $52.50)
Art Leather Brides' album

16 - 8x10's & 48 - 5x5's
1 - 16x20" wall print
2 - 36 print parent albums - $485.00 (savings of $73.00)
Art Leather Brides' album

OPEN PLAN - Build your own package by buying only what you want. Prices
 based on "Additional Candid Print Prices" listed below. There
 is no specific time limit - only a minimum order of $375.

Parent Albums (in "TAP" album books): 24 - 5x5's - $85.00
 36 - 5x5's - 125.00
 48 - 5x5's - 155.00

Additional Candid Print Prices: 5x5" - $4.50
 5x7" - 6.50 in folder
 8x10" - 8.50 in folder
 11x14" - 27.50 in folder
 16x20" - 48.00
 20x24" - 90.00

Deposits - A deposit of $50 is required to confirm and hold wedding date.
 When the previews are delivered approximately 1 - 1½ weeks after
 wedding the remainder of the bride's wedding package price is
 asked for. When the previews are being returned to place the
 final order, one-half of the total remaining balance shall be
 paid; all other charges, including tax, will be paid when the
 finished prints and albums are delivered.

 PLEASE NOTE: there can be no partial deliveries of print orders.

Price List #1 (Original size: 8½x11")

Price List #1 (circa 1977)

Working Conditions

This price list is from around 1977—after I'd been in photographing weddings for about three years, and had been a full–time professional for a year or two.

I was working from my home, which at the time was a simple duplex apartment.

This is a very "straight" price list; no attempt was made at all to describe anything or answer any questions. I just listed what I was selling, like hamburger in the grocery store. Since I didn't know how to emphasize quality, the only thing I could think to do was emphasize savings. I was selling by *price*. This is a "Basic Level" price list.

Pricing

The prices...well, about all I can say is that at these rates I had no trouble undercutting the prices of other local photographers.

My early prices were low not so much because the pictures weren't worth much, but because I was still not aware of how much people were willing to pay for even "average" photography. I was looking at the pictures as a *photographer*, not as a couple would. In other words, my prices were more a result of *my* trouble understanding the value of wedding photography than it was from the customers' hesitancy to pay more for good pictures from one of the most important days in their lives. It took me many long years to finally get my prices up where they should have been all along. I'm sure this blind spot on my part cost me tens of thousands of dollars in profits.

In many ways, I fell into the classic trap of setting prices based upon my costs. If a print cost $3 from the lab, I felt I was pushing the bounds of decency to add more than a few dollars profit. I was also afraid that people would call my bluff and I'd lose customers because my prices were so much higher than what they were paying for pictures the same size from the drugstore. I still see this tendency in the pricing of new professionals today. Most of us go through that stage, especially those of us who originally got into photography because we enjoyed making great images.

Bridal Packages

The structure of my first bridal packages was a direct copy of what I saw on other photographer's price lists. If these ideas worked for them, they were a good place for me to start, too. Only I would do it *cheaper!*

• **"Basic Wedding Coverages."** The 8x10s I delivered were the cheapest on my lab's price list. The 5x5s were proofs. The number of hours included in the first two packages was "typical."

The last package, however, has "no specific time limit." This idea was short lived, but it accomplished it's goal: I regularly booked this largest package. The couples were happy because they knew I'd be at the wedding for as long as they were there. I was happy because I knew I needed all the time I could get to make sure I got a selection of good pictures. Once I became more adept at getting my pictures quickly, I dropped this "no time limit" policy because I no longer needed to be at the wedding for 10+ hours.

• **"Custom Wedding Packages."** For a brief period, I (foolishly) tried increasing sales even more by cutting my profits. It didn't work well. I was giving away my main products—always a dead-end process. I was discounting the Bridal Album, the Parent Albums, and the Wall Prints. After those, what else is there except a few loose prints for grandparents? People liked these packages, but they did absolutely nothing for me and my profits. I dropped the idea of grouping Bridal Albums with Parent Albums—and selling the super package at a discount.

• **"Open Plan."** I'm not sure when, but I know I got the idea for the Open Plan from another photographer. Since I wasn't yet sure what people were looking for, or *why* they were booking a specific package, I included the Open Plan as a way for people to still choose me as their photographer even if they didn't like my packages. The Open Plan proved to be a great learning tool since it provided a way for me to watch people as they created their own packages.

Albums

When prices are low, the cost of an album can be a major expense. That's the reason I offered a simple, no frills album as an automatic part of the package—then gave people the option of upgrading to the more expensive Art Leather line.

Once I realized that people expected an album to be included with pictures from a professional, I located a supplier and began stocking TAP albums. The album style I used was in keeping with my pricing structure: No frills. If the couple wanted to upgrade to an Art Leather album, they paid $25 additional.

Parent Albums

Here, too, I was free in my imitation of how other photographers structured their Parent Albums.

Although listed, I sold very few 5x7 albums to parents, or anyone else. As a Basic Level photographer, I was dealing with people determined to save money. 5x5 albums were more than adequate.

Additional Candid Prints

Nothing unusual here. Like most wedding photographers, I started out selling my proofs as loose, individual prints. Notice, however, how the low $4.50 price for 5x5s undermined all the other prices. If you were a customer looking for a way to spend as little money as possible on pictures, which print size do you think you'd buy? I sold almost no 5x7s and very few 8x10s. (Please refer to the book's main text for arguments against selling proofs individually.)

Wall Prints

I can tell by the prices I charged that at this point in my business, I was selling at low prices just to sell something. After all, if a couple had spent $315 for 16–8x10s and 48–5x5s, plus an album, there was no way they were going to spend more than $50 for a single "Wall Print." This is an example of how low prices limit options.

Also amusing is the fact that I delivered 11x14s in folders. I was treating an 11x14 like a giant 8x10. I remember those folders; they were huge. I imagine that if I'd been able to find 16x20 folders, I would have used those, too.

Deposits

From the wording of this section, I could see that I had already grown tired of being burned by people who took *months* to return their Previews and/or pay me for services rendered.

I required a $50 deposit when the wedding date was first booked. The balance of the bridal package was paid upon delivery of the proofs. So far, so good.

This requirement was a result of an earlier policy which didn't work. Previously, I had people pay a booking deposit, then a second deposit when the previews were delivered, and a final deposit on the Bridal Album when the previews were returned with the order. This was a disaster.

The reason this seemingly fair approach didn't work is that once the couple had copies of their pictures to pass around to friends, they were suddenly in no hurry to place their order for the finished album—*especially if it would cost them money to do so*. I got a lot of excuses about why people couldn't return their orders, excuses which miraculously disappeared once I instituted a policy of requiring that the couple pay the full balance for their album *before* they could pick up their proofs.

Collecting payment for additional prints was more of a problem. In this price list I was still having extra prints partially paid for when the orders were *placed*. If all went according to plan, when the bride brought back the Previews she would be carrying a pile of money amounting to one-half of the total billing. This caused many headaches since it was difficult for the couple to monitor all the people ordering prints as the proofs floated around the family. It also took a lot of time for me to double check the amounts. Couples resented the fact that they were becoming my "bill collectors." It took me several more price lists to figure out a way to collect payment for additional prints. Stay tuned.

No partial deliveries. This is very important! At one time, before I toughened up my policy on this issue, I had a shelf full of orphaned orders from where the Bridal Albums had been delivered, but some of the extra orders left with balances due. These represented money out of my pocket!

You must make sure the bride and groom understand that, from your viewpoint, all the prints ordered are a *single* order. Even if you break the order down into individual orders, this doesn't mean you will bill people individually for their orders or give the bride and groom their pictures while holding onto other people's prints. NO! Make it clear that no pictures will be delivered at all until the entire balance has been paid for all pictures. If you don't, couples will pick up their albums and leave you holding all the extra prints. You will have a hard time delivering these prints, especially if all you have to go on is the name "Aunt Mary." Knowing the name and address of *every* person placing an order should not be your concern. By making the bride and groom responsible for all the orders they bring to you, they will have an interest in making sure the orders are accurate and that the people are good for the money before you send the orders to the lab for printing.

BASIC WEDDING COVERAGES

 A. 6 – 8x10s & 24 – 5x5s (2 hour time limit) $ 215.

 B. 12 – 8x10s & 32 – 5x5s (3½ hour time limit) 275.

 C. 16 – 8x10s, 48 – 5x5s & 1 – 11x14 (5 hour time limit) 355.

 D. 20 – 8x10s, 64 – 5x5s & 1 – 16x20 (8 hour time limit) 465.

 * The above plans are complete, including a standard (white) Taprell–Loomis album. See supplemental price list for deluxe albums.

 * Availability of additional time beyond that included with the basic plan is not guaranteed. However, if available, additional time charged at rate of $17.50 per hour.

OPEN PLAN: This plan allows you to build your own custom album by purchasing only those sizes and combinations of prints you prefer. The minimum order for the Bride's Album is $490, with print prices based on the "Additional Candid Print Prices" listing below. Albums for the Open Plan are priced separately.

PARENT ALBUMS: These albums are delivered complete with finished prints and Taprell–Loomis album books. Deluxe albums are listed on the supplemental price list.

 5x7" albums: 18 prints – $ 125. 5x5" albums: 18 prints – $ 95.
 24 prints – 150. 24 prints – 110.
 32 prints – 175. 32 prints – 135.
 44 prints – 210. 44 prints – 165.

ADDITIONAL CANDID PRINT PRICES:

 Finished prints in folders: 5x7" – $ 7.75 11x14" – $ 24.50
 8x10" – 9.75

 Wall prints, mounted: 16x20" – $54.50 24x30" – $165.00
 20x24" – 95.00 30x40" – 225.00

 Additional previews, 5x5": $5.50

ADDITIONAL INFORMATION:

 deposits – To hold and confirm a specific wedding date, a deposit of $50 is required. No dates are reserved or promised without this deposit; no exceptions, please. This deposit is refundable only if the date reserved is later booked by another party; otherwise, the deposit is non–refundable.

 payments – When the previews are delivered (approximately 1–2 weeks after wedding) the remaining balance of the bride's basic package is requested. All additional orders must be paid for, including sales tax, when the preview book is returned.

 delivery – Orders will be delivered only to the bride and groom. There will be no separate deliveries or individual billings.

 tax – The California 6% sales tax applies to all purchases.

 reorders – For reasons of consistency in print quality, and to help reduce the chance of negative damage due to increased handling, it is best if all orders are placed at the time the bride and groom order their prints. However, negatives are kept on file for at least one year and will be available for reorders. Prices for these prints will be the then current price, plus 25% for special printing and handling. Reorders must be paid for in advance.

 (effective date: 2/79)

Price List #2 (Original size: 8½x11")

Price List #2: (February, 1979)

Working Conditions

By February, 1979 I had been a full-time photographer for three and one–half years. I was still working from my home. The biggest changes over the situation from Price List #1 was that I was now becoming a busy and experienced wedding photographer. In 1979, I photographed over 50 weddings.

Volume meant I was forced into becoming more organized in every part of my business. In the early days, I had been willing to discuss prices and policies with couples, listen to what they had to say, and bent over backwards to be "fair." As often as not, I ended up getting shafted. I was learning the "hard way" the value of having firm and specific policies; these were beginning to show up on this price list.

Another major change for me was that by 1979 I was beginning to get serious about the potential of professional photography. People were telling me I was good—and I was starting to agree. Mentally, I began to shift gears and target local *studios* as my competition. I set out to compete with them head to head: Doing a comparable job with the photography, and charging "studio level" prices.

Bridal Album Pricing

My early pricing was not terribly aggressive. As a Basic Level photographer, I should have been pushing prices up faster to keep pace with my growing experience and expertise. However, I was still hungry for volume and I didn't want to lose any weddings over price.

Part of the reason for this hesitancy was that my business was 80–90% weddings. This meant that I did little photography during the week, and needed to be busy on the week-ends. I remember thinking that a week without a wedding was a wasted week.

By 1979, increased overhead was also becoming a factor. I'd taken out a large ad in the Yellow Pages, I had a nice letterhead designed and printed. I was putting up displays of expensive Wall Prints in stores. Did any of those new expenses cause me raise prices drastically? Nope. I absorbed those costs myself and tried to make up the difference in *volume*. What else!

Bridal Album Packages

Instead of taking chances with prices, most of my efforts to boost income came from shifts in the *packages* I offered.

With this price list I added several "enhancements:"

• I added a two–hour package, priced roughly the same as the three–hour package on Price List #1. The two–hour package was my "phone package."

I was also toying with the idea of doing several weddings per day. I figured that I could make more money doing two, two-hour weddings (with two Bridal Albums, four potential Parent Albums, etc.) than I could with a single five hour wedding. I once did three weddings in one day.

• I added Wall Prints to the two largest packages. These worked very well and helped people make the correct decision that they really did *need* the more extensive coverage.

• I dropped the "Custom Packages." As I mentioned in the discussion on Price List #1, this was a losing proposition for me. If something doesn't work, *get rid of it!*

• The price of the Open Plan was raised substantially. This was becoming my "experimental" package—and on this price list I was testing the reaction to an *almost*–$500 offering. I was getting gutsy.

Time

The issue of time was now becoming an important factor in how my packages were structured. Time was now starting to be used as a *control*, not simply as a give-away booking tool.

Compare the way time is handled on this price list with what was done on Price List #1. Packages and prices have changed somewhat, but the number of hours has shifted downward precipitously. My photography was becoming more efficient; no longer did I need to spend as long at a wedding to get a decent set of pictures. Gone, too, is the "no specific time limit" on the standard coverages.

A major enhancement to this price list is the acknowledgment that I needed a way to charge for "additional time." Previously, I had no formal way of handling an extra hour or two. While that hadn't been a problem when I needed that time to take good pictures, it was becoming a problem by 1979. By adding a charge for extra time, *in writing,* I had a way of collecting payment for those instances where the bride asked "can you stay a while longer?"

The wording for the Open Plan is becoming more descriptive. Instead of saying "Pay this—Get that," I'm trying to make the Open Plan sound more exclusive and desirable.

Parent Albums

While I was hesitant to drastically raise prices with the Bridal Albums, doing so with the Parent Albums came much easier.

I moved on two fronts with this price list:

• I raised prices and lowered the number of prints included. I was beginning to understand the concept of using the Bridal Album as a low–priced "loss leader," then maximizing profits through the sale of additional prints and albums.

• 5x7 Parent Albums were added. I was learning to give people a choice. As hoped, quite a few parents opted for the nicer albums, which generated profits which never would have happened if I had stayed only with the 5x5 option.

Additional Prints

On a percentage basis, the prices for 5x7s and 8x10s were moving ahead smartly. But compare the prices of the larger sizes with those on Price List #1: I *lowered* the price of 11x14s, and only slightly raised the prices of sizes 16x20 and larger. I was still having trouble selling these prints as additional orders. I knew people wanted them, but I couldn't get people to buy them. All I could think to do was lower the price and see what happened.

Larger Wall Prints were added to the price list. I never did sell a 30x40, but I hoped that by adding these sizes the 16x20s and 20x24s would suddenly seem more reasonable.

In an effort to differentiate between "finished" prints and "Previews," I pulled the 5x5s out of the listing for prints 5x7 and larger. When I explained the differences to people, I began stressing that Previews were "rough" prints and not of the same quality as the 5x7s. I was getting tired of people wanting to pay as little as possible for my work; however, I still was not brave enough to drop 5x5s entirely.

Deposits

By 1979, I was getting serious about deposits and policies.

The booking deposit was made a firm precondition to "officially" hiring me as the photographer. No more verbal promises. (What had been happening under Price List #1 was that couples would *tell* me they wanted me as their photographer, and *promise* to send the deposit. Being a nice guy, I took them at their word and put their names down in my schedule. Other couples would call about the same date, and I would tell them I was "already booked." Then, when I called the first couple back to confirm details and ask for the deposit, they would inform me that they had *really* booked with another photographer. Lesson learned: Money talks, and the best way to know if a couple really wants you is to have them write a check.)

The deposit was also made non–refundable for much the same reason. I didn't want couples using their deposit with me to "hold" the date while they continued to look around—then come back to me later asking for their money

back. Again, before they asked me to put their name down in my schedule, I wanted them to be *positive* I would be taking the pictures.

Another change in this price list over #1 is that I now asked that all additional orders be paid for, *in full*, when the final order was placed. I was still having trouble collecting money for additional prints. On Price List #1 I had been asking for half. The net result was much the same: The bride felt I was asking her to do my work, and it was a hassle for both of us to make sure all the amounts were correct. It still wasn't right, but it was better.

Mid–Level Price Lists (1979–1983)

The four years between early 1979 and mid-1983 were exciting ones for my business. At the beginning of this phase I was just starting to recognize that I was indeed a major player in our local photography market. I saw that people were coming to me because my pictures were "good"—*and that I could raise prices and still get the business.* As a veteran by then of several hundred weddings, I also had enough experience to get a *feel* for what people wanted. In short, I was becoming a part of the mainstream.

The pieces were starting to fall into place.

While prior to 1979 my business pace had been leisurely, things began to speed up from that year on.

In 1977, our first child, Elizabeth, was born. For the first year or two I was in charge of child care while Mabel taught school. This arrangement worked out quite well, for during the week my schedule was essentially empty. On weekends, Mabel took over child care—and I took off to take pictures.

Things changed again in 1980, when Johnny was born. Now, we had two young children. The decision was made that it would be best if Mabel took a leave from teaching. By then, my photography was generating enough money that I could become the sole breadwinner. I was still doing weddings primarily; by 1980 my volume was reaching 60 to 70 per year. I was also getting into other types of photography, such as outdoor portraiture, school pictures and other miscellaneous non–studio work. The fact that my overhead was low meant that I was making a pretty good living.

In 1980, I decided that working from my home had become too much of a hassle. While this business format had been perfect during my "early years," as I became busier the home–based approach became restrictive. The house was often littered with toys. I was growing tired of evening appointments and always being in the midst of my work. I wanted a *real* "place of business." The fact that I was starting to charge realistic prices meant that I could *afford* to transplant my business from my home.

I started combing the classified ads for commercial office space.

When the time came to make my move, I rented a 500 sq. foot office for $250 per month. I called it my "Gallery:" A space where I could hang wedding pictures on the wall, meet with couples "by appointment only," and have "official" office hours. This was *not* a studio; I didn't even keep a camera at the office. I wasn't ready for a studio—technically, or mentally. Steve Herzog Photography was still functioning as a "home–based business," only now the business was transferred out of my home and relocated three miles away.

BASIC COVERAGES & BRIDE'S ALBUMS

 A. 6 – 8x10s & 24 – 5x5s (2 hour time limit) $ 240.

 B. 12 – 8x10s & 32 – 5x5s (3½ hour time limit)........... 295.

 C. 16 – 8x10s, 48 – 5x5s & 1 – 11x14 (5 hour time limit)... 380.

 D. 20 – 8x10s, 64 – 5x5s & 1 – 16x20 (8 hour time limit)... 465.

 ✻ The above plans are complete, including the white Taprell-Loomis album. Please refer to the supplemental price list for additional information on the deluxe General Products and Art Leather albums.

 ✻ Availability of additional time beyond that included with the basic plan selected is not guaranteed. However, if available, additional time is charged at the rate of $20 per hour.

OPEN PLAN: This plan is our most extensive and beautiful package, allowing you to design your own custom album by selecting only those print sizes and combinations you prefer. The Open Plan is recommended for those weddings where total coverage and highest quality are the main priorities. There is no time limit with the Open Plan; the only requirement is that the minimum order for the Bride's Album be $560. Print prices are based on the "Additional Print Prices" listing below. Albums for this plan are priced separately, with the Leather Craftsman albums suggested.

ADDITIONAL PRINT PRICES

 Smaller prints delivered in folders: 5x7" – $8. 8x10" – $10.50

 Wall Prints (mounted, textured & laquered):

 11x14" – $42.50 20x24" – $120. 30x40" – $275.
 16x20" – 74.50 24x30" – 190. 40x60" – 400.

PARENT ALBUMS: These albums are delivered complete with finished prints and Taprell-Loomis album books. Deluxe albums are listed on the supplemental price list. Available only at time Bride's Album order is placed.

 5x7" albums: 16 prints – $125. 8x10" albums: 12 prints – $125.
 20 prints – 150. 16 prints – 150.
 26 prints – 185. 20 prints – 185.
 32 prints – 210. 26 prints – 210.

PHOTOGRAPHIC GIFTS FOR THE WEDDING PARTY: If you would like to present the ushers and bridesmaids with prints from your wedding, we offer the 5x7" and 8x10" sizes at discounts of 15% in quantities of 8 or more from the same negative. These are finished prints, delivered in folders

OUTDOOR BRIDAL PORTRAIT SITTING: For those brides who have chosen us as their wedding photographers we offer a special 15% discount from our regular *portrait* prices. One of the best locations in Stanislaus County is La Loma (Keewin) Park. We extend this offer for up to one year following the wedding so as to allow taking advantage of prime weather conditions. Ask for details.

ADDITIONAL INFORMATION:

 deposits – To hold and confirm a specific wedding date, a deposit of $50 is required. No dates are reserved or promised without this deposit; no exceptions, please. This deposit is refundable only if the date reserved is later booked by another party; otherwise, the deposit is non-refundable.

 payments – When the previews are delivered (*approximately* 1 – 2 weeks following wedding) the remaining balance of the bride's basic package is requested. All additional orders must be paid for, including sales tax, when the preview book is returned.

 delivery – Orders will be delivered only to the bride and groom. There can be separate deliveries or individual billings.

 tax – The 6% California sales tax applies to all purchases.

 reorders – For reasons of consistency in print quality, and to help reduce the chance of damaged negatives due to increased handling, it is best if all orders are placed at the time the bride and groom select their photographs. However, negatives are kept on file for a minimum of one year and will be available for reorders. Prices for these prints will be the then current price, plus 20% for special printing and handling. Color match with the originals is not guaranteed, and all reorders must be paid for in advance.

 (effective date: 4/79)

Price List #3 (Original size: 8½x14")

Price List #3: (April, 1979)

Working Conditions

Price List #3 is the last of my "home–based" price lists. This is the version in effect at the time I made the decision to move my business out of the home and into the Gallery. I hadn't moved yet, but this impending change forced me into reevaluating my laid back approach to pricing. Although my photography had become quite good by this point, with the soon-to-be Gallery my prices were now forced to catch up—and I was forced into a Mid–Level mode. I was preparing myself for overhead.

I was also beginning to feel at home in the photographic industry. Instead of being a lone professional surviving month to month, I started to see how the "local market" functioned: Weddings, portraits, schools, etc. I'd been through several yearly cycles and could see the pattern developing. I saw that I was *building a business*, not merely doing odd assignments.

Price List #3 is where I can first see any meaningful shift from "Basic" level thinking to "Mid–Level." While I may have been *wanting* to raise prices and make changes, it's in this price list that I finally take action.

Bridal Packages and Prices

No major changes in the Bridal Albums over Price List #2, and only a minimal increase in prices. The price of Package D remained the same. (This price list came into effect only a few months after Price List #2.)

The Open Plan, however, was still getting more play; notice how the paragraph keeps growing in size and the wording becomes more descriptive. The "minimum order" price, too, keeps climbing. (Because the prices are tied to the Additional Print Prices, the costs of building a decent album with the Open Plan were climbing even faster than the minimum order would indicate.)

Additional Prints

Finally! 5x5s have been purged from the price list, making 5x7s the smallest size available. I was scared to death of this move—but, as I said, I was tired of working hard to take a picture, then have people buy a copy for only $5.50. Now, if they wanted a print, the cost would be at least $8. Since there was no way I could have charged $8 for a 5x5, I simply dropped that size entirely. (A side effect of this move was that I saw a sudden surge in orders for 8x10s. I wasn't expecting this, yet what people did was look at the prices and see that for only $2.50 more they could get a print twice as large. In other words, 5x5s had been killing the sales of all print sizes—not just 5x7s.)

On this price list I also retreated from trying to sell Wall Prints via lowball prices. The price for an 11x14 jumped from $24.50 to $42.50. I also quit classifying 11x14s as small prints "in folders" and added them to the group of Wall Prints. I must admit, however, that as long as 11x14s and 16x20s were included in Bridal Packages, I didn't sell many of these as "additional prints."

With this price list I also began exploring ways to further increase income through the sale of extra services: Gifts for the wedding party, an outdoor sitting. Every little bit helps.

Parent Albums

Gone, too, on this price list are the 5x5 Parent Albums. The dollar figure for the minimum sized album was kept the same, while the number of prints included dropped by two.

Since I now had an empty spot on the price list, I added 8x10 Parent Albums. I actually sold a few. More importantly, the effect of the 8x10 albums was to make the 5x7s look more "reasonable." The transition was a success, with only a few dissenting votes.

(To defend why I had dropped 5x5s to those parents who dared ask, I rationally explained that "5x5s and 5x7s cost about the same from our lab. We've decided that 5x7s are a better value, and so are eliminating the smaller size. You can have 5x5s made if you wish, *but the price will be the same* as for the 5x7 albums." After looking at our sample 5x7 albums and comparing them with the 5x5 Previews, only a few parents opted for 5x5 albums—and then only because that was the size they had from other children's weddings.)

Note in the description the sentence "Available only at time the Bride's Album order is placed." This was added in response to some parents' plans to pay for the Bridal Album, not place an order for their album, wait a year or two, then call me back and expect to be able to order a Parent Album at the same price quoted on their original price list. No way. Not only did this mean having to organize a lab order twice from a single wedding, but it also meant that many parents would never get around to ever ordering an album. After six months, any wedding is history. On the price list, I wanted to make it explicitly clear that the listed prices for Parent Albums applied only if those prints were ordered at the same time as those going in the Bridal Album. (The wording on this price list is a little vague; it's tightened up on the next price list.)

Deposits

While the deposit amount is still holding at $50, there has been a slight shift in how deposits were handled. The "nice guy" in me was reasserting himself.

I was getting some flack for my non-refundable policy. Couples were telling me that if they called off their wedding six months before the date, they thought they should get their deposit back. I tended to agree.

My solution to this dilemma was to tie a deposit refund to whether another couple later booked the *same* wedding date. This new policy twist stated that if another couple did call and book the date, I would refund the first couple's deposit. If the date did not later book, and I ended up with no wedding, the deposit would not be refunded.

This seemed fair—to me. As long as I was at a wedding on the date in question, I wasn't concerned with keeping deposits. This policy worked fine for awhile...until I had an upset bride on the phone canceling her date—and demanding her deposit back. I remember this conversation well. When I explained my "maybe–yes, maybe–no" refund policy, she screamed at me "How do I know you'll tell me if you book another wedding? How do I know you won't book the second wedding, not tell me, and still keep my deposit?" With that conversation I decided that it was no use trying to be "reasonable." No more Mr. Nice Guy. I went back to a stated policy of deposits being non-refundable. That way, I could refund the deposit if I wanted to, but wasn't setting myself up for a fight. I was learning to control my policies.

Delivery

If you'll read the second sentence, you'll notice that I say there can be separate deliveries and individual billings. This is not a change in policy; this is a typographical error. I managed to omit the word "no." A customer pointed this out to me as she challenged my insistence that all orders must be picked up and paid for at once. She won. Moral: Carefully proofread *everything* on your price list. Mistakes can be expensive.

Price List Format

In the process of all my experimentation with packages and additional options, I failed to notice that my price list had become a monster; note that it was printed on 8½x14" paper. This price list is also very confusing to read and contains too much information. Part of the reason I had trouble explaining some of the options is simply that there were too many of them. Too many choices lead to indecision.

(#14)

Wedding Photography by **Steve Herzog**

<u>WEDDING SERVICES & PRICE LIST</u>

<u>DELUXE COVERAGES</u>

Our finest photography, delivered complete as 8x10" prints in the outstanding Art Leather Albums. These coverages have been designed especially for those couples who appreciate quality and want the most splendid wedding album possible.

A. 32–8x10" prints in album (2½ hours included) $490.

B. 40–8x10" prints in album (3½ hours included) 575.

C. 48–8x10" prints in album (5 hours included) 650.

D. 60–8x10" prints in album (6 hours included)
 plus outdoor engagement or bridal sitting 720.

E. 72–8x10" prints in album (7 hours included)
 plus outdoor engagement or bridal sitting 865.

<u>COMBINATION ALBUMS</u>

Offering both high quality and a large selection of prints, all at a modest cost. These coverages are delivered complete in albums made by General Products.

F. 6–8x10s & 12–5x5s (Fridays only – 1½ hours included) $280.

G. 10–8x10s & 24–5x5s (2½ hours included) 355.

H. 16–8x10s & 32–5x5s (3½ hours included) 430.

I. 20–8x10s, 40–5x5s & 1–11x14 (4½ hours included) 525.

J. 24–8x10s, 48–5x5s & 1–16x20 (6 hours included) 620.

** availability of additional time beyond that included with the individual
 coverages is not guaranteed. However, if available, additional time
 is charged at the rate of $15 per half-hour.

<u>PARENT ALBUMS</u>

These 5x7" albums are delivered complete with finished prints in Taprell Loomis album books. The prices listed below apply only when the parent albums are ordered at the same time as the bridal album.

| 20 prints – $155. | 32 prints – $230. | 48 prints – $325. |
| 26 prints – 190. | 40 prints – 275. | 60 prints – 390. |

<u>WALL PRINTS</u> (mounted, textured and given protective lacquer finish)

| 11x14" – $48.50 | 20x24" – $170.00 | 30x40" – 440.00 |
| 16x20" – 95.00 | 24x30" – 320.00 | |

<u>DESK PRINTS</u> (individual orders, not part of albums. textured, delivered in folders)

	1–19	20–29	30–39	40–49	50+
8x10"	12.50	12.10	11.70	11.30	11.00
5x7"	9.00	8.70	8.40	8.10	7.75

<u>NEWSPAPER GLOSSIES</u> – one print for the paper of your choice is included with
all coverages. Additional prints, $6 each.

Price List #14 (Original size: 8½x11", reduced from typed 8½x14")

Price List #14 (1980)

Price List Numbering

Let me take a paragraph or two to explain my nonsensical system of numbering price lists.

Prior to Price List #14, I didn't use any kind of identifying code to keep track of which price list I had used when I booked a wedding. Price list changes were infrequent, I kept notes, and everything ran smoothly.

With #14 however, I was getting busy enough that I needed a shorthand method of keeping track of this information. Simply numbering my price lists seemed like the best way to quickly know which price list I was working with on a particular wedding.

I have always used the system of booking weddings that the price list used is the one in effect at the time the wedding is *booked*. This has nothing to do with the wedding date itself. In practice, this means a couple booking a wedding a year before the date may well be on a totally different price list than another couple planning a wedding for the same month—but not booking until five months before the wedding. This means that when the wedding dates arrive, I have several price lists in effect at one time. I still use this system.

Working Conditions

Price List #14 sports a few major changes—most importantly, my new business address. This price list is the first issued from my Gallery. You can be sure that overhead played a large part in any changes you see.

Although my main reason for moving was to simply separate home and business, once I was out of the house I noticed one immediate change: The attitude of my customers towards me, my photography, my business and my prices. This was something I hadn't really considered. What I saw was a sudden surge in *respect*.

When I had been working from my home, I was very conscious of the fact that people were hiring me partly because I took good pictures, and partly because the prices I charged for these pictures were low in comparison with what local studios were charging. By 1980 I was no longer a Basic Level photographer, but at least in my own mind I wasn't yet sure if I could compete with established studios unless my prices were markedly lower. When people are coming to your home to discuss wedding photography, tripping over toys on their way to sit on the sofa, kids are running around the house—well, it's not easy to view yourself as being on an equal footing with an uptown studio. I realize this has absolutely nothing to do with the pictures, but it had its effect. You might say I was a little insecure.

An amazing transformation took place when I moved into my Gallery. Suddenly, people were calling my business phone, coming to my business address, opening the door to my business–only place of business, and sitting down on my business sofa—to discuss business. No distractions. It was great.

Once I became used to this arrangement, I started to get cocky. I got over my reluctance to raise prices, declared myself a "wedding specialist," and set out to beat the studios at their own game. I was now essentially "one of them," and I wanted the best weddings—at the best prices. No longer did I feel the compulsion to keep my prices low just because I was working from my home.

In a sense I had no choice. When I mentioned *"serious* overhead" above, I meant it. Gone were the days of working a few Saturdays a month, paying for film and the lab bill, and still netting a good income. Payments still had to be made on the house—but now I had a second set of payments for Gallery rent, utilities, upkeep, etc. I still didn't have any employees, but as a one–man show, I had to generate a hefty volume of sales to make any money. No longer could I just hope people would call; now I had to learn about advertising and promotion to make sure they did. This added another layer of overhead. Previously, if I wasn't busy on a particular weekend, I knew I could make up the income the next week. Now, if I wasn't busy the ongoing overhead at the Gallery meant I was *losing* money. This realization brought about a whole new burst of energy on my part. It also sparked some newly serious thinking on how to fine tune the performance of my wedding price list.

Bridal Packages and Prices

Looking at Price List #14, I can see I was suffering from a split personality on the issue of album formats. I was still close enough to my home–based roots that I wasn't ready to eliminate the 5x5/8x10 packages, but I wanted to see the reaction to all–8x10 albums. Solution: I typed up a price list which offered both.

Part of the reason for wanting to move away from 5x5s in the Bridal Album was because of problems I was having with combining 5x5 *Previews* with 8x10 finished prints. I was having a hard time reconciling the idea of billing myself as a perfectionist who did everything possible to produce a first–rate album, with the fact that the color balance of the two sizes didn't always match when the album was delivered. (See the book's primary text for a discussion on this.) My prices, at first, weren't high enough to justify having scores of 5x5s printed again. My solution was to simply look for a way to eliminate the problem, by eliminating the 5x5s.

I was also curious to learn whether I could sell all–8x10 albums. This was the format many of the studio photographers were using. If it was good enough for them, and they were making money offering it, then it was good enough for me. The prices were higher in relation to the combination albums, mainly because I was paying to have the *entire* album printed as 8x10s.

I added the small "Friday only" package as part of the 5x5/8x10 packages because I wasn't yet ready to lose *any* weddings. Since I wasn't very busy during the week, even a weekend with three weddings was a manageable pace. I lowered the time limit to one and half hours, from the two hours on the previous "any package, any day" price list, to both maintain its appeal as a "phone" package while reducing its appeal as a "booking" package. Over the phone I needed a package which would grab their attention and make them want to make an appointment to visit the Gallery. When they came to the Gallery and saw the quality of my work it wasn't difficult to convince people that it really was in their best interest to go beyond the minimum package and give me the time at the wedding to do a good job.

Notice how I hedged my bets on the issue of incentives: With the 8x10 albums I offered an outdoor engagement or bridal sitting with the larger packages. With the combination albums, I kept with the "traditional" Wall Print. With the outdoor sitting I was not giving away any prints, just waiving my sitting fee, which at the time was maybe $20. I was curious to see whether a free sitting for people willing to spend more on a larger bridal album could be translated into additional print sales. I was beginning to notice that while people were gladly accepting anything I gave away, these freebies weren't actually contributing much in the way of booking weddings. People were booking anyway. If that was the case, I wanted to learn if I could quit giving these prints away—and *sell* them!

With this price list I also dropped the Open Plan. It had served its purpose: I'd learned that most couples preferred either 5x5/8x10 or all–8x10 albums. Explaining the Open Plan took quite a bit of time, introduced one more layer of decision making, and generally was becoming counterproductive. I saw that I was booking as many weddings as I could handle in the easier to present "package" format, so I simply eliminated it from the price list. I knew that if I ever needed it, I could always verbally present it to any couple who was interested.

Additional Time

The policy for Additional Time has been changed on this price list, from one hour to a *half*-hour. This made it easier for couples to have me stay "a little longer."

The change also allowed for a half hour charge of $15, in effect raising the *hourly* rate from $20 to $30.

Parent Albums

I can't remember why I dropped the 8x10 Parent Albums with this price list, going solely with the 5x7 format.

The best explanation I can offer is that parents weren't ordering the 8x10 albums often enough to justify using valuable space on the price list. Instead, I opted to expand my listing of print quantities for the 5x7 albums up to 60 prints in the hope of making it easier for parents to go with larger albums in this "smallest" size.

At any rate, I upped the smallest size album from 16– to 20–5x7s, and raised the price of this album by $5.

Additional Prints

Every price list should be bold enough to experience triumph, and abject failure. On this price list, my attempt to increase Desk Print orders via discounts on multiple orders qualifies as one of the latter.

A complete discussion of this fiasco is in the book. For now, let me just say that I lived to regret ever adding this option to my price list. It's one of those situations which looks brilliant in theory, but until you try it you never realize how misguided it really is.

Chalk this one up to experience.

Deposits

My booking deposit was still $50.

As you can see, this price list is getting BIG in terms of the amount of package and pricing information listed. I was running out of room to print my growing list of policies on the front side. Rather than print the price list on 8½x14" paper as I had done with the with Price List #3, I moved the information on deposits, etc. to the reverse side and had the printer reduce the copy for Price List #14 to fit on standard "letter size," 8½x11" paper.

(#AA)

WEDDING SERVICES & PRICE LIST

Standard Coverages

 Good quality wedding photography at a moderate cost. Delivered in a combination
format of 8x10" and 5x5" print sizes. Complete with album.

 V. 6–8x10s & 12–5x5s (Friday only – 1 hour included) $280.
 W. 8–8x10s & 24–5x5s (2 hours included) 360.
 X. 12–8x10s & 32–5x5s (3 hours included) 440.
 Y. 16–8x10s & 40–5x5s (4 hours included) 530.
 Z. 20–8x10s & 48–5x5s (5 hours included) 620.

 ** Availability of additional time beyond that included with the individual coverages
 is not guaranteed. However, if available, additional time is charged at the rate
 of $15 per half hour.

Family Albums

 Delivered as finished albums, the below listed prices apply only when ordered at
the same time as the Bridal Album.

 5x7" albums: 20 prints – $189. 8x10" albums: 18 prints – $215.
 26 prints – 239. 24 prints – 274.
 32 prints – 279. 30 prints – 329.
 (additional 5x7" prints for albums (additional 8x10" prints for albums
 larger than 32 prints – $8.50@) larger than 32 prints – $11.00@)

Wall Prints (mounted, textured & sealed with protective lacquer finish)

 16x20" – $115. 24x30" – $230. (** deduct 10% from 16x20 price, 15%
 20x24" – 170. 30x40" – 300. from larger sizes, if wall prints reserved
 prior to wedding date.)

Desk Prints (individual orders, not part of albums. Textured, delivered in folders.)

 5x7" – $10.50 8x10" – $13.75

Newspaper Glossies – One black & white print for the paper of your choice is included
 with all coverages. Additional prints, $6 each.

Reorders – When additional prints are ordered at a later date than the original order,
 a special service surcharge of 25% will be added to then current print prices.

Deposits & Payments – A deposit of $100 is required to hold a specific wedding date.
 The balance of the Bridal Album price is due upon delivery of the proofs; payment
 for additional prints is due upon delivery. Reorders must be paid for in advance.
 The 6% California sales tax is added to all orders.

Price List #AA (Original size: 8½x11")

#21

WEDDING SERVICES & PRICE LIST

Deluxe Coverages

The finest wedding photography, delivered in the 8x10" print format complete with album. These coverages have been designed especially for those couples who appreciate quality and look forward to the most splendid wedding album possible.

A. 24–8x10" prints in album (2 hours included) $425.

B. 32–8x10" prints in album (3 hours included) 525.

C. 40–8x10" prints in album (4 hours included) 625.

D. 48–8x10" prints in album (5 hours included) 725.

E. 60–8x10" prints in album (6 hours included)
 ** plus outdoor engagement or bridal sitting 825.

F. 72–8x10" prints in album (7 hours included)
 ** plus outdoor engagement or bridal sitting 925.

** Availability of additional time beyond that included with the individual coverages is not guaranteed. However, if available, additional time is charged at the rate of $15 per half hour.

Family Albums

Delivered as finished albums, the below listed prices apply only when ordered at the same time as the Bridal Album.

5x7" albums: 20 prints – $189. 8x10" albums: 18 prints – $215.
 26 prints – 239. 24 prints – 274.
 32 prints – 279. 30 prints – 329.

(additional 5x7" prints for albums (additional 8x10" prints for albums
larger than 32 prints – $8.50@) larger than 32 prints – $11.00@)

Wall Prints (mounted, textured & sealed with protective lacquer finish)

16x20" – $115. 24x30" – $230. (** deduct 10% from 16x20 price, 15%
20x24" – 170. 30x40" – 300. from larger sizes, if wall prints reserved
 prior to wedding date.)

Desk Prints (individual orders, not part of albums. Textured, delivered in folders.)

5x7" – $10.50 8x10" – $13.75

Newspaper Glossies – One black & white print for the paper of your choice is included with all coverages. Additional prints, $6 each.

Reorders – When additional prints are ordered at a later date than the original order, a special service surcharge of 25% will be added to then current print prices.

Deposits & Payments – A deposit of $100 is required to hold a specific wedding date. The balance of the Bridal Album price is due upon delivery of the proofs; payment for additional prints is due upon delivery. Reorders must be paid for in advance. The 6% California sales tax is added to all orders.

Price List #21 (Original size: 8½x11")

Price Lists #AA & #21 (1981–82)

Working Conditions

The years 1981 and 1982 represent the Golden Years of my wedding photography. My business was still 80% wedding photography, which meant all my energies went into perfecting the pictures. I was also learning how to read couples and tell from talking with them what they wanted. I was also starting to have my own ideas about how a wedding photography business should be run.

The couples I was attracting at this time were solidly "Mid–Level:" They were looking for good photography at reasonable prices. I delivered. Because my prices were lagging behind the quality of my work, I was "booked solid" for the most part and reaching the saturation point.

This success brought with it some problems, however. *Good* problems, but problems nonetheless. As I became busier, I saw that I was booking weddings further and further in advance. I had one wedding in 1981 which was reserved 16 months prior to the date; still a record. In one sense that was great, but in another it meant I was having to turn away a lot of other good weddings. While a few years earlier I was happy to book any wedding, now I was chafing at the sight of a date booked with what I knew would be an average wedding—then having to turn away a couple who I knew represented a great wedding.

Finally, I realized that the structure of Price List #14 was working against me. I saw that people were reacting favorably to the photography, deciding to hire me, then choosing the least expensive way to have me photograph their wedding.

I set out to change that with Price Lists #AA and #21.

Bridal Packages

Price Lists #AA and #21 have been grouped together because they really are the same price list. Everything about them is the same *except* the structure of the Bridal Albums.

While on previous price lists I had attempted to add every idea I could think of to a single sheet of paper, with #AA and #21 I started breaking price lists down into different "editions." With Price Lists #AA and #21, I decided to cut the two apart—literally. If you look closely at each price list, you'll see that the Bridal Album coverages occupy exactly the same amount of space. What I did was type up Price List #21 and make a copy. Then, with the copy I took a pair of scissors and cut out the "Deluxe Coverages" section. Into this hole I dropped the newly typed "Standard Coverages" section, glued it down with rubber cement—and presto!, two complete price lists from one.

#21/"Deluxe Coverages"

The all–8x10 format is the same as with Price List #14, with these changes:

• The number of prints included in the *minimum* Package A dropped from 32 to 24. I didn't want this coverage to represent too much of a good thing.

• The 32–print album now became the second album option, and its price increased from $490 to $525. (The price differential between each package was now a flat $100, which represented one hour and 8–8x10s. I was trying to make the choice as easy as possible.)

• The amount of time included with Package A was lowered to two hours to further reduce its appeal, and make it easier for couples to select Package B.

• The reference to Art Leather albums was dropped. I wanted to be free to try different album companies.

#AA/"Standard Coverages"

If Price List #21 represented the packages I *wanted* to book, #AA represented my "fall back" option. If the response to #21 was lukewarm and I saw I was in danger of losing a wedding I wanted, all I had to do was go to my desk drawer, pull out #AA, and let the couple know that while I favored the all–8x10 format of #21, there did exist an alternate—and cheaper—way they could have access to my photography.

Now that the 5x5/8x10 format was becoming my emergency album, I set it up to handle any situation.

The time limit on the Friday–only package was lowered to one hour. I was still not ready to lose weddings for *any* reason—even a one hour wedding. I never did book one.

With Packages V through Z (I used this letter sequence to avoid, as much as possible, having two "Package A's" in effect at one time) I massaged the print quantities and hours somewhat from what had been used in Price List #14. I was just "experimenting." These minor changes made absolutely no difference in whether people booked or not.

A major change was that Wall Prints were dropped as incentives with the larger packages. My prices were low enough, and my photography strong enough, that I realized I didn't need to pile on extras just to book weddings.

Making Good Use Of Two Price Lists, Simultaneously

While I had a general idea of why I needed to break up my price list, it wasn't until I had two totally separate versions in my desk drawer that I began to understand how to use price lists as a strategic booking tool. Before, the price list had been simply that—a list of what I would give the couple, and how much

money they would give me. Now, with two price lists at my disposal, I could *selectively* use them to control the booking process.

Here's how I used this idea of dual price lists:

Now that my pricing had become somewhat complicated, the first move I made was to stop giving out prices over the phone. When a couple called, I told them "I have a wide range of packages available. Why don't you make an appointment to come over and talk with me, tell me about your wedding and your plans, and then I can help you select the best package for your needs." (The only time I broke this new rule was when a bride called about a wedding which was only weeks away and a date I knew would probably stay unbooked. If she sounded like someone I wanted to work with, I'd use as my phone package the smallest applicable package from Price List #AA. If she was calling about a Friday wedding, I was ready with a rock–bottom quote of $280.)

When a couple would come to meet with me, for the first half of the conversation no real mention was made of prices or packages. Instead, we talked about the wedding. Mentally, I was taking notes about what kind of wedding this would be, how much time they would need me, *and which price list I would show them.*

If, for example, the wedding date was far in the future and seemed like a good wedding, I'd start with #21—and leave it to my discretion whether or not to show #AA. Whether I did or not depended upon my gut feeling about this wedding's potential to become the best wedding I could book for that date.

If I thought the wedding would be "average," I never would present Price List #AA. Why? I knew that with the number of calls I was getting that if this couple didn't book, my chances were excellent that by the time that date arrived, I would have a good wedding booked. I let the couple leave with absolutely no pressure to book, wished them luck with their plans, and hoped they booked with another photographer. I was willing to wait.

On the other hand, if the couple seemed like they were interested in spending a lot of money on pictures and just weren't particularly leaning towards all–8x10s, I would definitely show them the Price List #AA. They might well book the largest package. Or, they might be telling me how both sets of parents are definitely interested in large Parent Albums.

As you might guess, this approach was very subjective. Of course I made mistakes and lost weddings which would have been excellent. Of course I guessed wrong and lost weddings for dates which I never did book. But, and this is the important part, I was discovering ways to control the booking process and keep my schedule clear for those weddings I wanted.

Another benefit was that I became very adept at selling all–8x10 albums. Because the 5x5/8x10 coverages weren't listed on Price List #21, I no longer had to deal with that option unless I wanted to bring out Price List #AA. As I learned that I could do quite well without the "crutch" of 5x5s, I prepared myself for

simply eliminating this option from my price list—which I did with the next version. Price List #AA is the last price list on which I used 5x5s.

Using two price lists was a revolutionary change for my business. Now, I was in *control* of what happened. Instead of talking with a couple, handing them a price list and *hoping* they didn't opt for the smallest package, with a two price list approach I was in control of the minimum package.

In fact, I learned quickly that I could control everything because I could have as many price lists in effect as I wanted, employing any options I wanted to offer. I could test ideas against each other, rather than simply wondering what the difference might be. (You'll see this thinking at work in the next set of price lists.)

Parent Albums

Aside from the radical changes in the Bridal Album coverages on Price Lists #21 and #AA, all the other sections are exactly the same between the two.

Only a few changes with Parent Albums over Price List #14:

• The name was changed to "Family Albums" to reflect the fact that any-one could purchase these albums. I saw no reason to let a name discourage grandparents from ordering an album.

• 8x10 Family Albums have been resurrected. The new, tighter format of the Family Album listings gives room on the price list without crowding.

• For the same reason that I dropped the reference to Art Leather albums with the Bridal Albums, I have omitted saying that parent albums are de-livered in Taprell Loomis albums.

• Prices have again been pushed upward, with no noticeable effect on sales.

• Rather than listing a large assortment of sizes, I changed tactics and listed prices per–print for larger albums. This not only let people know that they could order larger albums than those listed, but also gave a specific price per print which they could use to see exactly how good the discount was for Family Albums over the individual "Desk Print" prices below.

By the time I got to these prices lists, I'd learned that the best way to sell Family Albums is simply to take pictures which parents want, and are willing to buy. Playing games with the price list is not as effective as simply producing good photography.

Additional Prints

Aside from the obligatory price increase, the major changes on Price Lists #21 and #AA for Wall Prints and Desk Prints are:

• 11x14" prints have been cut from the listing. I've never liked this size; it's too close to 8x10 to justify any major price differential. And, since it provides people with a way to purchase a "Wall Print," it kills sales of prints 16x20 and larger. On these price lists, I tried doing away with 11x14s altogether.

• In yet another effort to begin selling prints 24x30 and larger, the prices for these sizes have been lowered dramatically. (It didn't work.)

• In a further attempt to ignite interest in (or at least discussion of) Wall Prints, I initiated a discount program. As a rationale for this discount, I specified that these prints had to be "reserved" prior to the wedding date. (This didn't work, either.)

While most of these ideas met with resounding defeat, the point is that I tried. Since I hadn't been selling many of these sizes before, I ended up no worse for the effort.

Newspaper Glossies

Black and white prints for newspaper are not one of the great profit centers of wedding photography, yet they do represent effort and expense. Once I noticed that people were requesting more of these than they really needed, I decided to close this loophole by including a single print free as part of the package—then charging for each additional print. When people began having to pay for these prints, the requests tapered off.

Deposits

With these price lists, I finally began asking for a *realistic* deposit. The $50 I had been using for years was now acknowledged as being too low, not to mention out of balance with my package structure. (See book for discussion on Booking Deposits.)

Another major shift was that I backed away from collecting any money when the Previews were returned and orders placed. Instead, once the Previews were returned, I sent the couple an "official" letter which summarized all the orders and gave a *total balance due* when the finished prints and albums were delivered. I re–explained, as I had done several times before, that no pictures would be delivered until that balance was paid. This includes the Bridal Album, as well as Family Albums and any additional prints.

This approach worked very smoothly. If the bride and groom had paid for their pictures, and knew that they would not get the album until *everyone* else had paid, then they would be darn sure to have all the money before they came for their pictures.

I've learned that the keys to making this policy work are:

• To have this policy *clearly* stated on the price list. You need something specific to point to if ever there should be a question about it later. If the words are there on the price list you gave them when they first booked the wedding, there's not much they can say.

• You have to explain it fully when the Previews are first delivered. Don't assume they will read your price list, word for word. They won't.

• *No exceptions.* When you call the couple to tell them their pictures are ready, make sure they *know* that you will not deliver those prints—any of them—until every penny of the balance is paid. This is how most businesses operate and if the policy is clearly stated, your customers should have little trouble with it.

It sure would have been nice if I had known about those three keys when I was first getting started.

High End Price Lists (1984–Present)

1982–83 marked the end of my Mid-Level days as a wedding photographer for one simple reason: The insurance agent next door moved. I saw my chance to open a studio without having to move to a new location—and I grabbed it.

In late 1982, I signed a lease for the new office space and began building a camera room. In February, 1983 I took a course in basic studio portraiture at West Coast School in Santa Barbara. In May, I cut the hole in the wall between the two offices. I was now open for business as a full–service studio.

This expansion had a dramatic effect on my *wedding* business. Money began coming into the studio which wasn't generated by wedding photography. As I learned how to build volume during the week in the studio, I was no longer as dependent upon making most of my money photographing weddings on weekends. Now, instead of having to structure my pricing to make sure I was busy most weekends, I could afford to be selective about whom I worked with. Now, I could afford to have weekends when I wasn't photographing weddings. Talk about a revelation!

To give you an idea of how my business shifted, prior to 1983 and my debut as a studio owner, about 80% of my volume was wedding photography. When I opened the studio, I went after other markets with a vengeance. For example, in 1982 I had photographed only 26 high school seniors. For the Class of '84, which we began photographing in July, 1983 we did 155 seniors. The next year we did around 225. By the Class of '88, our volume of seniors had climbed to over 350 sittings for this one category alone. That doesn't include children, families and the other studio portraiture we covet. Now, weddings represent less than 30% of our volume—even with an average wedding order of over $2,800.

Add to this the fact that I didn't want to do a lot of weddings! In October, 1984, Matthew was born and I was wanting to spend more time at home. If people wanted me to photograph their wedding, they were going to have pay me *a lot*. Being busy six or even seven days a week ceases to be a thrill when you're doing it month after month, even when the money is good.

That thinking, plus the volume of non–wedding work, resulted directly in my High End attitude towards weddings. Once I could afford to *lose* weddings, I learned one very important lesson: If people are coming because of *quality*, then prices must be raised substantially before *volume* is impacted. In other words, I timidly tried minor increases of 10% or 20%, thinking these would lead to a big drop in wedding bookings while still maintaining profits. Didn't happen. In fact, these wimpy increases had no effect at all. I was still booking as many weddings as I had before, only now people were paying quite a bit more. Why didn't I learn this lesson ten years ago!

When I saw that people were still writing checks for deposits and I was committed to more photography than I really wanted, I knew I would have to raise prices to insanely great levels to bring about the volume decrease I wanted. It was torture, but it wasn't until I got downright brazen about my pricing and

implemented increases of 30% to 50% that I saw demand falling into line with what I wanted. The great thing about this is that while volume dropped, income didn't. Those higher prices generated a much higher level of *profit*, meaning I was making more money doing 30 weddings per year at the new prices than I had been making before doing 40 or 45+ weddings. Plus, the lower volume meant I could do a better job with those weddings I did book—which meant the customer could get what they were paying for.

Basically, what I've done is set up my pricing to prune the lower layer of my market to free up time, energy and cash for expansion at the top end. This keeps my schedule open for moves into other, equally lucrative assignments. In the long term, my objective is to skim the cream of assignments off of several categories of photography. I want the best weddings, the best seniors, the best children. If I can do that, I'll be busy doing the best assignments for the best pay. I'll be diversified. This is preferable to concentrating on assignments in one category (weddings, for example) and having to work with "average" jobs at average pricing to get volume and "be doing something."

Another factor pushing me into High End pricing was the increasing overhead at the studio. By 1987, I had three full-time employees, plus one part-time, to help me get the work out the door. Long gone were the days of the lone photographer (me) doing everything from taking the pictures, to taking the orders, to talking on the phone, to scheduling appointments, to sending film to the lab, to running errands. I was now the picture–taking cog in a rather large studio machine. There was no way I could afford to be anything *but* "expensive" in my wedding pricing if I wanted that category to generate a fair share of cash flow to cover overhead, finance expansion, pay myself, earn a profit and still have some free time left to "enjoy life."

On the down side, an increasingly critical component of my need to cut down on volume has been a persistent lower back problem I've had since my days as a forklift driver. The wear and tear of weddings hasn't helped. My equipment seems to be getting heavier, and it's taking me longer to recover from even a small wedding.

Increasingly, I'm feeling less and less comfortable committing myself to dates six and twelve months in the future. I'm not as sure as I used to be that on a specific date and specific time, I will be ready, willing and able to run at full speed for as long as the bride and groom need me. Unlike my studio sittings, where I can reschedule sittings and shuffle appointments to accommodate the fact that I can barely walk, with weddings I don't have that option. I've photographed a wedding wearing a back brace, and it was no fun. (If *you* have any kind of back problems, take care of yourself! It's absolutely depressing how quickly one can become incapacitated. If anything's going to force me out of weddings—it will be my back, *not* my competition!)

Luckily, my photography has improved enough over the years that I could earn more doing less, keep raising prices and have people continue to think the work was worth the cost. I shudder to think of the volume of work I would have to do if my prices were even 10% lower.

```
         Steve
         Herzog
         Photography
                                    (#31)

                              WEDDING SERVICES & PRICE LIST

                         The finest wedding photography, delivered as 8x10"
                      prints, complete with album.  These coverages have
                      been designed especially for those couples who appreciate
                      quality and expect the most splendid wedding album possible.

         A.  28-8x10" prints in album  (4 hours included)............    672.

         B.  36-8x10" prints in album  (5 hours included)............    864.

         C.  44-8x10" prints in album  (6 hours included)............   1056.

         D.  52-8x10" prints in album  (7 hours included)............   1248.

         E.  60-8x10" prints in album  (8 hours included)............   1440.

         F.  68-8x10" prints in album  (9 hours included)............   1632.

         **  Availability of additional time beyond that included with the
             selected coverage is not guaranteed.  However, if required, any
             extra time will advance the coverage to the package including
             the total number of hours spent at the wedding.  If requested,
             packages may be extended beyond nine hours.

     FAMILY ALBUMS (Delivered as finished albums, the prices listed below apply
     only when the albums are ordered at the same time as the Bridal Album.)

         5x7"        18 prints - $199.    8x10/5x7   2/20 prints - $234.
         Albums:     24 prints -  253.    Albums:    4/26 prints -  306.
                     30 prints -  295.               6/32 prints -  375.
         (additional prints may be added   (additional prints may be added
            to these albums as needed)         to these albums as needed)

     WALL PRINTS (mounted, textured & sealed with protective lacquer finish)

         11x14" - $ 62.        20x24" - $193.        30x40 - $352.
         16x20" -  121.        24x30" -  275.        40x60 -  679.

     DESK PRINTS (individual prints, not part of albums.  Delivered in folders.)

         5x7"   - $ 12.25      8x10"  - $ 15.75

     Newpaper Glossies - One black and white print for the paper of your choice
         is included with all coverages.  Additional prints, $8. each.

     Deposits & Payments - A deposit of $250 is required to reserve a specific
         wedding date.  A second deposit of $200 one month before the wedding.
         The balance of the Bridal Album price is due upon delivery of previews.
```

Price List #31 (Original size: 8½x11")

(#06)

WEDDING SERVICES & PRICE LIST

The finest wedding photography, delivered as 8x10"
prints, complete with album. These coverages have
been designed especially for those couples who appreciate
quality and expect the most splendid wedding album possible.

Bridal
Album

A. 6 hours included* (44-8x10" prints)..................... 1056.

B. 7 hours included* (52-8x10" prints)..................... 1248.

C. 8 hours included* (60-8x10" prints)..................... 1440.

D. 9 hours included* (68-8x10" prints)..................... 1632.

E. 10 hours included* (76-8x10" prints)..................... 1824.

F. 11 hours included* (84-8x10" prints)..................... 2016.

* Availability of additional time beyond that included with the
selected coverage cannot be guaranteed. However, if required, any
extra time will advance the coverage to the package including
the total number of hours spent at the wedding, in quarter hour
increments. Each quarter hour adds 2-8x10's to the package. (If
needed, packages may be extended beyond eleven hours.)

FAMILY ALBUMS (Delivered as finished albums, the prices listed below apply
only when the albums are ordered at the same time as the Bridal Album.)

5x7"	18 prints - $199.	Combination	2/20 prints - $234.
Albums:	24 prints - 253.	8x10 & 5x7	4/26 prints - 306.
	30 prints - 295.	Albums:	6/32 prints - 375.
(additional prints may be added		(additional prints may be added	
to these albums as needed)		to these albums as needed)	

WALL PRINTS: 11x14" - $ 62. 20x24" - $193. 30x40 - $352.
 16x20" - 121. 24x30" - 275. 40x60 - 679.

DESK PRINTS IN FOLDERS: 5x7" - $ 12.25 8x10" - $ 15.75

Newspaper Glossies - One black and white print for the paper of your choice
 is included with all coverages. Additional prints, $8 each at same time.

Deposits & Payments - A deposit of $250 is required to reserve a specific
 wedding date. A second deposit of one half the remaining balance for
 the package selected is required a month before the wedding. The
 balance of the Bridal Album price is due upon delivery of previews.

Price List #06 (Original size: 8½x11")

Price Lists #31 & #06 (1984)

Working Conditions

By 1984, I was a ten–year veteran of my local photographic market. People knew of me, knew I delivered good work, and so at this point I was still getting many calls for weddings. My prices were climbing, but they were still within reach of couples serious about their wedding photography. Instead of looking for ways to increase bookings, I was investigating ways to filter out "average" weddings and end up with only "the best."

In keeping with my intention of broadening my base, most of my efforts were directed towards studio work. The busy first year of studio sittings in 1983 had proven to me that I was right about the money–making potential of non–wedding assignments.

Weddings were still an important ingredient of my product mix—but no longer were they the *only* ingredient. The pressure was off. Now, I could afford to test the upper limits of what prices I could charge for weddings—and take some chances I wasn't quite ready to risk when weddings were my bread and butter.

Bridal Album and Prices

By the time these two price lists came into play, I was no longer willing to make automatic concessions simply to book a wedding. As you can see, all incentives and "deals" have been stripped from Price Lists #31 and #06.

The reason I have grouped Price Lists #31 and #06 together is because they are *almost* identical—but not quite. What I find interesting about these price lists is that while the *prices* were essentially the same, the structure and format of the price lists were different in some critical areas: The manner in which time limits and print quantities were listed, and the change in how the minimum package was presented.

Time Limits and Print Quantities

Time and print quantities have been reversed in the listing. With price list #06, the emphasis shifts to where it should have been long ago: To *time*, not print quantities.

The importance of time as a prime booking tool is discussed in detail in the book.

Variable Minimum Packages

The solution I found was a combination of simply raising prices and using *variable* minimum packages.

Look at the first package listed on Price List #31; it's four hours, 28–8x10s and $672. On Price List #06, however, the *smallest* package is six hours, 44–8x10s and $1,056.

As you might guess, which price list I handed a couple had a direct and immediate effect on whether or not they booked with me. This was *precisely* my intention!

While #31 was a stand–alone price list, #06 was part of a matched set. Sitting in my desk drawer, right next to #06, were sister Price Lists #04 and #05. (These are reprinted on the following pages.) These were smaller versions of the #06 price list, with minimum time limits of four and five hours respectively. If you'll look at #31, the four and five hour packages and prices were the same as those used on #04 and #05. (It's important to note that common packages carry the same prices on each price list. For example, the six hour packages on each price list cost the same and carry the same number of prints. The only difference between price lists was the starting point. I wasn't playing with prices so much as adjusting the starting package to achieve the desired goal of booking the wedding, or *not* booking it.) This is really a variation of idea I had been using for some time, as I did with Price Lists #21 and #AA. With those price lists, the major differences were in print sizes, combinations and prices. With Price Lists #31 and #06, everything remained basically constant, with only the minimum, entry–level package changing.

I employed this tactic simply as a way to control who booked, and who didn't. The price list I chose to show depended on the particular situation. For popular summer dates, I would only show 5– or 6–hour price list. For less busy periods, I showed the 4–hour price list.

I will admit that on occasion I used this pricing structure as a weapon. Over the phone, I could quickly discourage a price shopper by simply saying that "My packages begin at $1,056." Worked like a charm—and it conserved a lot of studio time slots which may have otherwise been used meeting with couples who never would have booked anyway. If, at a meeting, I sensed that a couple would be difficult to work with and/or I simply did not want to encourage them, I'd also present them with the 6–hour price list. The effect was the same: They thanked me for my time, said good–bye, and continued their search for a wedding photographer.

This capability of easily changing packages represents a perfect example of the power of the computer. I deleted one line at the top of the listing, and filled in the space again by adding another line to the bottom. The entire operation took about 5 minutes.

(#04)

WEDDING SERVICES & PRICE LIST

The finest wedding photography, delivered as 8x10"
prints, complete with album. These coverages have
been designed especially for those couples who appreciate
quality and expect the most splendid wedding album possible.

 Bridal
 Album

A. 4 hours included* (28-8x10" prints).....................672.

B. 5 hours included* (36-8x10" prints).....................864.

C. 6 hours included* (44-8x10" prints)....................1056.

D. 7 hours included* (52-8x10" prints)....................1248.

E. 8 hours included* (60-8x10" prints)....................1440.

F. 9 hours included* (68-8x10" prints)....................1632.

* Availability of additional time beyond that included with the
selected coverage cannot be guaranteed. However, if required, any
extra time will advance the coverage to the package including
the total number of hours spent at the wedding, in quarter hour
increments. Each quarter hour adds 2-8x10's to the package(If
needed, packages may be extended beyond nine hours.)

FAMILY ALBUMS (Delivered as finished albums, the prices listed below apply
only when the albums are ordered at the same time as the Bridal Album.)

5x7" 18 prints - $199. Combination 2/20 prints - $234.
Albums: 24 prints - 253. 8x10 & 5x7 4/26 prints - 306.
 30 prints - 295. Albums: 6/32 prints - 375.
(additional prints may be added (additional prints may be added
 to these albums as needed) to these albums as needed)

WALL PRINTS: 11x14" - $ 62. 20x24" - $193. 30x40 - $352.
 16x20" - 121. 24x30" - 275. 40x60 - 679.

DESK PRINTS IN FOLDERS: 5x7" - $ 12.25 8x10" - $ 15.75

Newspaper Glossies - One black and white print for the paper of your choice
 is included with all coverages. Additional prints, $8 each at same time.

Deposits & Payments - A deposit of $250 is required to reserve a specific
 wedding date. A second deposit of $200 one month before the wedding.
 The balance of the Bridal Album price is due upon delivery of previews.

Price List #04, making use of four hour minimum package.

Steve Herzog Photography

(#05)

WEDDING SERVICES & PRICE LIST

The finest wedding photography, delivered as 8x10"
prints, complete with album. These coverages have
been designed especially for those couples who appreciate
quality and expect the most splendid wedding album possible.

Bridal
Album

A. 5 hours included* (36-8x10" prints)....................$ 864.

B. 6 hours included* (44-8x10" prints).................... 1056.

C. 7 hours included* (52-8x10" prints).................... 1248.

D. 8 hours included* (60-8x10" prints).................... 1440.

E. 9 hours included* (68-8x10" prints).................... 1632.

F. 10 hours included* (76-8x10" prints).................... 1824.

* Availability of additional time beyond that included with the
selected coverage cannot be guaranteed. However, if required, any
extra time will advance the coverage to the package including
the total number of hours spent at the wedding, in quarter hour
increments. Each quarter hour adds 2-8x10's to the package. (If
needed, packages may be extended beyond ten hours.)

FAMILY ALBUMS (Delivered as finished albums, the prices listed below apply
only when the albums are ordered at the same time as the Bridal Album.)

5x7"	18 prints - $199.	Combination	2/20 prints - $234.
Albums:	24 prints - 253.	8x10 & 5x7	4/26 prints - 306.
	30 prints - 295.	Albums:	6/32 prints - 375.
(additional prints may be added		(additional prints may be added	
to these albums as needed)		to these albums as needed)	

WALL PRINTS: 11x14" - $ 62. 20x24" - $193. 30x40 - $352.
 16x20" - 121. 24x30" - 275. 40x60 - 679.

DESK PRINTS IN FOLDERS: 5x7" - $ 12.25 8x10" - $ 15.75

Newspaper Glossies - One black and white print for the paper of your choice
is included with all coverages. Additional prints, $8 each at same time.

Deposits & Payments - A deposit of $250 is required to reserve a specific
wedding date. A second deposit of one half the remaining balance for
the package selected is required a month before the wedding. The
balance of the Bridal Album price is due upon delivery of previews.

Price List #05 drops four hour package, making five hours the minimum.

I'd gotten my first computer in 1981. For the first few years of ownership, I used it simply as an automated typewriter. I quickly learned word processing and put it to good use generating letters to brides—and price lists.

Once it dawned on me how easily I could modify price lists, I became fanatical. At one point, I remember I had so many price lists in effect that I had to buy an accordion folder to keep track of them all. I also remember talking with a bride on the phone, inventing an on–the–spot Bridal Album package—then heading for the computer as soon as I hung up. I loaded my price list into the computer, changed the number of prints in the packages, the number of hours, and the prices to correspond to our conversation—and had the price list printed out when she arrived that afternoon for her appointment.

Finally, I had a way to test, reject or improve any idea I wanted, at any time I wanted. I loved it!

All in all, the tactic of using variable minimum packages represents the best control over booking I've found to date. It all came together on Price List #06.

Additional Time

The manner in which I handled additional time has also been tightened into a clearly defined, *specific* system. It took awhile, but I finally found a way to handle additional time and get rid of hourly charges.

Compare the wording between Price Lists #21 and #AA, and then #31 and finally #06.

What I did was make every minute I spent at a wedding apply to the package time limit. On Price List #06, if a couple booked a six–hour package and later added two hours, they would automatically jump to the eight–hour package—complete with 16 more 8x10s, and a new package price of $1,440.

This system has worked out beautifully. It totally eliminates any questions about how extra time will be handled and what the cost will be. (See the book for a complete run down on the specifics of this approach.)

Family Albums

With these price lists, I am still fine tuning my Family Albums—only now I have found a system which works.

The 5x7 albums have remained largely intact as they have been for years, plus "a few" dollars.

The changes have come in the albums using 8x10 prints. Rather than offering straight 8x10 Family Albums, I realized that more parents would be interested in mostly 5x7s, with a few 8x10s sprinkled in to highlight important pictures. The product of this realization is the "Combination" album. For example, with the "4/26" album the customer would select 4–8x10s and 26–5x7s.

This format has been much more successful than the all–8x10 album ever was, although it still trails the purely 5x7 album by a wide margin.

Wall Prints & Desk Prints

It's back to basics again in the Wall Print and small print departments. In keeping with my "no incentives" mood at the time, I eliminated discounts, raised the prices slightly, and left it at that.

I even brought back the 11x14—although at a more substantial price. I figured that if I wasn't going to sell Wall Prints, I might as well keep the price high and blame it on that.

Deposits

With these price lists, too, I was finally beginning to get my deposit system functioning smoothly. This is the other major difference between Price Lists #31 and #06.

With Price List #31, I was still charging a *fixed* amount for the second deposit—in this case, $200. That would seem reasonable, yet if the couple booked an eight–hour package and had paid a total of $400 by the wedding, they still had a payment of over $1,000 due after the honeymoon.

With my escalating prices, this became a problem since not all couples could afford to quickly pick up their Previews. I didn't like the idea that a couple couldn't get their pictures as soon as they were ready; it dampened their enthusiasm, embarrassed them, and made my prices seem oppressively expensive.

Not wanting any of these side-effects to undermine my photography, I overhauled my deposits policy with Price List #06.

I kept the initial booking deposit at $250, but eliminated the fixed $200 second deposit. Now, I made the amount of the second deposit hinge on the "remaining balance" of the booked package. This leveled out the payments and pushed the bulk of the money due to before the wedding, not after. This was a great help since before the wedding the couple is paying all the other merchants; why not pay me a lot too?

Using the eight hour package again as an example, a couple would pay $250 to book the wedding. A month before the wedding they would pay half the balance of $1,190, or $595. Then, after the wedding, they paid the final $595. (If additional time had been added at the wedding, those extra charges would be paid, too, when the proofs were picked up.)

I must say that I had very few problems with this system. By this point in my business, I was confident enough in my policies to know that they were fair. Even though couples had to sometimes bring me rather hefty checks to cover both the balance due on the initial Bridal Album, plus additional time, this fact did not stop them quickly hurrying over to collect their Previews.

Wedding Services Price List
5/3

Wedding
Photography
by
Steve Herzog

❦ Bridal Album Coverages

Please make your choice based upon the number of hours your wedding will require. (Additional prints may be added to your Coverage using the "Desk Prints" prices listed below.)

5 hours included* (38–8x10 prints)	..	$1520. *(plus tax)*
6 hours included* (46–8x10 prints)	..	1840. *(plus tax)*
7 hours included* (54–8x10 prints)	..	2160. *(plus tax)*
8 hours included* (62–8x10 prints)	..	2480. *(plus tax)*
9 hours included* (70–8x10 prints)	..	2800. *(plus tax)*
10 hours included* (78–8x10 prints)	..	3120. *(plus tax)*

** Availability of additional time beyond that included with the selected Coverage cannot be guaranteed.* However, if required, any extra time will advance the Coverage to the package including the total number of hours spent at the wedding, in quarter-hour increments. Each quarter-hour adds 2–8x10s to the Bridal Album. (If needed, Coverages may be extended beyond ten hours.)

❦ Family Albums

Offering a collection of prints, Family Albums are the perfect choice for parents, grandparents...*or anyone!* Complete with Album covers.

5x7 Albums			8x10 and 5x7 Combination Albums		
	20–5x7 prints –	$420.		2–8x10 & 18–5x7 prints –	$448.
	26–5x7 prints –	546.		4–8x10 & 24–5x7 prints –	644.
	32–5x7 prints –	672.		6–8x10 & 30–5x7 prints –	840.

(Additional prints may be added to these Albums as needed. Ask for details.)

❦ Wall Prints

Select your favorite photographs, and enhance the decor of your home with beautiful Wall Prints. A wide selection of frames is available.

	11x14	16x20	20x24	
Classic	$180.	$295.	$380.	*(Sprayed lacquer finish)*
Regency	205.	330.	425.	*(Textured lacquer finish)*
Heirloom	290.	440.	570.	*(Canvas–mounted print)*

(A wide selection of frames is available for Wall Prints. Ask for details.)

❦ Desk Prints

Ideal gifts, Desk Prints are delivered individually, in folders.

5x7 — $27. 8x10 — $40.

Newspaper Glossies: One black and white print for the paper of your choice is included with all Coverages. Additional newspaper prints, $12 each when delivered with the Previews.

Deposits & Payments: A deposit of one-half the selected Bridal Album Coverage is required to reserve a specific wedding date. The second deposit of the remaining balance is due a month before the wedding. If additional time is added to the selected Coverage at the wedding, payment of the additional balance is due upon delivery of the Previews.

Price List #5/3 (Original size: 8½x11")

Price List #5/3 (Current)

Working Conditions

For the moment, Price List #5/3 represents "state of the art" for wedding pricing strategy at my studio. It coexists with Price List #4/3 (which lists a four hour minimum) and Price List #6/3 (a six hour minimum) These are the price lists I plan to use into the foreseeable future.

Basically, I am very pleased with the performance of this pricing format and the ideas behind it. It requires very little explanation. And, most importantly, it helps me book the weddings I want—at the price levels I need.

By 1988–89, weddings had reached a "comfortable" level. The price lists I've been using for the last several years have helped me achieve my own objectives: Lowered volume and high profits for me, high quality photography and great service for my customers. The overall structure of the price list has stayed intact.

What changes have been made in this price list over the previous versions are mostly cosmetic, or efforts to clarify points which would sometimes be raised by customers. (For example, the words "plus tax" were added to *each* Bridal Album package after a woman could not comprehend that in California photographs are a taxable item, even if the packages are based upon time—which is generally non–taxable. A few minutes at the computer clarified this concept.)

When first designing this price list, the intent was to lay out the enire page on the computer, then load the laser printer with colored paper stock, hit the "Print" button, and have an instant "professional" price list. I was trying to get away from having to line up the print-outs on my studio letterhead. As good as the results looked initially, it wasn't long before I realized computers and laser printers were commonplace nowadays—and I wanted to avoid the "computer print-out" look. (And to think that a bare-bones laser printer seemed so miraculous just a few short years ago!)

Thankfully, the technology now exists that it's easy to achieve absolutely flawless, high quality typesetting by having files printed on a high resolution "Imagesetter." The resulting print-out is taken to a commercial printer, who then does the traditional job of running copies on a printing press. This allows for different colored inks, and better paper. Now that I no longer feel compelled to rewrite my price list every week, I can live with not having the ability to make instantaneous changes.The service bureau that prints my computer files has 1–day service, is located downtown a few miles away, and is right next door to my printer. The cost per 8½x11" is an affordable $6.95.

(I don't want to bore you with too much technotalk about the subject of computerized typesetting... but for those of you who are interested, Price List

#5/3, as well as the Wedding Income Log reproduced earlier in the book, were produced on a Macintosh IIci using the ReadySetGo! 5 page layout software.)

Bridal Album and Prices

There have essentially been no *structural* changes over what was discussed in the previous section on Price List #06. Of course, I had to tweak prices and packages somewhat. The rather substantial jump in prices is a direct result of the success we're having with studio work and the fact that more people call about wedding photography than I could ever photograph.

(Everything I've said in this book about the value of doing a great job for people, and building a flawless reputation, is absolutely true. That value is transferable *directly* to the prices listed on your price list.)

Family Albums

Only one minor change in how Family Albums are presented: The cryptic reference to Combination Packages labeled "2/20" (which few people quickly understood) has been replaced by a more complete "2–8x10 & 18–5x7." People do tend to buy more when they can easily understand what they're purchasing.

While I feel that my prices for Bridal Albums have gone about as high as they can go without cutting volume too much, it's in the area of Family Albums and additional prints that I am now pushing prices the hardest. As long as I pay attention to what people other than the bride and groom want, and get those pictures on film, the albums for parents and grandparents are not difficult to sell.

Wall Prints

Although we've been using the idea of offering people a choice of finishes with Wall Prints for awhile now, in terms of the price lists reproduced in this book, this is the first time those choices are listed. After seeing the impact they have on sales and profits, I am a definite believer in the theory of offering people a choice of "good/better/best".

(This idea was discussed in more detail earlier in this book, in Chapter 6, "Packaging Wall Prints.")

Desk Prints

Desk Print prices just keep rollin' along. No format changes here.

Deposits

The deposit format initiated with Price List #06 had proven itself to be 99.9% effective. Most couples had no trouble with the idea that when they would pay any balances due at the time the Previews were picked up. (The .1% refers to those couples who either "forgot" their checkbooks, or took longer than 15 minutes to call my studio once they heard that their Previews were ready.)

This approach to deposits, however, was based upon one idea which I had never really questioned: That couples *wanted* to see their Previews. I mean, really! It never occurred to me that after the wedding anyone would not come to retrieve their proofs—and write me a check.

An otherwise beautiful wedding in 1989 proved me wrong. And in the process cost me several hundred dollars in collection agency fees.

It seems, from what I was able to piece together talking with the bride's parents, that on the honeymoon the groom had second thoughts about whether or not he wished to be married. He decided not. His decision not only staggered his bride, but it also severely impacted the value of my photography.

Those Previews sat of my shelf for many weeks before I knew the reasons why nobody wanted to see them, touch them, remember them, or pay for them. By this point I also started to appreciate that I stood to lose a rather substantial amount of money. If only I'd collected all the money for the Bridal Album *before* the wedding! Live and learn.

It took awhile, and not a little persistence, but I finally was able to collect part of the money owed with the help of a collection agency. It was an $800 lesson.

In terms of *future* weddings, the net result of this fiasco was that I did what I should have been doing all along: *Get the money up front.* I abandoned my *old* firm policy of waiting until after the wedding to collect the final deposit, and made it my *new* firm policy that "*all* money for the booked Bridal Album must be paid, in full, no later than a month before the wedding." That way, should another marriage deteriorate this quickly, I would lose—at most—only the money due for additional time. I can live with that.

I see no reason to put my business' profits at risk because not everyone planning a wedding plans to stay married.

Where Next?

Although Price List #5/3 represents the best system for wedding pricing I've come up with to date, I'm still looking for new ideas for the future. *Always!*

Weddings continue to play a key role in my studio, but are a "mature" market for me. My strategic energies, however, are now primarily directed into studio work and building other areas into equally lucrative profit centers. I like the challenge of making photography into a five or six day a week income ma-

chine. There are some amazingly profitable assignment types which can easily co-exist with weddings. I'm zeroing in on children and high school seniors.

Your thinking may be different. You may have an established career and/or no desire to go beyond weddings. You may want to "specialize" in High End weddings and make them the central market for your business. One or two weddings a week may produce all the "extra" income you care to pursue. A lot of photographers do this—and why not, with the prices people are willing to pay for superior photography? If you are working out of your home, and have no intention of getting into studio work, this would be an excellent way to make an exceptional income. If you *are* planning to get into studio work, or are doing it now, then weddings can foot the bill for those plans. They will also get your name out in front of the people in your community and help you establish your reputation as an excellent photographer. You're on the right track—take my word for it.

Just don't be timid about pricing your work at its true worth. Be aggressive. People *will* pay "high" prices for good photography. Priced for profit, *nothing* beats weddings for single assignment income potential!

Appendix Conclusion

I didn't start this section until after I'd practically completed the main section of this book. As I searched though my files putting together this group of "historical" price lists, all I could do was shake my head. I was amazed at how many "strategies" I've attempted over the years.

Even though I can now look back on over 640+ weddings and see where I might have made changes which would have meant a more smoothly running business and tens of thousands of dollars, in my own defense I can honestly state that at all times I did the best I knew how. I attended seminars and workshops. I read everything I could find on wedding photography. I joined associations so I could rub shoulders with more experienced photographers—and copy their ideas. That's the way to learn.

One point I want to make clear is that while I can now look back on the price lists reproduced in this Appendix, and roughly explain point by point what I *thought* I was doing, at the time I was actually using these ideas I really had few clues of what would work and what wouldn't. If, here, it all looks organized and pre-planned, don't be fooled for a minute. 20/20 hindsight can make mud crystal clear. That's why I've included this Appendix: To demonstrate that wedding pricing is very much a matter of trial and error which takes time to implement. Successfully high prices and strategies aren't born overnight.

A major reason why this book was written is because you shouldn't have to subject yourself to the kind of long, drawn-out learning process that I went through—me, and 95% of the other wedding photographers in the world. While there's no escaping the fact that it can take years to master wedding *photography* itself, the *business* side of wedding photography should be an area you quickly get under control. The structure and thinking behind the price lists in this book should be easily adaptable to your business, whether in whole or in part. (For example, even if you've only photographed a single wedding, you should be able to use many of the concepts and strategies in this book to have a professional, functional, mostly bug-free price in place by the time you meet with your next bride. If you stay up all night tonight working on it, you should be able to have a price list ready by tomorrow morning.)

Above All, Enjoy It!

There is no reason pricing should not be fun. *Yes, fun!* One way to look at it is that higher prices are your reward for creating a more valuable product. The better your work, the more people will be willing to pay for it.

As you can see from the price lists reproduced in this Appendix, my approach to pricing has been: If an idea works, keep it. If it doesn't work, hit the keyboard and type up a new price list—and keep typing until it's right.

That's the best advice I can pass along. I hope I've supplied a few ideas which can either serve as the basis for a total overhaul of your pricing strategies, or which can smooth out a few rough spots in the system you're using now.

However you use this book, I'm sure that once you begin to see a direct link between quality, service, and price, you'll come to appreciate the money-making potential of making people happy with your wedding photography.

Making a good profit sure does contribute to the amount of fun you'll have in wedding photography.

That much I can *promise*.

Postscript To The Second Edition

Since this book was originally published, I've received scores of letters and notes from many of the thousands of photographers who are using it to get their wedding pricing under control. I have to admit it's been fun hearing from fellow photographers who are doing such an admirable job of *avoiding* most of the pitfalls I've outlined—and relived—on these pages.

One of the letters I received was from Jeff Spicer, of Spicer Photography in Sparks, Nevada. Jeff pretty well sums up what I'm hoping this book will do for any photographer who wants to both enjoy wedding photography—and make some fair and reasonable profits at the same time.

Here's Jeff's letter, in its entirety:

March,1992

Dear Steve:

I'm writing this letter hoping my experience will influence the many photographers that are confused about weddings. Not only have your pricing techniques helped our profits, but surprisingly have also provided a means for experimentation to satisfy our particular needs and personal taste.

Like most wedding photographers, this profession started out part-time. In 1980 I did my first wedding for $60. In contrast, we now have established fees that make us feel good by knowing we're getting paid what we feel we deserve. We would never have achieved this position if we had not applied your business strategies. Your pricing methods are easily understood by the client and clearly demonstrate why things are the way they are.

There was once a time when we considered giving up weddings and we began to sound like everyone else that complained about stress and lack of profit. It is without a doubt that the main problem experienced by most photographers is fear. Every time I raised our prices I thought we would soon starve to death. Interestingly, I did lose more clients but there were more available dates for quality-minded clients who really wanted our services. This was a much better situation, not having to deal with people who were just looking for a photographer. We continued to take chances. The clientele also continued to improve and so did our profits. After three seasons we realized our biggest mistake of all. We just never charged enough and wasted too much time trying to create the correct pricing.

The most exciting aspect of what we've accomplished is that we do fewer weddings each year and profits continue to increase. With 50% fewer weddings scheduled for this season we will attain our projected profits. This has allowed us to improve and experiment with other types of photography. Because of this, we are not only better photographers but we have found the time to focus on our strengths and found the time for family and friends. Weddings are more enjoyable than ever before.

When I first discovered what your techniques had done for us I thought I had discovered something worth keeping to myself. Later on I realized that if I could convince others to apply these techniques it would be to my advantage since most photographers are too afraid to charge what they're worth. This makes it difficult for customers to comprehend why there are so many price variations amongst photographers. I believe the average qualified photographer works himself to death and does not live the lifestyle he would prefer.

It is important to note that I purchased your book on the advice of my lab representative. I had put it off for about a year and prior to that was somewhat of a price list junkie. I purchased every price list I could find available and usually acquired one from every speaker I came in contact with. Most of them will work fine but none are as simple or as flexible as yours. We have proven what it will do. The key is to put the fear aside and apply these proven techniques while taking slow calculated steps to achieve pricing goals. No one can last sacrificing every weekend and they may miss out on the true enjoyment of photography.

One last thing, next year our goal is twelve weddings and we should easily gross $40,000. We will always do weddings but our greatest talents are with families and individuals. Thanks for making your book available.

Jeff & Martha Spicer
Spicer Photography
Sparks, Nevada 89434

Wedding Income Log

Wedding _____ Date _____ Day of Week _____

File # _____ Price List # _____ Location _____ Date Booked _____
© 1992 shp

	Income	Cost	Gross Profit	Mark Up
Bride & Groom	$	$	$	%
_____ rolls film @ $ _____ /roll				
_____ Print Bridal Album @ Booked				
SUB-TOTAL **BRIDAL ALBUM @ BOOKED**				
_____ Add'l Hours @ $ _____ /hr.				
Add'l Prints for Bridal Album				
_____ Previews @ Set	Other			
Bride & Groom's Totals				
Parents				
_____ Print Parent Album/Bride				
_____ Print Parent Album/Groom	Other			
Parent's Totals				
Friends/Family				
Friends/Family Totals				
Miscellaneous				
Reorders				
The Bottom Line	$	$	$	%
	Total Income	Total Cost	Total Gross Profit	Average Mark Up

Hours...

Invested Before Wedding _____

Invested On Wedding Day _____

Invested After Wedding _____

Total Hours to Complete _____

Hourly Gross Income From This Wedding

$

Notes

Photocopy this form, or take to your printer. (Enlarge 120% for full 8½x11".)

Sell More Wall Portraits!

NEW VIDEO!

If you're producing quality portraiture for your clients, then delivering the bulk of your orders as 5x7s and 8x10s—you know it can be a lot of work for a little money.

No doubt you've noticed, too, the impact on sales when your clients start with the same photography, and same prices…then proceed to order Wall Portraits in addition to the smaller prints. Orders increase, and profits soar!

The Big Questions: How to start delivering more Wall Portraits, more often? How to make 16x20s, 20x24s and larger prints a *normal* part of your business?

If you're anxious to find answers, and ready to start building Wall Portrait orders into a profit center for your business, you'll find the information you need in incite!'s new video, *Movin' Up To Wall Portraits*. Presented by Meg Patterson, the techniques you'll need to move up to increased Wall Portrait sales are fully and clearly demonstrated in this 110 minute video. You'll learn:

- **Effective Ways To Use Displays To Generate Interest in Wall Portraits**
- **Practical Tips For A Smooth Pre-Portrait Consultation, PLUS Essential Steps To Use During The Sitting To Set The Stage For Later Wall Portrait Sales**
- **Powerful Techniques For Using Projection Proofs To Help Your Clients Visualize Their Photographs As Wall Portraits**
- **Finally, How To Bring Everything Together As A Quality, High-Value Product That's Truly Worth The Higher Prices Wall Portraits Should Command**

These ideas work! They're ready-to-use! Best of all…they're an approach to Wall Portrait sales you can easily adapt to your current mix of portrait sittings and the prices you're using now.

If you're serious about increasing portrait sales, and making the most of your photography, you're 110 minutes away from putting Wall Portraits to work for your bottom line. *Movin' Up to Wall Portraits* will quickly prove itself one of your business' best investments.

> Since 1988, **Meg Patterson** has been the Creative Consultant at Steve Herzog Photography. Using the techniques and ideas presented in *Movin' Up to Wall Portraits*, she has helped tranform Wall Portrait sales from a rarity into a routine, *planned* part of the studio sales—and, in the process, more than tripled the average portrait order.

Please send me ____ copies of **Movin' Up To Wall Portraits** for $69.95 per videotape, plus shipping and handling. (The tape is available only in VHS format. Length: 110 minutes.)

Shipping and Handling: Add $4.75 per video for Ground UPS within the continental United States; $7.50 for UPS Second Day Air. (For orders to Hawaii, Alaska, and Puerto Rico, shipping is **only** via UPS Second Day Air; the cost is $9.50 per tape.) California residents add 7.25% sales tax.

Our Guarantee: If, after studying *Movin' Up to Wall Portraits* for 15 days, you don't agree it will help you increase Wall Portrait sales, return your copy for a full refund of your purchase price.

Name _____ Company _____

Street Address (no P.O. Boxes) _____

City _____ State _____ Zip _____

Daytime telephone _____

___ Payment enclosed (check or money order; no cash please)

___ Charge my VISA/MC Acc't # _____

Exp. Date _____ Signature (required)_____

Photocopies of this Order Form are OK.

2WP

incite! publications ■ 1809 Central Avenue ■ Ceres, CA 95307
800/322–6422 ■ FAX 209/537–7116 (Please don't duplicate your fax orders by mail.)

Add Your Name…Or Change Your Address on the

Incite! Mailing List

We don't know where to find you…*unless you tell us.* Make sure we can keep sending, and you can keep receiving, information on new incite! material to help YOU keep your business running smoothly. Photographers on our mailing list are the first to learn of new books! **MAIL IN THIS FORM TODAY!**

Yes! Please add my name to incite's mailing list of professional wedding/portrait photographers.*

Name _____ Company _____

Mailing Address _____

City _____ State _____ Zip _____

Daytime telephone _____

 * Note: You do **not** need to return this form if you purchased your copy of this book directly from incite! and have not changed your mailing address.

 If you purchased this book from another source and not directly from incite!, or if you borrowed a copy from a friend—then, **YES! please return this form to incite!**

incite! publications ■ **1809 Central Avenue** ■ **Ceres, CA 95307**
209/537–8153 ■ **FAX 209/537–7116**

I've Moved! Please update my mailing address on incite!'s mailing list.*

Name _____ Company _____

OLD Mailing Address _____

City _____ State _____ Zip _____

NEW Mailing Address _____

City _____ State _____ Zip _____

Daytime telephone _____

 * Be sure to let us know if the reason you've moved is because something you read from incite! helped you generate *so much money* that you could afford a new home, a *second* home, a new studio, or whatever. Let us know how you're doing. We definitely enjoy hearing from photographers using our books to improve their businesses.

Photocopies of these Forms are OK.

incite! publications ■ **1809 Central Avenue** ■ **Ceres, CA 95307**
209/537–8153 ■ **FAX 209/537–7116**

Order Additional Copies Of
Wedding Photography
Building A Profitable Pricing Strategy

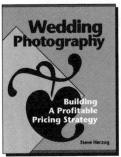

Please send me ____ additional copies of **Wedding Photography** *Building A Profitable Pricing Strategy* for $55.95 per book, plus shipping and handling.

Shipping and Handling: Add $5.00 per book for Ground UPS within the continental United States; $7.50 for UPS Second Day Air. (For orders to Hawaii, Alaska, and Puerto Rico, shipping is **only** via UPS Second Day Air; the cost is $9.50 per book.) California residents add 7.25% sales tax.

Note: 15% discount for purchases of 5–9 books. 20% discount for purchases of 10 or more books. Resellers please call 209/537-8153 for wholesale discount information.

Name _____ Company _____

Street Address (no P.O. Boxes)_____

City _____ State _____ Zip _____

Daytime telephone _____

____ Payment enclosed (check or money order; no cash please)

____ Charge my VISA/MC Acc't # _____

Exp. Date _____ Signature (required)_____

incite! publications ■ **1809 Central Avenue** ■ **Ceres, CA 95307**
800/322–6422 ■ **FAX 209/537–7116** (Please don't duplicate your fax orders by mail.)

2WP

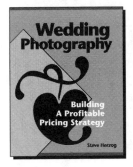

Please send me ____ additional copies of **Wedding Photography** *Building A Profitable Pricing Strategy* for $55.95 per book, plus shipping and handling.

Shipping and Handling: Add $5.00 per book for Ground UPS within the continental United States; $7.50 for UPS Second Day Air. (For orders to Hawaii, Alaska, and Puerto Rico, shipping is **only** via UPS Second Day Air; the cost is $9.50 per book.) California residents add 7.25% sales tax.

Note: 15% discount for purchases of 5–9 books. 20% discount for purchases of 10 or more books. Resellers please call 209/537-8153 for wholesale discount information.

Name _____ Company _____

Street Address (no P.O. Boxes)_____

City _____ State _____ Zip _____

Daytime telephone _____

____ Payment enclosed (check or money order; no cash please)

____ Charge my VISA/MC Acc't # _____

Exp. Date _____ Signature (required)_____

Photocopies
of these
Order Forms
are OK.

incite! publications ■ **1809 Central Avenue** ■ **Ceres, CA 95307**
800/322–6422 ■ **FAX 209/537–7116** (Please don't duplicate your fax orders by mail.)

2WP